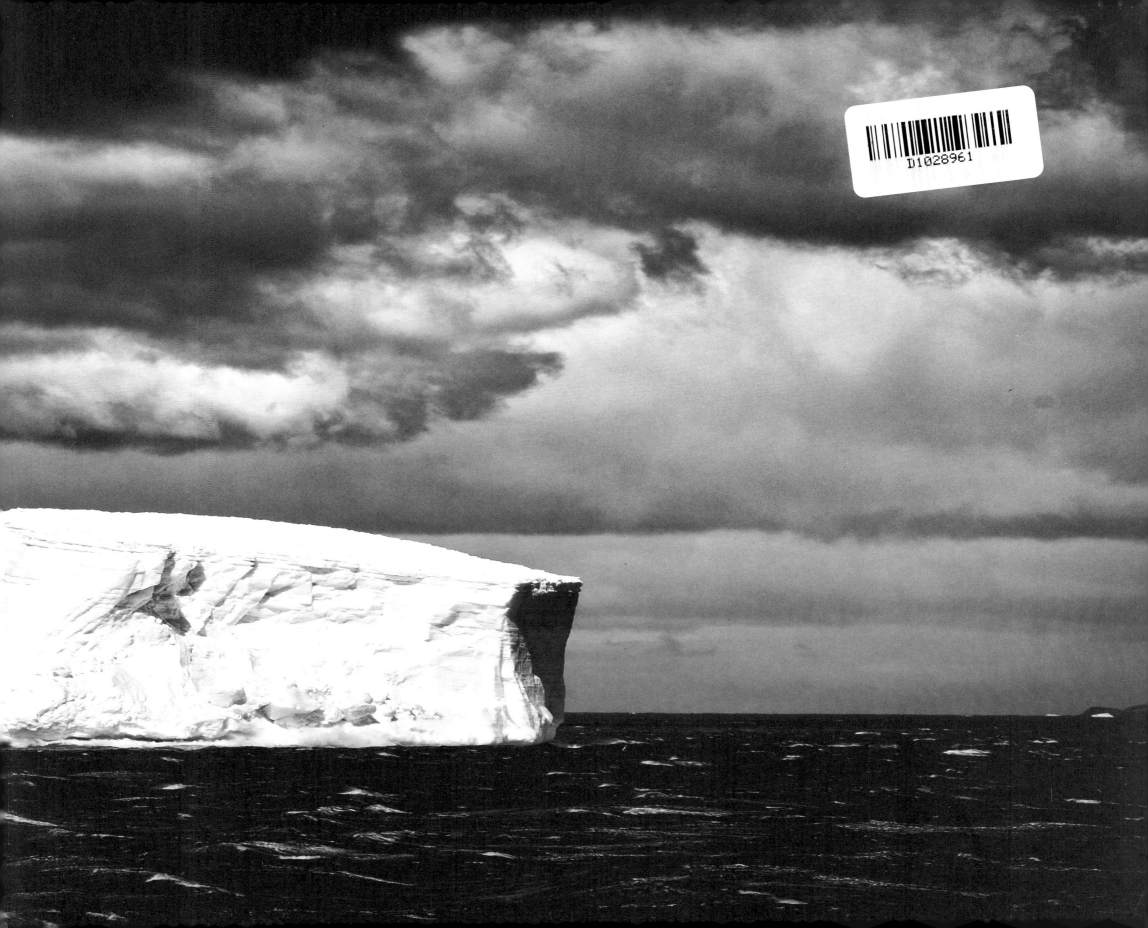

BLUE ICE

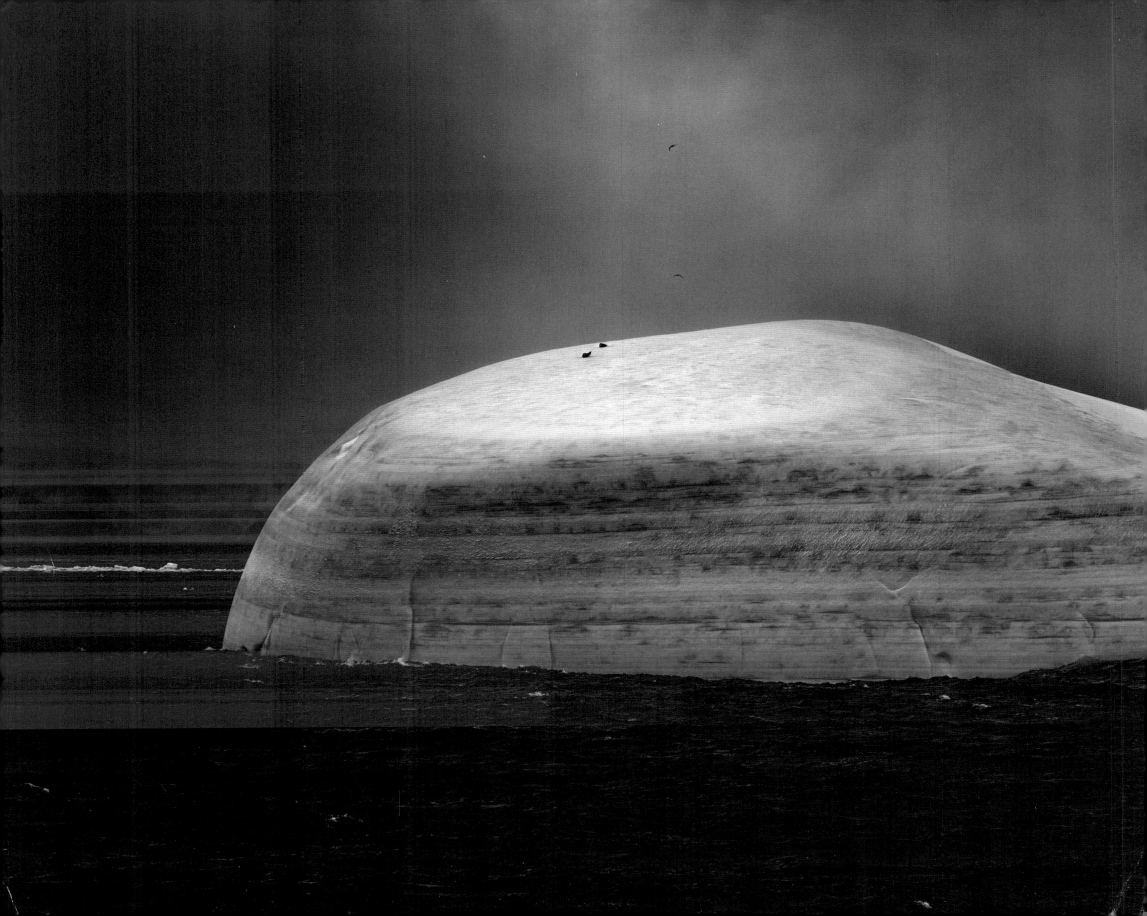

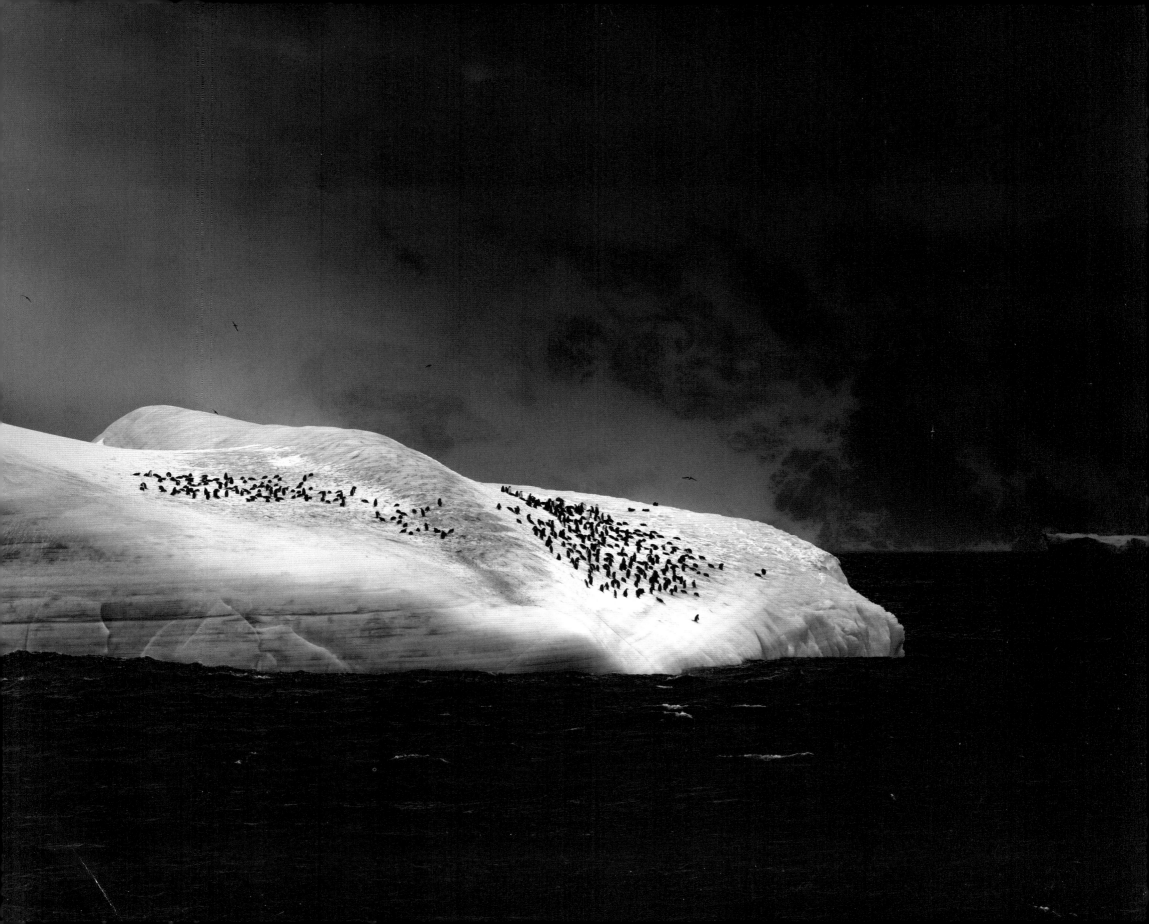

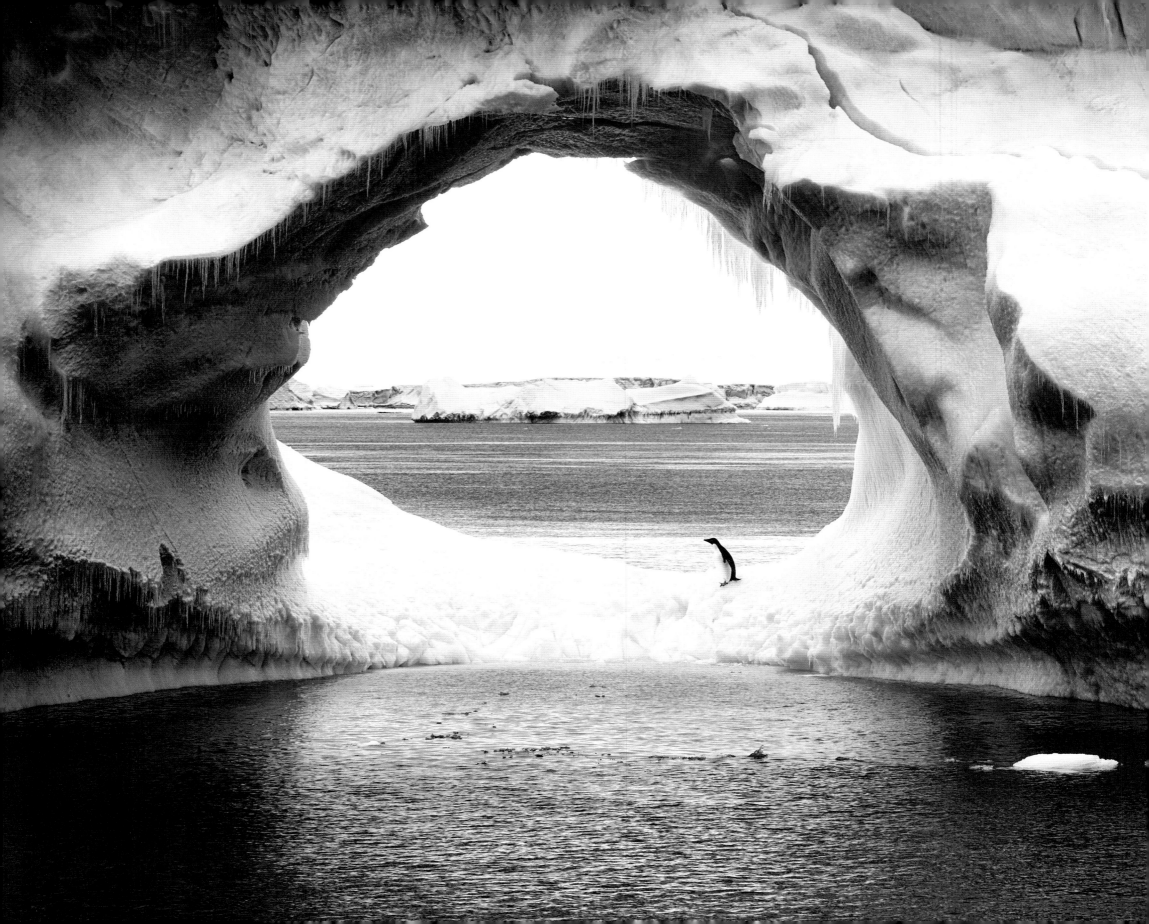

ALEX BERNASCONI

BLUE ICE

Foreword by
Professor Julian Dowdeswell

Introduction by
Dr Peter Clarkson

EARTH AWARE
EDITIONS

PO Box 3088
San Rafael, CA 94912

www.mandalaeartheditions.com

Follow us on Twitter @mandalaearth Find us in Facebook: www.facebook.com/mandalaearth

Publishing Director: Alexandra Papadakis

Design Director: Aldo Sampieri

Editor: Sheila de Vallée

Production: Dr Caroline Kuhtz

Production Assistant: Christine Edelmann

ISBN 978-1-60887-735-5

First published in Great Britain in 2015 by Papadakis Publisher

First published in the United States in 2016 by Earth Aware Editions, an imprint of Insight Editions

A CIP catalogue record of this book is available from the British Library.

 REPLANTED PAPER

ROOTS of PEACE

Insight Editions, in association with Roots of Peace, will plant two trees for each tree used in the manufacturing of this book. Roots of Peace is an internationally renowned humanitarian organization dedicated to eradicating land mines worldwide and converting war-torn lands into productive farms and wildlife habitats. Roots of Peace will plant two million fruit and nut trees in Afghanistan and provide farmers there with the skills and support necessary for sustainable land use.

Printed and bound in China.

Pages 2–3: Blue iceberg with Adélie penguins, near the South Orkney Islands. The first impression was of a dull, dark iceberg but suddenly an opening in the thick clouds shone a spotlight on it and revealed its extraordinary colour.
Page 4: Cave iceberg at Brown Bluff, a tuya (a volcano that erupted under ice) located at the northern tip of the Antarctic Peninsula.

CONTENTS

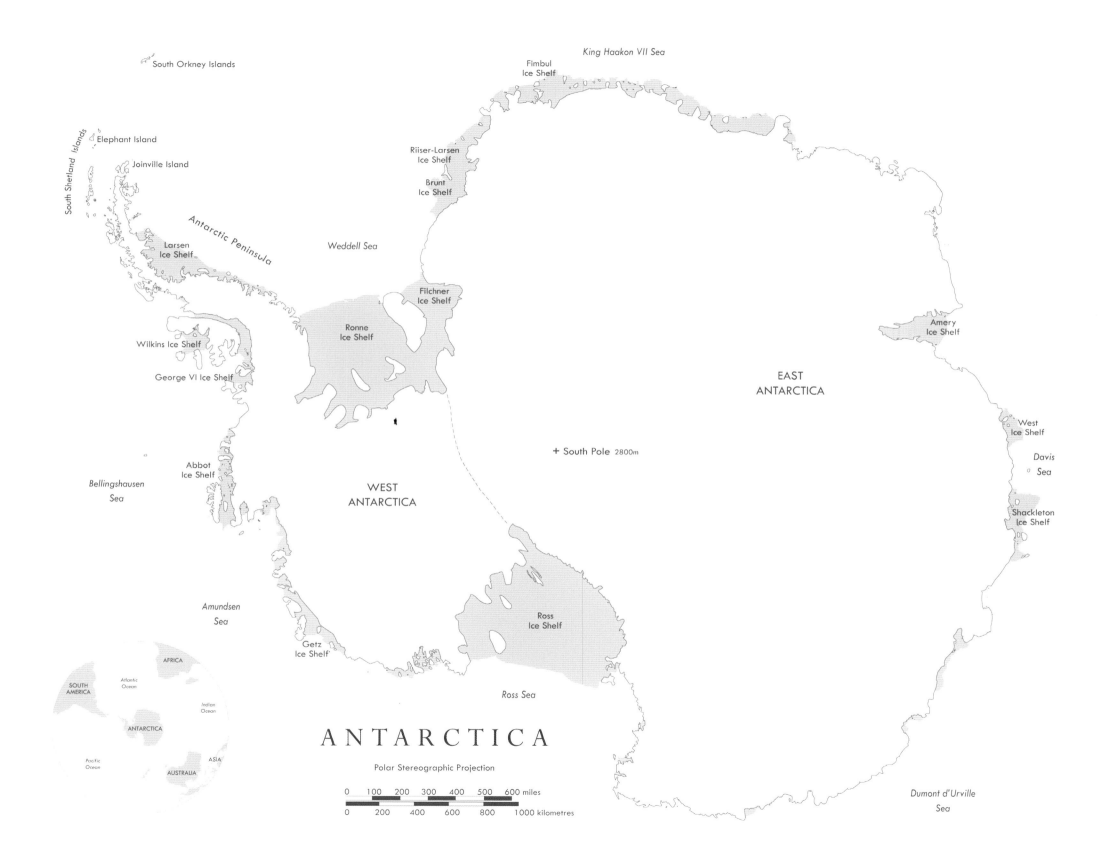

South Orkney Islands

King Haakon VII Sea

Fimbul
Ice Shelf

South Shetland Islands

Elephant Island

Riiser-Larsen
Ice Shelf

Joinville Island

Brunt
Ice Shelf

Antarctic Peninsula

Larsen
Ice Shelf

Weddell Sea

Filchner
Ice Shelf

Amery
Ice Shelf

Ronne
Ice Shelf

EAST
ANTARCTICA

Wilkins Ice Shelf

George VI Ice Shelf

West
Ice Shelf

*Davis
Sea*

+ South Pole 2800m

Abbot
Ice Shelf

*Bellingshausen
Sea*

WEST
ANTARCTICA

Shackleton
Ice Shelf

*Amundsen
Sea*

Ross
Ice Shelf

Getz
Ice Shelf

AFRICA

*Atlantic
Ocean*

SOUTH
AMERICA

*Indian
Ocean*

ANTARCTICA

Ross Sea

ASIA

*Pacific
Ocean*

AUSTRALIA

ANTARCTICA

*Dumont d'Urville
Sea*

Polar Stereographic Projection

0 100 200 300 400 500 600 miles

0 200 400 600 800 1000 kilometres

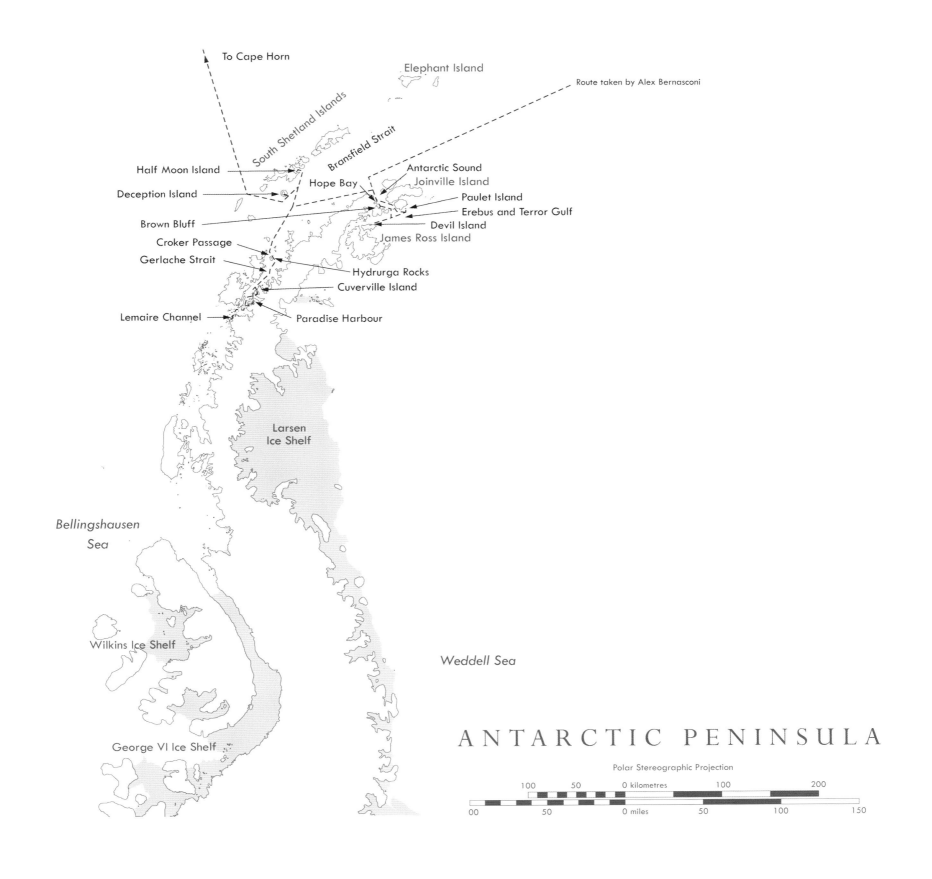

To Cape Horn

Elephant Island

Route taken by Alex Bernasconi

South Shetland Islands

Bransfield Strait

Half Moon Island

Antarctic Sound

Joinville Island

Deception Island

Hope Bay

Paulet Island

Erebus and Terror Gulf

Brown Bluff

Devil Island

James Ross Island

Croker Passage

Gerlache Strait

Hydrurga Rocks

Cuverville Island

Lemaire Channel

Paradise Harbour

Larsen
Ice Shelf

Bellingshausen
Sea

Weddell Sea

Wilkins Ice Shelf

George VI Ice Shelf

ANTARCTIC PENINSULA

Polar Stereographic Projection

100 50 0 kilometres 100 200

00 50 0 miles 50 100 150

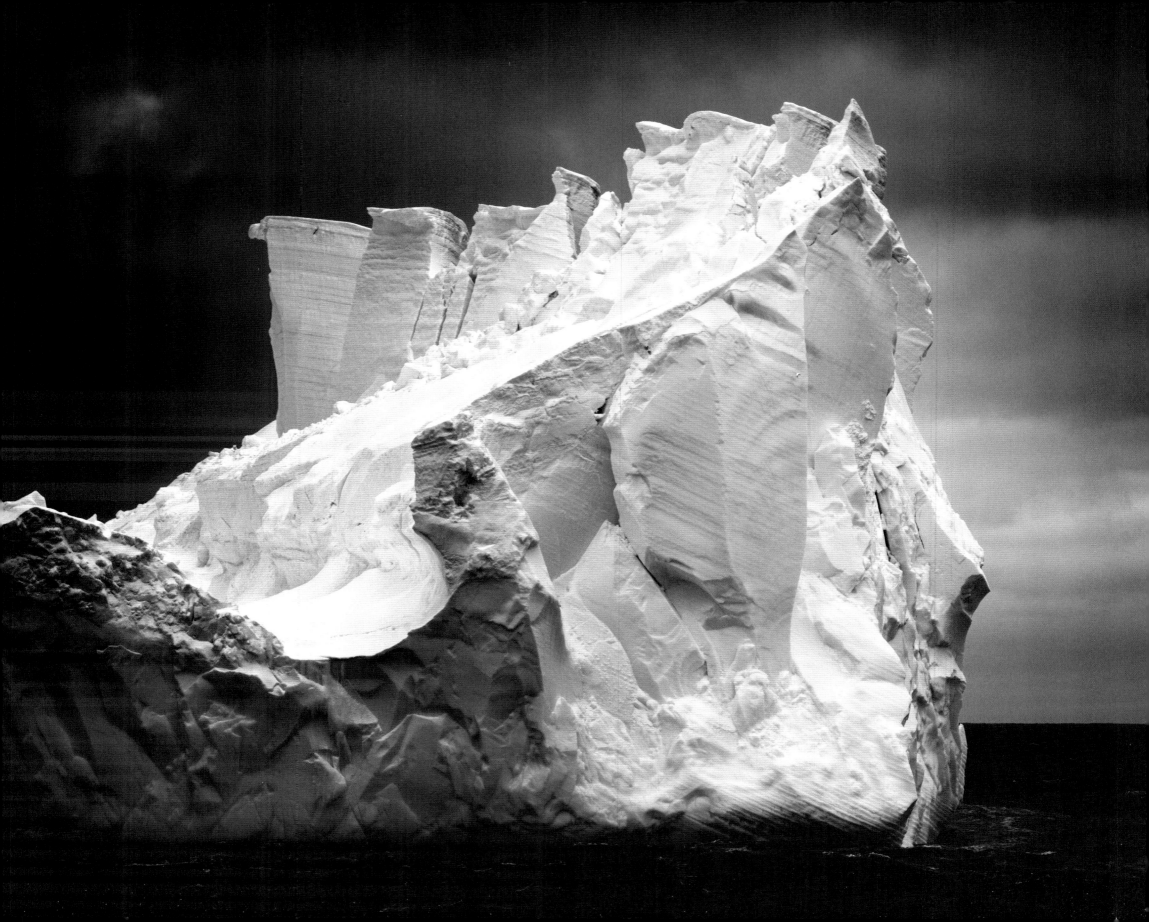

FOREWORD

Professor Julian Dowdeswell

Director

Scott Polar Research Institute, University of Cambridge

As Director of the Scott Polar Research Institute at the University of Cambridge, I have been fortunate to visit Antarctica as a scientist on a number of occasions. Not only have I undertaken research on the Antarctic ice sheets and relating to the icebergs and sea ice of its surrounding ocean, but I have also been able to experience the sense of history conveyed by spending time in Captain Scott's hut at Cape Evans. The Antarctic is a varied canvas and Alex Bernasconi's very fine photographs provide a superb record of its magnificent landscape and wildlife.

The continent of Antarctica, at almost 5.4 million square miles in area, is about the same size as Europe. The deep Southern Ocean has surrounded Antarctica for the last 40 million years or so, since South America separated from what is now the Antarctic Peninsula, as a result of the motion of continental plates. It is, to some extent, isolated from lower, warmer latitudes by the ocean currents and winds that circulate from west to east between its icy coast and the southern tips of modern South America, Africa and Australia.

The Antarctic continent itself is made up of three geographical elements, each of which is largely ice covered. The huge ice sheets of East and West Antarctica are separated by the aptly named Transantarctic Mountains, with the smaller Antarctic Peninsula (about the size of Britain) protruding north into the Southern Ocean. On average, the ice sheets are almost 2 miles thick, reaching a maximum of just over 3 miles in depth. This miles-thick cover acts to load and depress the Earth's crust beneath it by about one-third of its thickness. Much of the ice of West Antarctica lies largely on a bed that is over half a mile below the present sea-surface, whereas most of the larger East Antarctica sits on land that would be above sea-level were all the ice to be removed.

An iceberg in Erebus and Terror Gulf, reminiscent of a Navajo Indian with headdress.

Around Antarctica, the temperature of the cold Southern Ocean is often less than 0°C, with the ocean surface freezing to form a thin sea-ice cover at only −1.8°C because it is composed of saline marine water. Sea ice is distinguished from floating icebergs because the latter are derived from glacier ice, and are therefore made up of fresh water which fell in the interior of Antarctica as snow, rather than the simple freezing of the sea surface. Icebergs can be hundreds of metres in thickness, whereas Antarctic sea ice is typically no more than about 2 m thick. Sea ice extent varies from nearly 8 million square miles in the Antarctic winter, to only about three-quarters of a million square miles by the end of the austral summer.

The sea ice and waters of the Southern Ocean are home to some of the most impressive birdlife on the planet, and to the whales, seals and penguins that are a characteristic part of the Antarctic biota. Marine algae and the shrimp-like krill are the nutrients that largely sustain these birds and mammals, some of which, like the Emperor penguin, actually breed on Antarctica. With such a dependence on sea ice, the Antarctic ecosystem is potentially very vulnerable to future environmental change.

Today, the Antarctic is the coldest and windiest place on Earth. Temperatures at the Russian Vostok Station in central East Antarctica occasionally reach −90°C, with an annual average of −55°C. The winds in Commonwealth Bay on the shores of East Antarctica blow at an average of 80 km/hour (50 miles/hour): the explorer Sir Douglas Mawson named it the home of the blizzard. Antarctica is also among the driest locations on the planet, with snowfall in the interior of East Antarctica sometimes amounting to only a few centimetres a year. Parts of Antarctica have also been affected by considerable shifts in temperature since the beginning of regular weather-record collection about 50 years ago. The Antarctic Peninsula, in particular, has experienced a

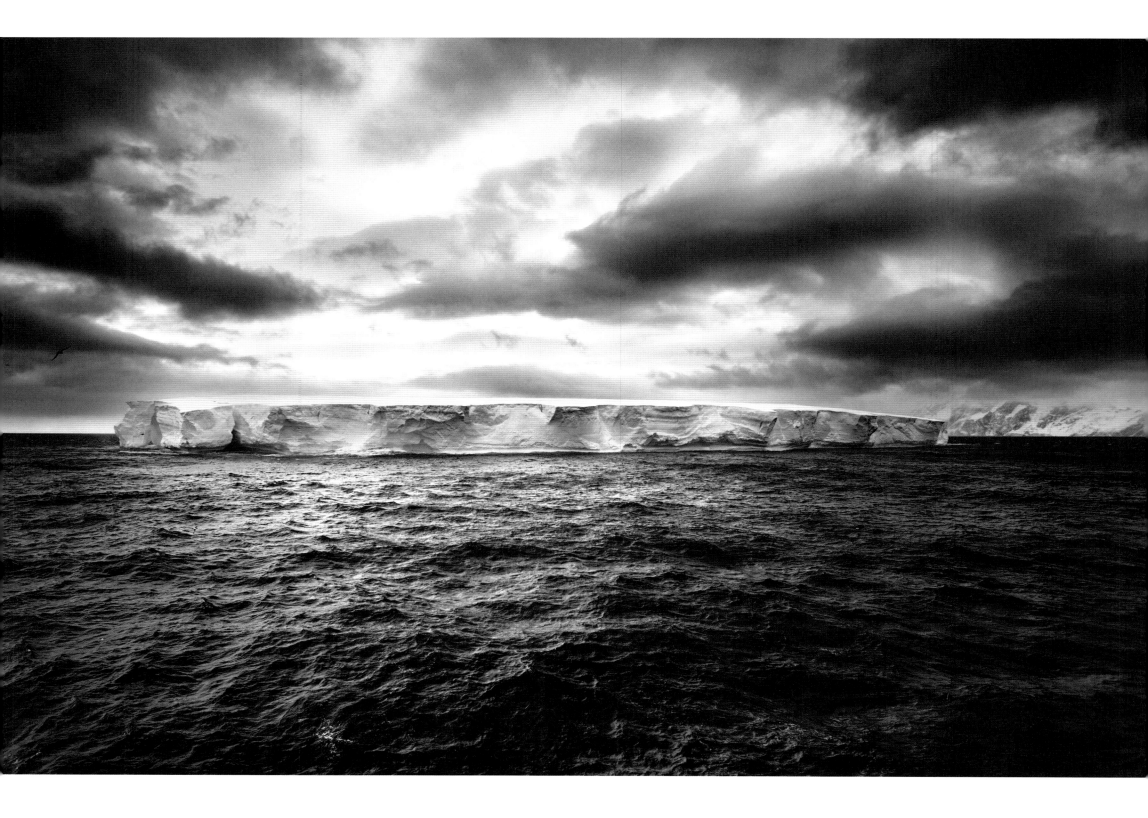

temperature rise approaching 3°C over this period, making it the most rapidly warming region of the Southern Hemisphere. In this part of Antarctica almost 90% of glaciers are retreating and about 10,000 square miles of ice have been lost through the disintegration of ten floating ice shelves around its margin – the best known being the dramatic break-up of the Larsen-B Ice Shelf in 2002.

It is important to recognise that Antarctica, and its continuing response to environmental change, has a relevance far beyond the continent and its surrounding ocean waters. First, changes in the amount of mass held as ice on land affect sea-level globally. If glaciers and ice sheets thin and retreat, then global sea-level rises, whereas if they gain ice then sea-level will fall. About 20,000 years ago the ice sheets of the world, including those on Antarctica and Greenland along with mid-latitude ice sheets over North America and Eurasia, were substantially larger than they are today. As a result, global sea-level was about 120 m lower than it is now. Conversely, global sea-level is rising today by just over 3 mm per year, as measured by highly accurate satellite radar altimeters. At present, Antarctica is probably neutral overall in terms of its gains and losses of ice and the observed rise in sea-level is related mainly to thinning of mountain glaciers and the Greenland Ice Sheet, and to thermal expansion of the oceans. It is important for scientists to continue to monitor change in Antarctica because the ice sheets here remain the biggest repository of fresh water held as ice on land anywhere in the world. If all this ice were to melt, global sea-level would rise by more than 60 m, although this would be a very slow process.

Secondly, in terms of wider relevance, sea ice and its oceanographic effects are also important. Sea ice covers nearly 8 million square miles of the ocean around Antarctica during winter. As sea-water freezes, the resulting thin cover of sea ice is less salty than the ocean water from which it is formed. Salts are rejected and the water immediately beneath the sea ice is therefore very cold and salty; in fact among the densest water anywhere in the global oceans. This dense water sinks, often several thousand metres, to the sea floor and flows northwards at depth, becoming an important driver of the ocean-current systems of the world that act to transfer heat from the equator towards the poles. Changes in the extent and thickness of sea ice may, therefore, influence global ocean-circulation patterns, again an effect that ramifies way beyond the cold shores of Antarctica. The extent of sea ice around Antarctica is very variable not only from year to year, but also by region. Today sea ice cover around the Antarctic Peninsula may be decreasing slightly but, in the Ross Sea sector, there have been notable increases in recent years.

It is remarkable to consider that the Antarctic continent was only discovered in the early nineteenth century. It was not until the first expedition of Captain R F Scott aboard the *Discovery*, between 1901–04, that the interior of the continent was penetrated, with the South Pole itself being attained by Roald Amundsen in December 1911 and Scott and his four companions just a month later in January 1912. Since then, the Antarctic has been the realm mainly of scientists trying to understand its unique attributes and how its carapace of ice may alter in the face of the environmental changes that have been particularly marked since the late twentieth century.

I value the experience of having been in Antarctica hugely for both the bleak grandeur of the continent and also because the studies we as scientists are undertaking have a relevance to humankind that extends far beyond this largely ice-covered continent. Alex Bernasconi's evocative photographs serve to remind us of just what a special place Antarctica is.

Professor Julian Dowdeswell

A tabular iceberg located near Antarctic Sound. After the sinking of the *Titanic* in 1912, the International Ice Patrol was created to warn ships of icebergs in the North Atlantic. The United States National Snow and Ice Data Center monitors icebergs larger than 500 sq.m in the waters around Antarctica. The study of icebergs enables scientists to learn more about climate and ocean processes.

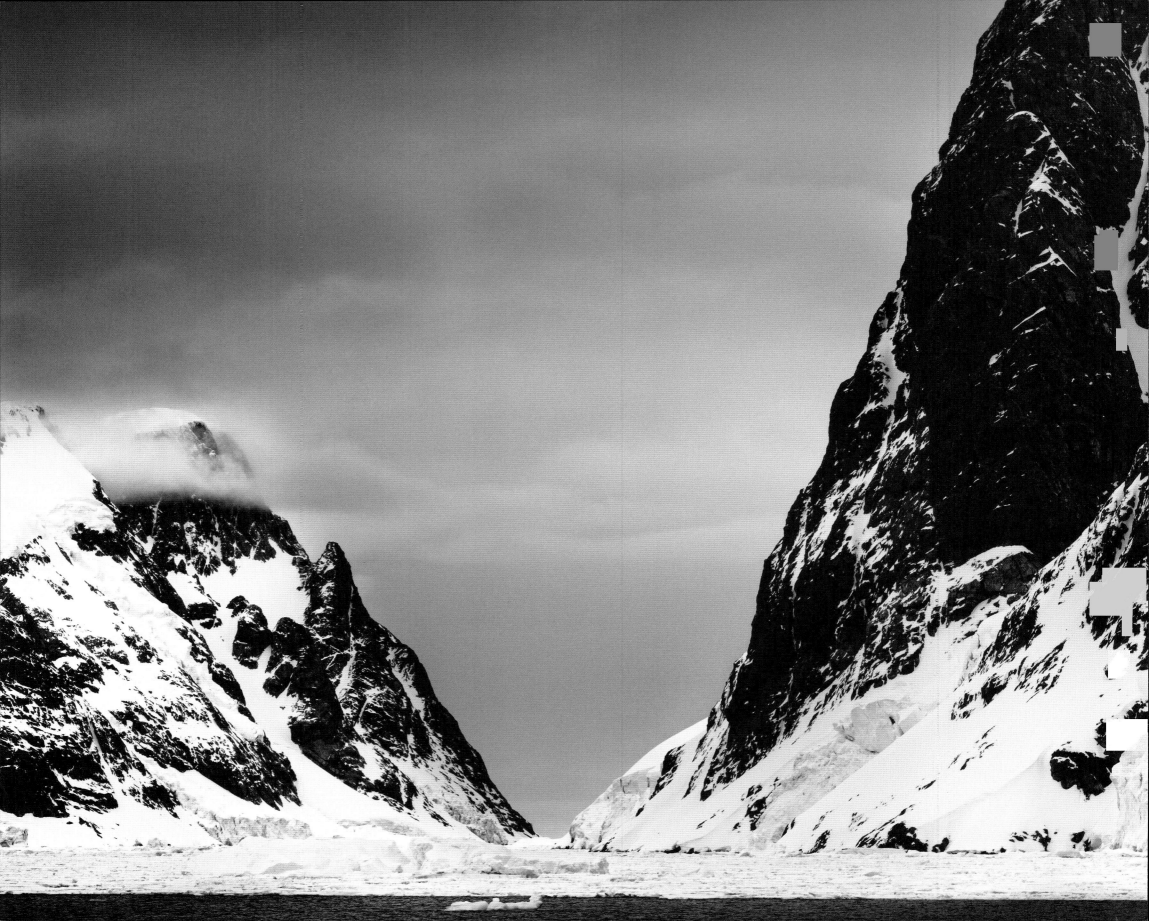

INTRODUCTION

Dr Peter Clarkson
Emeritus Associate
Scott Polar Research Institute, University of Cambridge

Antarctica is a continent of extremes. It is the highest, coldest, windiest continent on Earth. It is part of the Antarctic, the south polar region defined as the area south of the Antarctic Convergence or Polar Front where the cold surface waters of the Southern Ocean sink below the warmer surface waters to the north. In addition to the southern continent itself, the Antarctic includes many islands most of which form groups along or near the Antarctic Peninsula that extends north towards southern South America but there are others isolated in the Southern Ocean. The Southern Ocean, comprising the southernmost parts of the Atlantic, Indian and Pacific oceans, contains the Circumpolar Current flowing eastward around Antarctica. Where the current is restricted through the relatively narrow gap between South America and the northern end of the Antarctic Peninsula it is very strong and gives rise to some of the stormiest seas in the world. The Circumpolar Current provides a climatic barrier that effectively separates Antarctica from more northerly latitudes, making the Antarctic significantly colder than the Arctic.

It is also the most remote continent on Earth. From the northern tip of the Antarctic Peninsula to Cape Horn (Cabo de Hornos), the southernmost point of the South American continent, is about 620 miles but from New Zealand to Oates Land is about 1,650 miles and from South Africa to the coast of Dronning Maud Land is about 2,420 miles. The average height of the continent is 2,300 m; the coldest temperature ever measured on the surface of the Earth is −89.2°C at the Soviet (Russian) Vostok Station, 3,505 m above sea level on the Antarctic plateau; wind speeds as

high as 200 miles per hour have been recorded at Commonwealth Bay in George V Land, south of Tasmania. More than 98.6% of the continent is covered by ice, up to 4,776 m thick, with an average thickness of about 2,450 m. This represents about 90% of all the ice on Earth, which is around 80% of all the freshwater on Earth and yet, despite this, the continent is officially a desert because the mean annual snowfall is so small.

Antarctica was the last continent to be discovered although as early as around 140 BC the Chaldæan philosopher Seleukos postulated the existence of a 'Southern Continent'. About 150 AD Claudius Ptolemæus of Alexandria produced a world map showing a large theoretical 'Southern Continent' joining Africa and Asia. It was not until Ferdinand Magellan (Fernão de Magalhães) made the first voyage (1519–21) to circumnavigate the world that a 'Southern Continent', if such existed, was separated from the other continents. Magellan had sailed from Portugal and crossed from the Atlantic to the Pacific through what is now known as the Magellan Strait (Estrecho de Magallanes) so there was land to the south, possibly the northern extremity of the 'Southern Continent'. Sir Francis Drake made the second world circumnavigation, also sailing through the Magellan Strait, but then he was blown off course to the south and saw the ocean extending southward, now known as Drake Passage. Dutch voyages in the 1640s discovered Tasmania, New Zealand and Australia but did not prove their insular nature. However, they did substantially reduce the possible extent of the 'Southern Continent'.

On 14 August 1592 John Davis in HMS *Desire* discovered the Falkland Islands (e.g. pp. 16, 27 and 37), having been blown off course from near the Magellan Strait. However, a Portuguese chart of 1522 by Pedro Reinel showed islands in this position, possibly indicating earlier knowledge. In January 1600 the Jason Islands, lying off West Falkland, were discovered and gradually, over the next 160 years the general extent of the island group was charted. In 1764 a settlement

Lemaire Channel was discovered by the Belgian Adrien de Gerlache on the *Belgica* in 1898 and named after Charles Lemaire who explored the Congo but never visited Antarctica. The first mate on the vessel was the great polar explorer Roald Amundsen. It is a very beautiful, protected channel, its calm waters more like a lake than the stormy southern oceans, which enables tourists to reach and land at Petermann Island.

was established at Port Louis, East Falkland, by a French expedition from Saint-Malo. In 1765 the British made preparations for a settlement at Port Egmont in West Falkland, unaware of the French at Port Louis. A year later the British returned in HMS *Jason* and HMS *Carcass* to establish the settlement at Port Egmont and ordered the French to leave within six months. Arguments over sovereignty of the islands have continued ever since.

In April 1675 Antoine de la Roche, commander of an English mercantile voyage from Lima to London, was blown off course and probably discovered South Georgia, the first land discovered in the Southern Ocean. On 1 January 1739 Jean-Baptiste Charles Bouvet de Lozier, senior commander of a French voyage, discovered Cap de la Circoncision that he took to be a promontory of the 'Southern Continent'. He had actually discovered Bouvet Island (Bouvetøya), the most remote island in the world. It was another 69 years before it was sighted again.

In 1768 Captain James Cook, the greatest navigator of the age, made his first foray into the Southern Ocean in command of HMS *Endeavour* (1768–71). He crossed 60°S in Drake Passage and went on to show that Australia was not part of the 'Southern Continent'. He returned to the Southern Ocean (1772–75) with the ships HMS *Resolution* and HMS *Adventure* and circumnavigated the Earth in high southern latitudes. This was the first expedition to cross the Antarctic Circle, on 17 January 1773 and again on 30 January 1774 to 71°10′ S off the coast of Marie Byrd Land. During the voyage he charted the north-east coast of South Georgia (e.g. pp. 30, 33 and 34) and discovered and mapped the South Sandwich Islands. Cook's third voyage (1776–80) was intended to search for the north-west passage from the Pacific Ocean. He sailed via the southern Indian Ocean where he proved that the Iles Kerguelen were not part of the 'Southern Continent'. He discovered the Hawaiian Islands before sailing through the Bering Strait and crossing the Arctic Circle. The ships, HMS *Resolution* and HMS *Discovery*, returned to Hawaii where Cook was killed on 14 February 1779, aged 50, in a skirmish with some natives. Cook had sailed 18,000 miles through uncharted southern seas but had failed to sight the fabled 'Southern Continent'. Cook was not impressed by his discoveries in the Southern Ocean and wrote in his diary for 6 February 1775: … *I can be bold to say, that no man will ever venture farther than I have done and that the lands which may lie to the South will never be explored. … a Country doomed by Nature never once to feel the warmth of the Sun's rays, but to lie for ever buried under everlasting snow and ice*

The report of Cook's second voyage contained a detailed description of South Georgia and the vast numbers of fur seals to be found on its beaches. His account was remarkably gloomy whereas, for many tourists visiting today in fine weather, the sights of South Georgia form a highlight of the voyage. No one will forget the spectacular panorama of the mountains or the abundance of wildlife, particularly the King penguins at St Andrews Bay (e.g. pp. 34, 56–60 and 62–63). Despite Cook's description, in 1786 Thomas Delano from London made the first visit to South Georgia to take fur seals. Further visits were sporadic until the 1790s when the industry gathered pace as American sealers from the New England ports rapidly depleted stocks. During this time, Elephant seals were also frequently taken for their oil. On 19 February 1819 William Smith, sailing from London to Valparaiso in the *Williams*, was blown off course when rounding Cape Horn and discovered the South Shetland Islands. During his return voyage to Montevideo he tried to reach the islands but was prevented by ice. In October 1819 he ventured south again and landed on King George Island on 16 October, taking possession in the name of King George III. News of this discovery and the numbers of fur seals on the islands soon became known and the sealers descended on the islands in hordes. The relentless slaughter of the animals was so great that within two years sealing expeditions to the islands were no longer economic.

On a clear day the mainland of the Antarctic Peninsula is visible from the South Shetland Islands across Bransfield Strait (p. 18) and when Smith returned to the islands with Lieutenant Edward Bransfield RN the latter was credited with the first sighting of the peninsula on 30 January 1820. He called his discovery 'Trinity Land'. Many sealers undoubtedly visited the distant mainland to search for further sealing grounds but they were secretive about their discoveries for commercial reasons. During the same season, a Russian expedition was exploring the Antarctic for Czar Alexander. Fabian Gottlieb Benjamin von Bellingshausen was in command aboard *Vostok* and sighted an area of hummocked ice on Kronprinsesse Märtha Kyst, Dronning Maud Land, on 27 January 1820. Thus Bellingshausen was the first man to see the Antarctic mainland, three days before Bransfield saw 'Trinity Land', but he did not recognize it as land. However, Bellingshausen went on to discover Peter I Island (Peter I øy) on 20 January 1821 and Alexander Island on 27 January 1821. During the 1821–22 season George Powell aboard *Dove* from London (UK) and

Gentoo penguin landing on a beach on Saunders Island (Falkland Islands).
A Gentoo penguin makes as many as 450 dives a day in search of food.

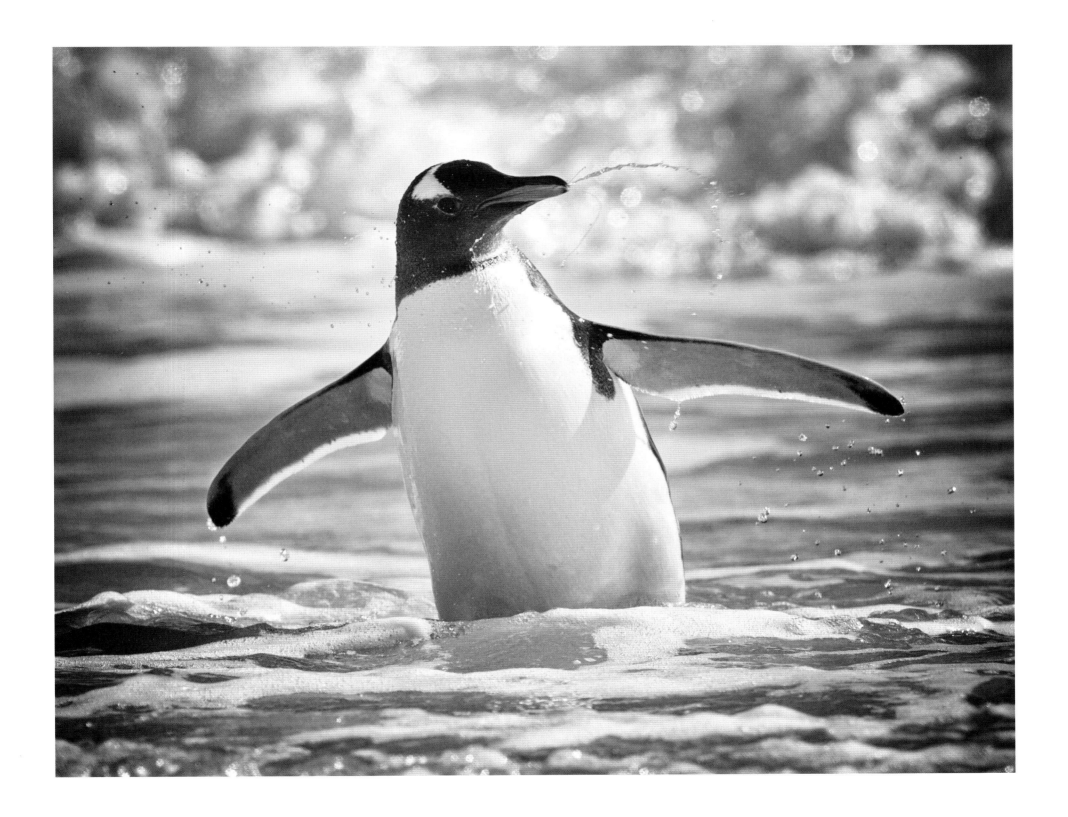

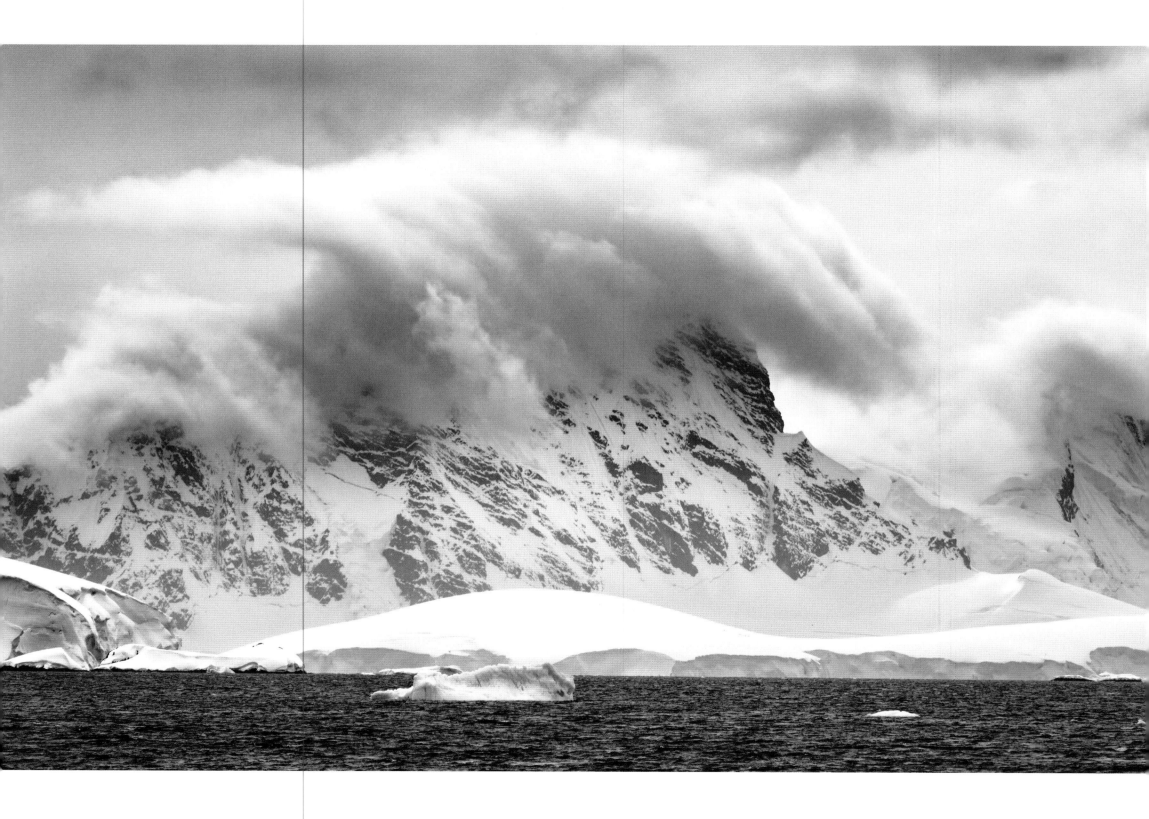

Nathaniel Brown Palmer aboard *James Monroe* from Stonington (USA) jointly discovered the South Orkney Islands (e.g. pp. 2–3, 48–49 and 84) on 6 December 1821. In 1823 James Weddell in the *Jane* sailed into the sea that now bears his name and reached a new farthest south at 74°15′ S, 34°16′ W on 20 February 1823. He reported being in open water and seeing many whales.

During the 1820s sealing voyages made many new discoveries in their exploration for new sealing grounds. Some of these discoveries were made public and appeared on various contemporary maps. On some of these voyages collections of flora, fauna and rocks were made but the first scientific expedition to the region was by the Royal Navy in HMS *Chanticleer* in 1828–31 under the command of Henry Foster. In addition to charting new areas and making natural history collections, the ship visited Deception Island in the South Shetland Islands to make pendulum and magnetic observations. Deception Island is a horseshoe-shaped, dormant volcano. The sea has breached the rim of the central caldera so that ships can sail through the narrow entrance at Neptune's Bellows into the crater that forms a natural harbour. The volcano erupted in 1967, 1969 and 1970 destroying the Chilean station and much of the old whaling station.

Over the next few decades most voyages to the Southern Ocean were concerned with sealing and some whaling but a few could be considered as exploration for its own sake. Dumont d'Urville from France led a naval expedition that circumnavigated Antarctica. He landed near Pointe Géologie on 22 January 1840 and claimed the area for France as Terre Adélie, named after his wife. D'Urville had already achieved distinction in 1820 as the discoverer of the Venus de Milo statue on the Greek island of Milos. The Enderby Brothers, a London company, was in the sealing business but actively encouraged exploration. John Balleny, with two ships part-owned by the company, reached 69°S in the Ross Sea on 1 February 1839 and discovered the Balleny Islands on 9 February where he landed 3 days later, the first landing south of the Antarctic Circle. The United States Exploring Expedition, comprising six vessels under the command of Charles Wilkes, charted a series of landfalls and 'appearances of land' between longitudes 160°E and 98°E. James Clark Ross RN in the ships HMS *Erebus* and HMS *Terror* broke through the pack ice

Mountains shrouded in cloud. Bransfield Strait, Antarctica, which is located between the northern Antarctic Peninsula and the South Shetland Islands. It is named after a British naval officer who was one of the first to sight the continent of Antarctica when sailing from the South Shetland Islands in 1820.

of the Ross Sea to reach Ross Island and a new farthest south (78°10′ S). He roughly charted 560 miles of new coast in Victoria Land and discovered the 'Britannia Barrier', now known as the Ross Ice Shelf. He also calculated the position of the South Magnetic Pole as 75°50′ S, 154°08′ E. During this voyage (1839–43) he circumnavigated the continent, sighted Joinville Island and James Ross Island at the head of the Antarctic Peninsula and annexed them for the British Crown on 6 January 1843 at Cockburn Island. Most of these voyages included some scientists and naturalists, notably Joseph Dalton Hooker – Charles Darwin's closest friend and future Director of the Royal Botanic Gardens, Kew – with Ross, so that knowledge of the Antarctic was beginning to accrue.

The outline of Antarctica was becoming delineated as isolated stretches of coastline were being added to the charts. The fabled 'Southern Continent' had shrunk dramatically and the myth of a land suitable for colonization had finally been dispelled. Indeed James Cook, writing about South Georgia and the South Sandwich Islands, had described: *Lands doomed by Nature to perpetual frigidness: never to feel the warmth of the sun's rays; whose horrible and savage aspect I have not words to describe.* In the 1873–74 season Eduard Dallmann led the first German expedition to the Antarctic. His ship, the whaler *Grönland*, was the first steamship to enter Antarctic waters. He roughly charted the mainland and islands along the west coast of the Antarctic Peninsula as far as 65°S. A year later, HMS *Challenger*, during a world circumnavigation (1872–76), was the first steamship to cross the Antarctic Circle reaching 66°40′ S, 78°22′ E off the coast of Princess Elizabeth Land. The first known photographs of icebergs and of some of the peri-Antarctic islands were taken on the voyage.

The value and importance of scientific observation in the polar regions was recognized with the organization of the first International Polar Year, 1882–83. Eleven countries took part and established 14 scientific stations; most of these were in the Arctic but Germany operated the only Antarctic station at Moltke Harbour in Royal Bay on the north-east coast of South Georgia. Geophysics, meteorology, glaciology, biology and other sciences were studied during the year.

Sealing voyages to the Antarctic continued but a new commercial era was to open in the 1892–93 season when a fleet of four whalers from Dundee, Scotland, made an exploratory voyage to the northern Antarctic Peninsula. The fleet met Carl Anton Larsen aboard *Jason* near Joinville

Island on 24 December 1892. Larsen was also exploring for whales although neither expedition successfully caught a whale. However, on Seymour Island Larsen did collect the first fossils from Antarctica and the first photographs of Antarctica were taken. Nevertheless the scene had been set for the indiscriminate slaughter of the great whales over the next several decades.

On 25 January 1895 Henrik Bull landed at Cape Adare in northern Victoria Land from the sealing and whaling vessel *Antarctic*. One member of the company, Carsten Borchgrevink, had already landed on a nearby island and collected specimens of lichen, the first plant life to be recorded within the Antarctic Circle. Borchgrevink was determined to return with an expedition but it was the Belgian, Adrien de Gerlache, who led the next expedition in the *Belgica*, which raised the curtain on what is now popularly known as the Heroic Age of Antarctic exploration.

De Gerlache sailed from Belgium in 1897, visited the South Shetland Islands, discovered and mapped Gerlache Strait (pp. 74–75, 160–161 and 180–181) and Danco Coast, named the Palmer Archipelago, discovered Paradise Harbour (e.g. pp. 76–77 and 176–177) and Lemaire Channel (pp. 14, 96–99 and 166–167) and sighted Alexander Island. Then the ship was beset in the pack ice south of Peter I Island and became the first expedition vessel to winter south of the Antarctic Circle, albeit accidentally. The first mate of the *Belgica* was Roald Amundsen who would later achieve fame in both polar regions; the expedition doctor was Frederick Cook, an American who would later achieve infamy in the Arctic, dubiously claiming to have reached the North Pole and falsely claiming to have made the first ascent of Mount McKinley in Alaska. Two men died during the expedition but the ship was eventually released from the ice after a year and returned to Belgium with many scientific data.

Borchgrevink returned in the *Southern Cross* and ten men spent the austral winter of 1899 in two huts at Cape Adare while the ship returned to New Zealand. A party was landed on the Ross Ice Shelf and sledged to a new farthest south at 78°50′ S on 23 February 1900 before returning to Australia. The scientific programme included zoology, geology, meteorology and geomagnetism. A year later Robert Falcon Scott led the British National Antarctic Expedition (1901–04) in *Discovery*. The expedition wintered at Hut Point on Ross Island and carried out a full scientific programme. The first Antarctic flight, in a tethered hydrogen balloon, was made and the first aerial photographs were taken on 4 February 1902. Scott and two companions, Ernest Shackleton

and Edward Wilson, man-hauled over the Ross Ice Shelf and reached a new record south at 82°17′ S on 30 December 1902. One party led by Albert Armitage reached the polar plateau and discovered the Dry Valleys in Victoria Land. At the same time the German South Polar Expedition led by Erich von Drygalski in the ship *Gauss* explored in the area at 90°E. The ship wintered in the pack ice, this time intentionally, and a substantial scientific programme was carried out.

Meanwhile, the Swedish South Polar Expedition under Otto Nordenskjöld with the ship *Antarctic* was exploring the northern Antarctic Peninsula. Six men spent the 1902 and 1903 winters in a hut on Snow Hill Island from where they carried out a comprehensive scientific programme and dog-sledged to 66°03′ S along the east coast of the peninsula. Antarctic Sound (pp. 12, 46–47 and 70–71) and Prince Gustav Channel were discovered and parts of the west coast of the peninsula were mapped from the ship. The ship was unable to return to Snow Hill Island at the end of the 1902 winter and three men were landed at Hope Bay where they spent the winter in a small stone hut. The *Antarctic* was then beset in Erebus and Terror Gulf (pp 10, 82–83), was crushed and sank. The crew escaped to Paulet Island (e.g. pp. 38–39, 119 and 150) where they spent the winter in a stone hut. At the end of the 1903 winter the three men at Hope Bay walked towards Snow Hill Island and were met by an astonished Nordenskjöld at Cape Well-met on Vega Island. Nordenskjöld wrote: *Black as soot from top to toe; ... my powers of guessing fail me when I endeavour to imagine to what race of men these creatures belong.* None of them knew what had happened to the *Antarctic* but there was concern in Sweden at the expedition's disappearance and three relief ships were dispatched. On 7 November 1903 Captain Larsen and the men on Paulet Island began to row across Erebus and Terror Gulf towards Snow Hill Island, the same day that Lieutenant Irizar, commander of the Argentine relief vessel *Uruguay*, found a message on Seymour Island. The ship made haste to Snow Hill Island where Nordenskjöld was delighted to be rescued but greatly saddened by the total lack of news of Larsen and the *Antarctic*. Just before going to bed that night he stepped outside to see why the dogs were barking and saw Larsen and his men arriving!

William Speirs Bruce led the Scottish National Antarctic Expedition (1902–04) in the *Scotia*. The men built a base on Laurie Island, South Orkney Islands, where they spent the 1903 winter, carrying out a comprehensive scientific programme. The island was charted and the Caird Coast on the eastern side of the Weddell Sea was discovered. After the expedition the base was offered to Argentina and has been manned ever since, making it the longest permanently occupied site

in Antarctica. Jean-Baptiste Charcot in his ship *Français* led the French Antarctic Expedition (1903–05). In addition to scientific observations the west coast of the Palmer Archipelago and the Loubet Coast southward to Adelaide Island were charted. The expedition wintered on Booth Island. Charcot returned (1908–10) in *Pourquoi Pas?* to continue charting the west coast of the Antarctic Peninsula, discovering Marguerite Bay, Fallières Coast and Charcot Island. The expedition spent the 1909 winter on Petermann Island.

Meanwhile, on the other side of the continent, Shackleton had returned to Ross Island, leading the British Antarctic Expedition (1907–09) in the *Nimrod*. Three men reached the summit of Mount Erebus (3,794 m) on 10 March 1908 while another 3-man party reached the vicinity of the South Magnetic Pole (72°25′ S, 155°16′ E). Scientific observations were made but Shackleton's main thrust was an attempt to reach the South Pole. Shackleton, with Jameson Adams, Eric Marshall and Frank Wild, using ponies trekked south across the Ross Ice Shelf and found the Beardmore Glacier rising ahead of them, through the Transantarctic Mountains and onto the polar plateau, the gateway to the south. By now the party was man-hauling the sledge and reached a new farthest south, just 110 miles short of the pole. Shackleton wrote in his diary: *Our last day outwards. We have shot our bolt, and the tale is latitude 88°23′ South, longitude 162° East.* Here they unfurled the flag given to Shackleton by Queen Alexandra, took photographs and turned north. Shackleton regarded their lives as more important than reaching the South Pole and, as he later told his wife, Emily: *I thought you'd rather have a live donkey [for a husband] than a dead lion.*

In 1910, with the South Pole still unattained, three more expeditions sailed for the Ross Sea with the intention of reaching the southernmost point of the Earth. Captain Scott returned in the *Terra Nova* and made his base at Cape Evans on Ross Island. Roald Amundsen from Norway in the *Fram* made his base at the Bay of Whales on the Ross Ice Shelf. Lieutenant Nobu Shirase from Japan in the *Kainan-Maru* also landed at the Bay of Whales and sent a 'Dash Patrol' of five men 155 miles south-east, although they had no realistic expectation of reaching the pole. Scott's expedition was essentially a scientific expedition that would continue and extend the work begun on the *Discovery* expedition, 10 years earlier. Amundsen had really wanted to be the first man to reach the North Pole and that was the original intention of his expedition. However, when he heard that Frederick Cook, his friend from the *Belgica* expedition, claimed to have reached the North Pole he felt there was no glory in being second so he secretly changed his plans and sailed for Antarctica.

In the autumn both expeditions began laying depots towards the south, ready for the polar journey in the spring. During the winter, Edward Wilson led Birdie Bowers and Apsley Cherry-Garrard in an expedition to Cape Crozier to collect eggs of the Emperor penguin. It was a terrible journey that they were lucky to survive. Cherry-Garrard wrote an account of it in his book *The Worst Journey in the World*. Meanwhile the Northern Party spent the winter in Borchgrevink's old hut at Cape Adare. In the spring Amundsen started south across the Ross Ice Shelf with no real idea of what lay ahead. Scott was able to follow Shackleton's route and so knew what to expect except for the last 100 miles to the pole itself. Amundsen discovered the Axel Heiberg Glacier that provided his ascent through the Transantarctic Mountains to the polar plateau and the South Pole, where he arrived on 11 January 1911. When Scott reached the foot of the Beardmore Glacier the last five ponies were shot and they continued man-hauling their sledges. At the top of the glacier on the edge of the polar plateau Scott's last supporting party returned and the five men, Scott, Wilson, Bowers, Oates and Evans, continued, reaching the South Pole on 17 January 1912. There they found the tent left by Amundsen and they knew they had lost the so-called race. Scott wrote in his diary: *Great God! This is an awful place and terrible enough for us to have laboured to it without the reward of priority. Now for the run home and a desperate struggle. I wonder if we can do it.*

The Norwegians with their dog teams romped back to the Bay of Whales while Scott and his party began the long march back to Ross Island. Near the foot of the Beardmore Glacier Petty Officer Evans collapsed and died. The others toiled on with Oates' frostbitten feet making it almost impossible for him to maintain the pace. On 16 or 17 March 1912 he walked out into the blizzard saying: *I am just going outside and may be some time.* He was never seen again. The remaining three kept going for another 4 days when they were tent-bound by a blizzard. They planned to make a dash for the depot just 11 miles away but the weather and their condition, physically weak, suffering from frostbite, and possibly scurvy, confined them to the tent. On 29 March 1912 Scott wrote the final entry in his diary: *We shall stick it out to the end, but we are getting weaker, of course, and the end cannot be far.*

Scott's Northern Party, after the winter at Cape Adare, had been collected by *Terra Nova* and then re-deployed farther south at Evans Cove in Terra Nova Bay to undertake further fieldwork. When the party returned to the rendezvous point there was no sign of the ship which was held 30 miles

offshore by pack ice. The pick-up was abandoned and the party left to spend the winter of 1912 in a snow cave. They all suffered tremendous hardship and privation but finally reached Hut Point on 7 November 1912 where their joy of relief was tempered by the news of the loss of the polar party. Scott's last camp was found on 12 November 1912. Diaries, letters and personal effects were removed from the tent, which was then collapsed over the bodies, and a large cairn of snow blocks built over them.

It is often thought that Amundsen and his men had an easy time of getting to the South Pole and back, being dragged along on their skis or even riding on the sledges while the dogs did all the work. This is an over-simplification; it was not all plain sailing for Amundsen who had numerous problems to overcome, not least finding a route to the polar plateau. His decision to use dogs was the crucial factor. No one since that time has taken ponies to Antarctica and man-hauling sledges is avoided as far as possible.

While the so-called 'Race for the South Pole' was taking place in the Ross Sea region, the second German South Polar Expedition (1911–12) was penetrating deep into the Weddell Sea and the Australasian Antarctic Expedition (1911–14) was exploring King George V and Queen Mary lands. Wilhelm Filchner in his ship *Deutschland* visited South Georgia and the South Sandwich Islands before sailing to the head of the Weddell Sea and discovering the Filchner Ice Shelf. The ambitious plan was to cross the continent from the Weddell Sea to the Ross Sea via the South Pole. A hut was built on the ice shelf at Vahsel Bay that almost immediately calved a large iceberg, which took the hut with it. The ship became beset and drifted for 9 months before being released by the ice and returning to Germany.

Douglas Mawson, who had been on Shackleton's *Nimrod* expedition in 1907, led the Australasian Antarctic Expedition in the *Aurora*. Huts were built at Cape Denison and on the Shackleton Ice Shelf where parties wintered under Mawson and Frank Wild respectively. Sledge journeys were made from the Shackleton Ice Shelf to Gaussberg, discovered during the German *Gauss* expedition in February 1902, and towards the South Magnetic Pole, which was determined on 21 December 1912 as 70°37′ S, 148°10′ E. Mawson led the main sledge journey east from Cape Denison. They crossed the treacherous Mertz and Ninnis glaciers and were 315 miles from their base when Belgrave Ninnis and his dog team disappeared down a seemingly bottomless crevasse. Most of their food and equipment, including the tent had gone. They began to make do, fashioning a makeshift tent, jettisoning non-essential items and, after a couple of days, killing the weakest dogs to provide food for themselves and the remaining dogs. After 11 days Mertz was beginning to weaken and the diet of dog meat was suspected as the cause. Eventually Mawson had to haul Mertz on the sledge and on 7 January 1913 he died, probably from Vitamin A poisoning caused by eating dog liver. Mawson was now alone, weak, exhausted and 100 miles from the base. Somehow he managed to continue, including hauling himself out of a crevasse, and on 1 February 1913 he reached the depot at the top of the snow slope, 5 ½ miles from the hut. The weather deteriorated and he was unable to move but when the weather cleared he could see the relief ship, *Aurora*, disappearing to sea. He was condemned to another winter in Antarctica with six men who had stayed to search for him.

Despite the disaster of his sledge journey, Mawson's expedition was very successful. A huge amount of scientific data had been collected and large areas had been mapped for the first time. The expedition was the first to use long-range radio communications via a relay station on Macquarie Island. Mawson also took the first aeroplane to Antarctica but it never flew there; its engine was unreliable but it was used as a tractor to relay loads to the edge of the polar plateau.

Shackleton was looking for a new challenge in Antarctica. The South Pole had been conquered so he planned to cross the continent and succeed where Filchner had failed. The Imperial Trans-Antarctic Expedition (1914–17) was formed with the crossing party, led by Shackleton from a base on the Filchner Ice Shelf, supported by the Ross Sea party that would lay depots from Ross Island towards the pole. On 4 August 1914 with the expedition almost ready to depart in *Endurance*, Britain declared war on Germany and Shackleton offered the entire expedition to the Admiralty as a fighting unit but Winston Churchill, then First Lord of the Admiralty sent a telegram: *Proceed*. The expedition sailed from Plymouth on 8 August 1914 via Buenos Aires and South Georgia and into the Weddell Sea. *Endurance* was beset in the pack ice without reaching the ice shelf and Shackleton declared the ship a winter station.

Ice floes near Devil Island, which is an ice-free island in the James Ross Island group. It is important for its large breeding colony of Adélie penguins.

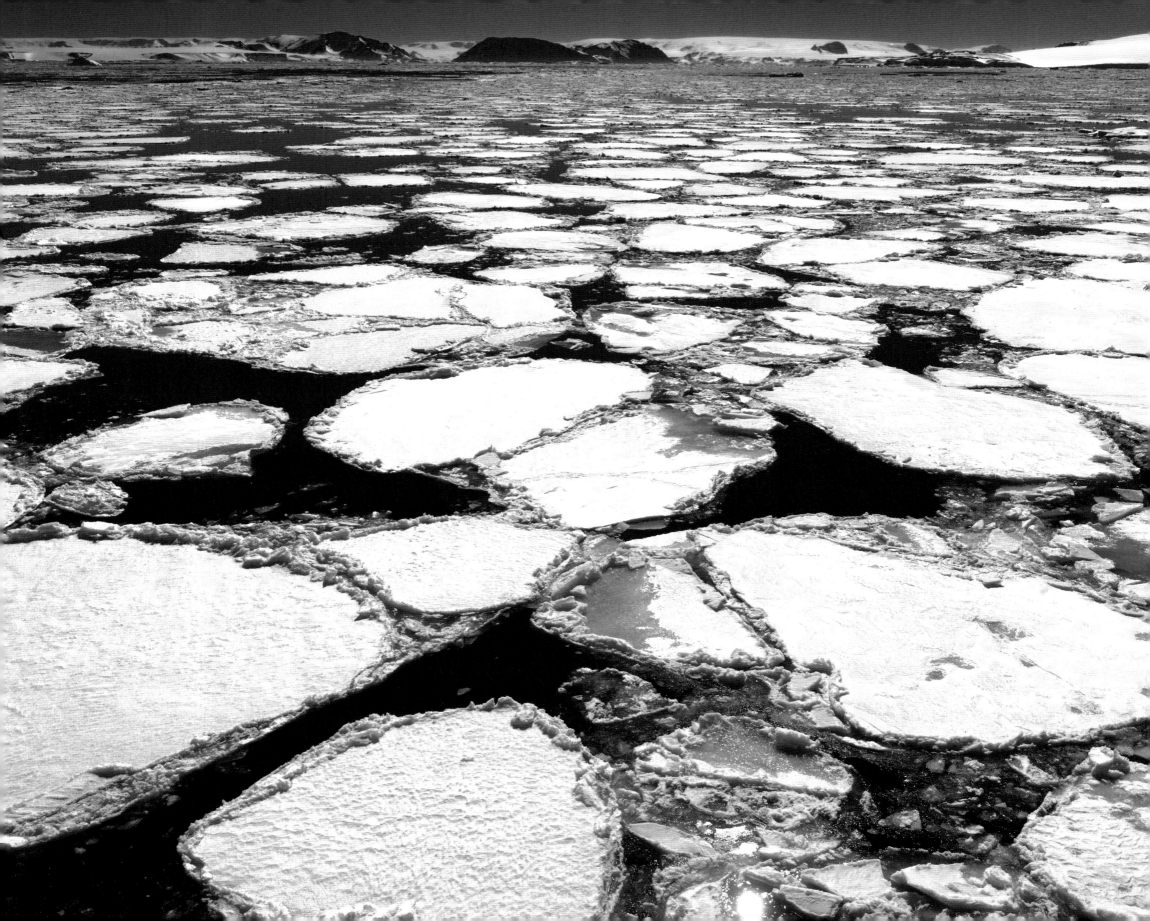

On the opposite side of the continent the Ross Sea Party, led by Æneas Mackintosh in the *Aurora*, arrived in McMurdo Sound and immediately began laying depots to the south. A party of 10 men wintered at Cape Evans but the *Aurora* was blown from her moorings and was not seen again for two years. Depot-laying was continued during the 1915–16 summer as far as the foot of the Beardmore Glacier, thus completing all Shackleton's requirements for the crossing party but at considerable cost. The weather was appalling; several men were suffering from scurvy and Arnold Spencer-Smith died. Eventually they reached Hut Point where they remained, waiting for the sea to freeze so that they could continue to Cape Evans. In May 1916 Mackintosh and Victor Hayward left Hut Point but were lost on the sea ice. The remaining three men at Hut Point waited until July before leaving and successfully reached Cape Evans only to learn that Mackintosh and Hayward had never arrived.

In the Weddell Sea the *Endurance* was drifting generally northward, held fast in the ice. Gradually the ice pressure increased and began to crush the ship. She was abandoned on 27 October 1915 and sank almost a month later. 'Ocean Camp' was established on the pack ice and later they moved to more solid ice at 'Patience Camp' where they waited for the ice to break. On 9 April 1916 they launched the three lifeboats and sailed to Elephant Island. Here the *James Caird*, the best of the lifeboats, was prepared to sail to South Georgia to seek rescue while 22 men lived underneath two upturned boats under the command of Frank Wild. On 24 April 1916 Shackleton, Frank Worsley, captain of the *Endurance*, Petty Officer Tom Crean and three others set sail to cross the storm-wracked waters of the Southern Ocean to South Georgia, 800 miles away. On 10 May 1916 they landed in King Haakon Bay on the south-west side of the island, the opposite side to the whaling stations. After a few days rest, Shackleton, Worsley and Crean crossed the snowfields and mountains that form the central spine of South Georgia and, 36 hours later, staggered into the Norwegian whaling station at Stromness. The whalers immediately sent a ship around to King Haakon Bay to collect the three men there. Then Shackleton boarded the whaler *Southern Sky* to return to Elephant Island. The pack ice prevented the ship from reaching the island, as it did for the next two rescue attempts. Eventually Shackleton returned to Cape Wild in the steamer *Yelcho*, loaned by the Chilean government, and the 22 men there were rescued.

For the men the expedition was over and they returned to Britain where most enlisted in the armed forces to fight in the war. Shackleton still had to rescue the Ross Sea party. He went to New Zealand and joined the *Aurora*. The ship reached Cape Evans on 10 January 1917, boarded the seven survivors of the expedition and returned to New Zealand. The expedition had been 'a glorious failure' but the tales of endurance, hardship and heroism stand proudly among the best that have emerged from the exploration of Antarctica.

After the war Shackleton heard again the call of the South. He purchased the *Quest*, a former Norwegian sealing vessel, but it was barely seaworthy. The expedition sailed in September 1921 with the intention of carrying out charting, and meteorological and geological research. On 3 January 1922 the *Quest* reached Grytviken in South Georgia after a troublesome voyage, not least the storms of the previous few days. In the evening after supper Shackleton announced that they would celebrate Christmas the next day. Shortly after 0200 Dr Macklin watched as Shackleton suffered a massive heart attack. He died a few minutes later. He was buried in the small whalers' cemetery at Grytviken.

The death of Shackleton, the most charismatic of all Antarctic explorers before or since, brought to a close what is now called the 'Heroic Age' of Antarctic exploration. In just 25 years men had spent the first winter on the Antarctic mainland, had reached the South Pole, charted much of the coastline, explored and mapped parts of the interior, and added vastly to knowledge of the south polar regions. However, the appetite for knowledge had merely been whetted, more and larger expeditions would follow, together with commercial exploitation of the living resources of the Southern Ocean.

In the 1920s and 1930s whaling, largely by Norwegian companies, was the principal activity in the Southern Ocean. There were whaling factories at several sites on South Georgia and on Deception Island but in December 1923 the Norwegian Carl Anton Larsen began a pelagic whaling industry in the Ross Sea with the first factory ship. The British Government initiated the Discovery Investigations to conduct research into all aspects of whale biology. The Investigations were funded by taxes on the whaling industry. Scott's old ship *Discovery* was used for the first voyage (1925–27) but was replaced by RRS *William Scoresby* and RRS *Discovery II* for subsequent voyages. A marine biological laboratory was established at Grytviken. Many of these whaling voyages also undertook geographical exploration, charting many sections of the Antarctic coastline for the first time. Some vessels also provided support for various other enterprises. In

1920–22 Thomas Bagshawe and Maxime Lester spent a winter at Waterboat Point conducting meteorological, tidal and zoological research.

Sir Hubert Wilkins led the Wilkins–Hearst Antarctic Expedition (1928–29) based at Deception Island, the first to use aircraft in the Antarctic. A flight was made along the east coast of the Antarctic Peninsula to 71°20′ S during which it was suggested that the peninsula was, in fact, an archipelago with segments separated by channels. The era of airborne exploration of the Antarctic had begun and this was rapidly expanded by the United States Antarctic Expedition (1928–30) led by (later Rear Admiral) Richard Byrd. A wintering station 'Little America' was built on the Ross Ice Shelf at the Bay of Whales from where much of Marie Byrd Land was photographed from the air with some geological exploration and ground mapping in the Queen Maud Mountains. This was the first expedition to make extensive use of aircraft, mechanized transport and radio communications in Antarctica. In 1929–30 Wilkins returned with a second expedition to extend the aerial reconnaissance of the previous year. During the same season Sir Douglas Mawson returned to Antarctica leading the first season of the British-Australian-New Zealand Antarctic Research Expedition, which charted the coast between 45° and 75°E from both the sea and the air. The following season the expedition discovered Princess Elizabeth Land, made several continental landings and five territorial claims in the name of King George V.

The international scientific community declared 1932–33 as the second International Polar Year. There were no stations in the Antarctic, although some had been planned, but meteorological data were contributed from South Georgia and the South Orkney Islands, as well as from many ships operating in the Southern Ocean.

Byrd returned in command of the American Antarctic Expedition (1933–35) that wintered in an extended station – 'Little America II' – at the Bay of Whales. Further geological and topographical surveys were made in western Marie Byrd Land and the southern Transantarctic Mountains. An advance weather station – 'Bolling Base' – was established on the Ross Ice Shelf, 105 miles south of 'Little America II'. Byrd spent the winter there alone from 28 May to 14 October 1934 until he was rescued suffering from carbon monoxide poisoning from which he almost died.

The British Graham Land Expedition (1934–37) led by John Rymill sailed for the Antarctic Peninsula in the steam yacht *Penola*. The ship carried a de Havilland Fox Moth aircraft equipped with both floats and skis that was used for ice reconnaissance and supplying field parties. The first winter was spent in the expedition's pre-fabricated hut in the Argentine Islands but opportunities for sledging were not good. After the winter the ship returned to Deception Island to load timber for a new hut that would be built for the second winter farther south on the Debenham Islands in Marguerite Bay. Extensive dog sledge journeys for mapping and geological studies were made, including a long journey along George VI Sound to 72°S between the mainland of the peninsula and Alexander Island. Ornithological, biological and meteorological studies were also made but perhaps the most important result was to show that the peninsula was a continuous feature, not divided by channels into an archipelago as Wilkins had earlier suggested.

In the 1935–36 summer Lincoln Ellsworth returned with his third private expedition. He had failed twice previously to fly an aircraft across Antarctica from the Antarctic Peninsula to the Ross Ice Shelf. This time the aircraft *Polar Star*, piloted by Herbert Hollick-Kenyon, took off from Dundee Island on 23 November 1935. Four landings were made to re-fuel during the flight across Marie Byrd Land. When the aircraft finally ran out of fuel, on 5 December 1935, they were actually 12 miles short of their destination at the Bay of Whales and the two men had to walk the last 12 miles to 'Little America'. RRS *Discovery II* had been diverted to search for them and she arrived four days ahead of the expedition's own ship, *Wyatt Earp*. Ellsworth made a further expedition in the 1938–39 summer to Princess Elizabeth Land and flew inland to 72°S, 79°E, named the area American Highland and claimed it for the United States.

In the same season the German Antarctic Expedition, aboard the ship *Schwabenland* under Alfred Ritscher, spent three weeks off the coast of Dronning Maud Land. Two aircraft launched from the ship by steam catapult flew more than 7,450 miles and photographed about 135,000 sq. miles of territory between 10°W and 20°E. The area was re-named 'Neu Schwabenland' and was claimed for Germany several times between 19 January and 15 February 1939. A second expedition, to provide ground survey for the photographs, was planned for the following season but was cancelled due to the outbreak of the Second World War.

Despite the war, the United States Antarctic Service Expedition (1939–41) was launched under Byrd. Wintering parties were placed at 'Little America III' ('West Base') and at

Stonington Island ('East Base') in Marguerite Bay. Field parties from 'West Base' built on the survey work of previous expeditions and those from 'East Base' extended the work of the British Graham Land Expedition. A semi-secret aim of the expedition was to make territorial claims for the United States. Farther north on the Antarctic Peninsula, the British established 'Operation Tabarin' in 1944, partly to monitor German shipping activities in the far south but also to counter rival territorial claims by Argentina and Chile in the peninsula region. After the war 'Operation Tabarin' became civilian as the Falkland Islands Dependencies Survey (FIDS) and gradually established more British bases southward along the peninsula. Thus began the permanent occupation of the Antarctic continent, continued by Argentina and Chile.

In the 1946–47 summer Byrd returned with the largest single expedition yet sent to Antarctica. It was primarily a naval training exercise employing 13 ships and providing polar experience for 4,700 men. The main purpose was to take further aerial photographs and reinforce territorial claims. This was followed in the next season by a smaller expedition, 'Operation Windmill', to provide ground control for the aerial photographs. At the same time, Finn Ronne led a private wintering expedition, Ronne Antarctic Research Expedition (1947–48), to re-occupy the former East Base on Stonington Island and to undertake further survey work. Much of this was done in conjunction with the British at the FIDS 'Base E' on Stonington Island.

Several countries, in addition to Argentina, Chile and Britain, were beginning to take an interest in Antarctica and started sending expeditions south, some of which established bases on the Antarctic Peninsula and elsewhere. The first truly international expedition was the Norwegian-British-Swedish Antarctic Expedition (1949–52) that wintered at 'Maudheim' (71°03′ S, 10°56′ W) in Dronning Maud Land led by the Norwegian John Giæver. An extensive field programme of glaciology and geophysics was conducted using dog teams and tractors for transport. Aerial photographs were taken and survey parties provided the necessary ground control.

Profile of an albatross on New Island, western Falkland Islands. The albatross has the largest wingspan (up to 3.4 m) of any bird. It can glide for hours without resting or even flapping its wings and is rarely seen on land except when breeding in colonies on remote islands. Young albatrosses fly at three to ten months but once they fly do not return to land until they are ready to breed some five to ten years later.

During the early 1950s the international scientific community began to consider organizing another International Polar Year. In particular the physical scientists were keen to make scientific use of the new technology that was available, much of it having been developed originally for military purposes in the Second World War. Ideas and plans began to crystallize and the polar year became the International Geophysical Year (IGY) with a special focus on Antarctica. The IGY would begin on 1 July 1957 and continue for 18 months to 31 December 1958 to ensure that a full calendar year was covered. A key point was that all the observations made in the physical sciences would be made at the same standard times to ensure comparability around the globe. Twelve nations would take part in Antarctica: Argentina, Australia, Belgium, Chile, France, Japan, New Zealand, Norway, South Africa, Union of Soviet Socialist Republics (now Russia), United Kingdom, and the United States of America. New research stations were built and many existing ones contributed data. This would provide the most extensive scientific investigation of Antarctica that had ever been undertaken. Meteorology, geomagnetism, seismology, auroral studies, glaciology, tidal measurements, ozone measurements and other aspects of Earth's geophysical parameters would be recorded. Biology, geology and cartography were not official IGY disciplines but many studies in these fields were also undertaken.

The International Council of Scientific Unions (ICSU) – now the International Council for Science but with the same acronym – was the parent organization for the IGY and in February 1958 hosted a meeting of the national academies of science of the countries participating in Antarctica. It was agreed that the momentum of the IGY should not be lost and the Special (later Scientific) Committee on Antarctic Research (SCAR) was formed to coordinate the continuing research. Since the end of the IGY all those nations involved have continued to research all aspects of Antarctic science.

During the IGY the Commonwealth Trans-Antarctic Expedition, under the leadership of Vivian Fuchs, was organized to make the first surface crossing of Antarctica. In 1955 the Advance Party sailed from Britain in the former sealing vessel *Theron*. 'Shackleton Base' was built on the Filchner Ice Shelf but many stores were lost on the sea ice and the hut could not be completed before winter. Eight men spent the first winter in a tractor crate. During the following summer dog teams explored three previously unknown mountain ranges. The main party arrived in *Magga Dan* and an advance base 'Southice' was established by air some 275 miles

south of 'Shackleton Base' along the route that the tractors would eventually take. Meanwhile on Ross Island the New Zealand support party led by Sir Edmund Hillary had established 'Scott Base' and begun to reconnoitre a tractor route to the polar plateau. Depots were laid in readiness for the crossing party. After the 1957 winter the crossing party of 12 men with Sno-cat and Weasel tractors departed towards the South Pole while Hillary, with modified farm tractors, completed the depot-laying and eventually continued to the South Pole, arriving before Fuchs. On 2 March 1958 the crossing party reached Scott Base, 2,190 miles and 99 days after leaving 'Shackleton Base'. The expedition's single-engine Otter aircraft was flown non-stop from 'Southice' to 'Scott Base' via the South Pole. Shackleton's dream of some 40 years earlier had finally been achieved.

One of the mountain ranges discovered by the expedition was named the Shackleton Range and I was privileged to be a geologist in the next party into the range in the 1968–69 season. We enjoyed the exhilaration, and sometimes frustration, of sledging with dog teams. On one occasion when we stopped to untangle their traces. I worked with bare hands, my sledging mitts dangling from their harness around my neck. When I slipped my hands back into my mitts one was wet inside; a form of canine thank you, I suppose!

During the 1940s and early 1950s the Antarctic territorial claims had been problematic, especially in the Antarctic Peninsula where the Argentine, British and Chilean claims overlapped. This was largely a diplomatic problem although there had been occasional exchanges of gunfire by enthusiastic naval officers exceeding their authority. It was obvious that a diplomatic solution was needed to facilitate the work of the scientists who cooperated together so successfully.

There was much preparatory discussion but on 1 December 1959, at the end of a 6-week meeting in Washington DC, the Antarctic Treaty was adopted by the 12 nations that had taken part in the IGY and entered into force on 23 June 1961. It refers to all lands and ice shelves south of 60° South latitude. It has been remarkably successful in preserving the peace in Antarctica and encouraging scientific research. Its key articles hold all the territorial claims in abeyance and nothing that is done during the operation of the Treaty can enhance or detract from those claims. Antarctica is, in essence, international territory. The Treaty prohibits all military activity,

except in support of science, prohibits nuclear explosions and the disposal of nuclear waste, and promotes scientific research and the exchange of data. The Parties now meet annually at the Antarctic Treaty Consultative Meeting.

The Treaty has continued to evolve and is now referred to as the Antarctic Treaty System. In 1964 the Agreed Measures for the Protection of Fauna and Flora included provisions for the protection of particularly sensitive areas as Specially Protected Areas and Sites of Special Scientific Interest. A list of Historic Sites and Monuments was also begun to ensure protection for the historic huts of Scott, Shackleton and others. The Convention on the Conservation of Antarctic Seals was adopted in 1972 to ensure that if commercial sealing were to begin again there would be adequate legislation in place to safeguard the stocks of seals. Commercial fishing in the Southern Ocean for finfish, squid and krill was in danger of exterminating some species so the Treaty adopted the Convention on the Conservation of Antarctic Marine Living Resources which established a Commission that meets annually to set realistic quotas for catches, based on the advice of marine biologists.

Over the years more countries have become active in Antarctic research and have joined SCAR which now (2015) has 31 Full Members and 8 Associate Members. Similarly, more governments have signed the Antarctic Treaty which currently has 29 Consultative Parties and 22 Non-Consultative Parties. Consultative status is granted when a Party has demonstrated that it has an active and varied scientific programme in Antarctica.

During the 1980s the Treaty Parties spent several years negotiating the Convention on the Regulation of Antarctic Mineral Resource Activities. The Convention was adopted but never signed because several parties, driven by environmental considerations, felt that Antarctica should not be exploited for its mineral and hydrocarbon resources, if they are ever found in commercial quantities. This caused considerable consternation and some even predicted the collapse of the Treaty. As a result the Treaty Parties rapidly negotiated a Protocol on Environmental Protection to the Antarctic Treaty together with five annexes on: Environmental Impact Assessment; Conservation of Antarctic Fauna and Flora; Waste Disposal and Waste Management; Prevention of Marine Pollution; and Area Protection and Management. Crucially, the Protocol states in Article 7: 'Any activity relating to mineral resources, other than scientific research, shall be prohibited.'

The Protocol and its Annexes entered into force in January 1998. The Protocol provides for a Committee for Environmental Protection which meets annually to consider all environmental matters and advises the Antarctic Treaty Consultative Meetings accordingly. In 2005 a sixth Annex on Liability arising from Environmental Emergencies was adopted.

In less than 250 years Antarctica has changed from being the last great *Terra Incognita* to being an international arena for science. Scientific research in Antarctica is vital to our understanding of the Earth as a whole. The only commercial industry is the fishing that is done under the rules of the Commission for the Conservation of Antarctic Marine Living Resources; or is it? In January–February 1966 Lars-Eric Linblad chartered an Argentine naval vessel *Commandante General Irigoyen* to take 58 passengers to the South Shetland Islands and the northern Antarctic Peninsula on the first United States tourist cruise. Since then, Antarctic tourism has, quite literally, taken off. Most tourism is seaborne from South America to the Antarctic Peninsula region but there are also voyages to the Ross Sea to see the historic huts of Scott and Shackleton. Some voyages have even circumnavigated Antarctica. One company operates an airlift to a base camp near the Ellsworth Mountains taking mainly mountaineers to climb Mount Vinson (at 4,892 m the highest peak in Antarctica) and the other high peaks. In 1991 several companies, which had been taking tourists

by ship to Antarctica, formed the International Association of Antarctica Tour Operators. This organization regulates Antarctic tourism based on guidelines promulgated by the Antarctic Treaty. In the 2013–14 season a total of 37,405 tourists visited Antarctica by sea and air although not all of them landed on the continent. Over the years some of these tourists have been 'adventurers' who have aimed to repeat some of the classic expeditions or to reach the South Pole or to cross the continent by yet more imaginative means such as man-hauling without support, skiing solo or skiing with kites. Life on bases is considerably more comfortable than in the past but outside the environment is just as cruel and demanding as it ever was. As Charles Swithinbank, a renowned Antarctic glaciologist remarked: *I have heard it said that today, with easier access to high latitudes, the challenge has gone out of polar fieldwork. Those who believe it should stay at home – to avoid being disappointed.* At the same time, the environment is still as beautiful and the visitor will be rewarded with spectacular views of the last great wilderness on Earth as the magnificent photographs of Alex Bernasconi so ably demonstrate.

Dr Peter Clarkson

March 2015

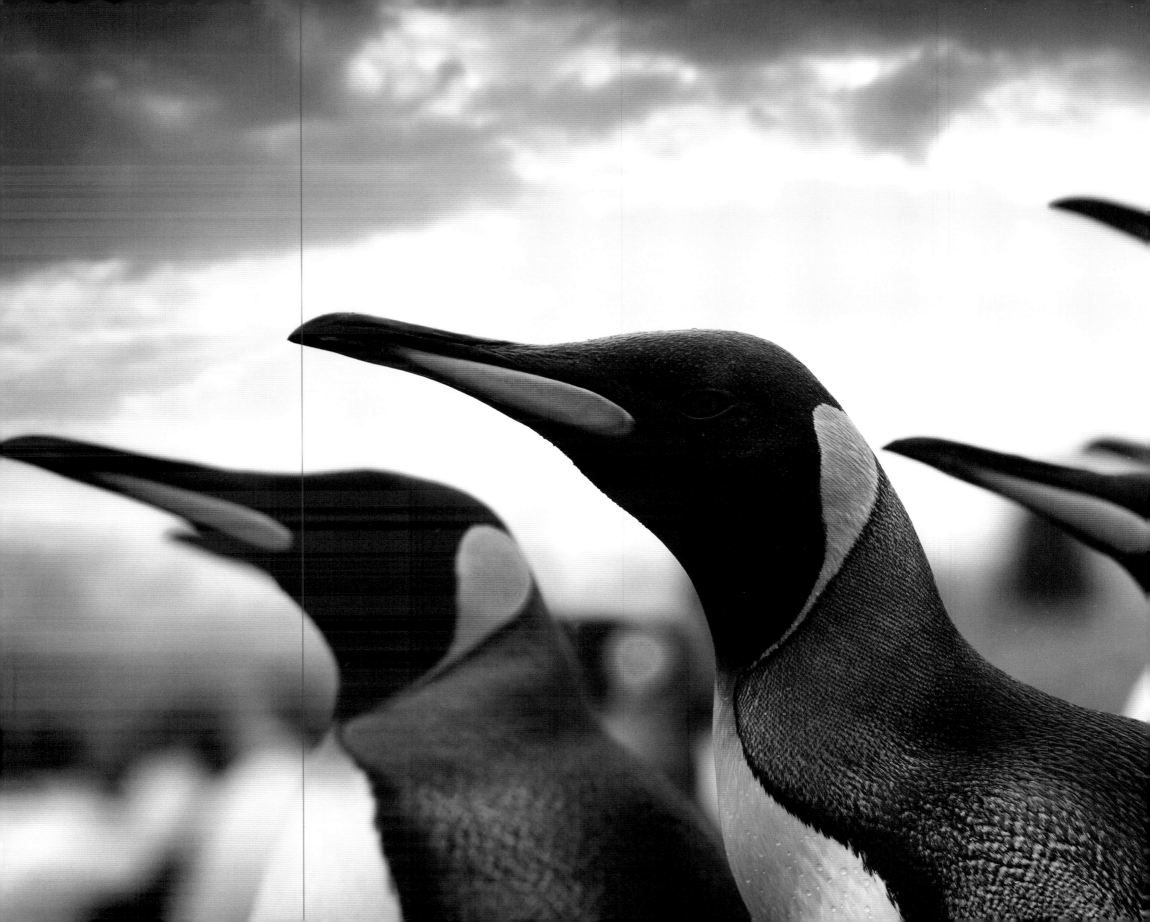

BLUE ICE

Alex Bernasconi

I am walking in the snow with careful steps, on my shoulders the weight of an always overfull backpack and my tripod. I'm climbing a small hill in order to reach a high point overlooking Paradise Harbour in Antarctica, so that I can capture the bay from above. My breath forms a cloud in the air as I exhale. There is a little mist, and the light is strange, the sunlight veiled; there is very little wind. I reach the summit, unload my equipment and stop to look around me: I remember the silence of the desert, and the peace! It feels as if the world has come to a halt.

I always feel something mysterious and powerful in the presence of certain natural vistas, a force, a trembling that charges me with renewed energy. I am in a state of euphoria. I can see so far; I am like a tiny dot above a small corner of a vast icy paradise: what wild, unsettling beauty.

I'm moving upwind on a small island (Hydrurga Rocks) on the east side of Two Hummock Island, in northern Gerlache Strait. The wind has been blowing since I disembarked from the boat, a chill wind. I make my way painstakingly searching for a view that encapsulates the essence of such a remote place in the middle of nowhere. Here the snow is deep, in some places frozen solid, sometimes I break the surface crust and sink deep into it. The gusts of wind throw the icy snow into my face and I have to wear a mask.

I finally "find" the view I want. I stop, set down the stand and try to anchor it with the weight of my backpack but the wind is very strong and it's difficult to keep it stable although I'm shielding

King penguins on Salisbury Plain, South Georgia. King penguins are the second largest of the penguin species. It is estimated that there are two to three million breeding pairs. The colonies are inhabited all year either by the parents or the chicks. They are extraordinary parents: while one parent guards the chick the other will make a round trip of as far as 250 miles in search of food.

it with my body. I want to use a very long exposure to recreate the ethereal, timeless scene in front of me, so that the waves crashing on the rocks become a silk blanket of ice and the moving clouds provide a background of serenity. I have to take many shots, as the wind and sleet could compromise the sharpness of the image; my fingers are frozen. Something is still missing. Now I can see what it is: a small group of penguins is walking on the slippery rocks, and finally they stop almost in the centre of the frame. I move a little to align the iceberg towering in front of us in the middle of the channel. They start to dive into the water, one after another until only one remains. He seems to hesitate; he looks around but remains just where I want him to be – at the exact centre of my composition. Another long shot, I hope that the lone penguin will remain motionless for the duration of the exposure, and he does, as if he, too, is absorbed by the spectacle before us. Click.

If there are still wild places in our world, places where man has not yet been able to impose his presence, where nature protects its wonders with force and sometimes violence, one of them is definitely the Antarctic. I have always been attracted by such wildernesses; I find their fascination irresistible; to experience them first hand helps me to recover the sense of our own existence, to sort out in my mind more clearly what is so important about them.

The days and weeks before the start of an expedition like this are always hectic: you need to check that you have all the necessary equipment and that it is in good working order while also making provision for anything that may break or not function properly. You cannot afford any mistake or oversight when you're at the end of the world.

In Africa enemy number one is the dust, in the polar regions it is the cold, rain and salt spray. Very often you are photographing in extreme conditions – fog, gusts of wind, snow and ice all test the equipment as well as the photographer.

There are several ways to reach the Antarctic Peninsula: when the weather permits, many people fly from Chile to avoid days of sailing in the stormiest seas in the world. But the experience of navigating the routes of the great explorers, and visiting the wonderful Falkland Islands and South Georgia with their spectacular views and extraordinary fauna before reaching the Antarctic Peninsula, makes this expedition one of the most incredible that man can undertake.

It's a long journey involving many days of sailing in the open sea, which presupposes long breaks from the real work on the ground but there are sightings of many species of birds (seabirds), whales, killer whales and of icebergs providing an opportunity to reflect on the difficulties that the more adventurous explorers of the past such as Sir James Clark Ross, Roald Amundsen and Sir Ernest Shackleton, not equipped with modern equipment and boats built to navigate such dangerous waters, had to face in order to discover the wonders of this part of the world.

There are natural vistas that literally take your breath away: navigating around huge icebergs on board the Zodiac, being in the middle of hundreds of thousands of penguins on Salisbury Plain or St. Andrews Bay, South Georgia, surrounded by the sound of their calls and their incessant activity, is something that transports you to another dimension.

Stormy skies, dramatic light and atmosphere: sometimes I seem to arrive in places just when a divine providence has prepared them to be immortalized.

In my other photographic expeditions, especially in Africa, I plan my trips and activities with some precision, fixing my goals according to the season, the best times and locations. In polar expeditions it is completely different: you must programme the journeys, days and landings depending on the weather forecast and plans must be changed accordingly.

Sometimes the weather can become so adverse that it requires a change of route and long hours of enforced inactivity as far as possible from storms, with no possibility of reaching landings or resuming navigation. Winds and currents often prevent landing with Zodiac boats, and then the weather can change so quickly that it is impossible to reboard the ship.

To remind us that these places are protected by an extreme climate, there are the famous katabatic winds, the most terrible and fearsome on our planet; they blow from the glaciers suddenly and quickly attain hurricane force. To give an idea of the violence and unpredictability of the climate in these areas, remember that in a short time the winds can reach up to 150 km per hour, with gusts of 200 km per hour. At the first sign of the arrival of these winds it is very important to react quickly, to recover all the equipment, place it in dry bags and return to the ship as quickly as possible.

Unfortunately, we did not always succeed in time: I still remember the courage of one of the crew members who, in an attempt to bring the last of us on board overturned his Zodiac in a strong gust of wind and ended up in the icy waters.

Fortunately, he was rescued before hypothermia set in and we were able to drink some hot tea together on deck in the evening.

Most of the ships used in the Antarctic, as well as being built to navigate these seas, have reinforced hulls to protect them from collisions with ice; they are also equipped with an operating room and first aid equipment, since at these latitudes they have to be completely autonomous. Because of the enormous distances and adverse weather conditions, sometimes it is not possible for relief to arrive for several days. Even a seal bite can be dangerous and require stitches and antibiotics, as was the case with another member of the expedition. There are many days when you are photographing surrounded by dozens of these animals that seem to be ignoring you, but they can attack without warning: in fact, the Antarctic fur seal is an aggressive animal, so it is advisable to be cautious and occasionally look away from the viewfinder and over your shoulder to avoid an unpleasant surprise!

It is therefore necessary to be very careful when exploring: walking through rocky terrain, on ice and snow, wading through streams with several kilograms of equipment on your back can cause injuries that, in these conditions, can represent a serious problem and may prevent you from completing a job for which you have been preparing for a very long time.

Elephant seal, Fortuna Bay, South Georgia. Elephant seals live in the brutally cold Antarctic and sub-Antarctic waters that have plentiful supplies of fish, squid and other marine foods. They get their name from the male's inflatable proboscis used to make loud roaring noises, especially when mating.

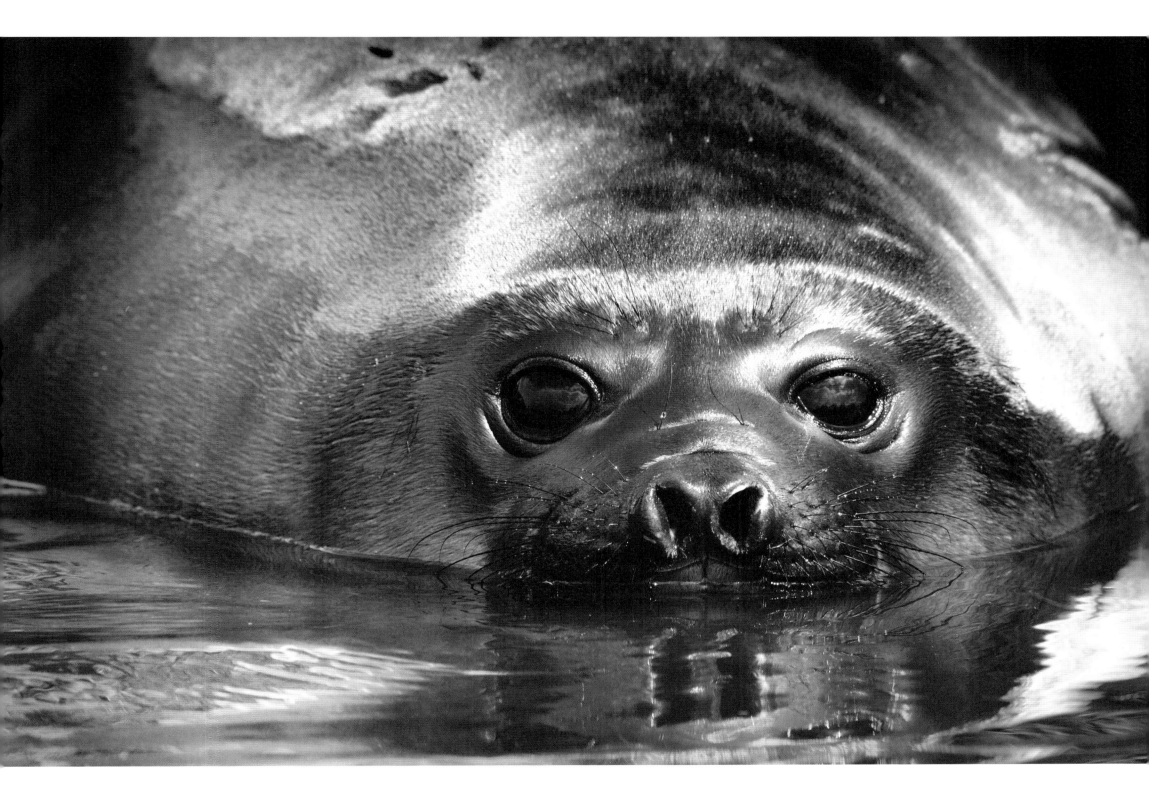

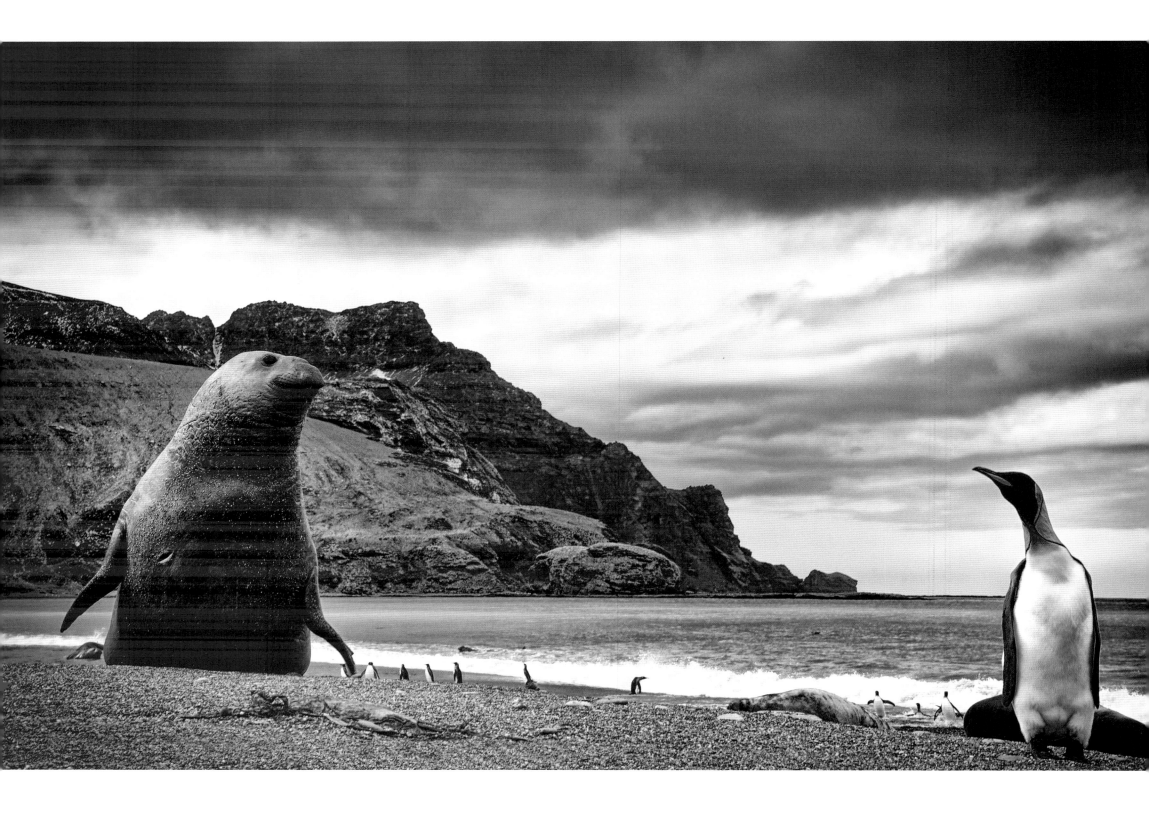

Then there are the usual minor setbacks that can cause serious difficulties. For example, in St. Andrews Bay, South Georgia, I found a wonderful, long beach inhabited by a colony of tens of thousands of King penguins and many other species of animals, with a backdrop of snow-capped mountains and dozens of wonderful watercourses flowing from the glaciers into the sea. The landing was particularly complicated because the beach was totally exposed to the ocean, and we waited anxiously for several days before going ashore.

Finally one morning the weather conditions looked good, so we started landing operations early in the day. Since conditions can change very quickly, I walked swiftly towards the first area where I wanted to photograph the colony with the best background and light, but unfortunately because of an unseen hole and the swift current, I lost my balance crossing a stream. I somehow managed not to fall into the water and I protected the equipment, but both my boots were full of water, despite being thigh-high. I took them off and emptied them, but my socks were completely soaked and I did not have a spare pair. It was not yet eight o'clock in the morning and I had eleven hours of photographing to do. I leave you to imagine the state of my feet that night …

I have been in many other wild, remote places but only in Antarctica do you have the impression of being at the end of the world. The colours, landscapes and atmosphere are unique, unlike any other place on the planet. I have to confess that I am much more at ease in a jeep in the middle of the savannah, or walking in the jungle, than sailing these turbulent seas.

During the long days at sea I spent a lot of time on deck fascinated by the huge expanse of foaming water and hypnotized by the power of the waves and the minute size of our ship in the midst of the turbulent ocean. The grey skies, the wind, the rain and the snow seemed to indicate that our presence was barely tolerated and that nature could at any time decide to get rid of such an intrusion; and I reflected on all those extraordinary creatures that have found their natural habitat here and can live and survive in such conditions.

Stand-off in St. Andrews Bay.
An Elephant seal vs. a King penguin.

We faced days of sailing from South Georgia to the South Orkney Islands with the wind at times in excess of 50 knots (force 9 on the Beaufort scale), with 10 m waves.

A separate section is devoted to the infamous Drake Passage, the stretch of sea that must necessarily be conquered to reach – or return from – the Antarctic Peninsula from Cape Horn or Tierra del Fuego. It is one of the toughest and stormiest stretches of sea on the planet, and although it can sometimes be crossed in periods of relative calm, we were not always so lucky; the storms we had encountered previously seemed quite minor by comparison.

To avoid falling over or getting injured on the ship, I tried to spend a few hours each night in my bunk, but I was forced to cling to it to avoid being thrown out by every wave. The objects in the cabin were all on the floor; it was not possible to read or use a computer, and the waves were so violent that they hit the ship with a deafening roar that caused it to shudder as if it was about to break up.

And each time it got worse, until I began to be really worried.

I had no experience of this type of situation, but at some point I decided to leave my cabin and go to the bridge to see for myself how bad the situation was, and possibly take some photographs, although there was little visibility. As I walked along the narrow corridors of the ship I was bounced from wall to wall like a tennis ball; another member of the expedition who had attempted to leave his cabin had all the fingers of one hand broken when a door slammed shut on them.

When I finally reached the bridge on the upper deck I found only the captain, a Russian with more than twenty years' experience of the Arctic seas, and his deputy, both focused on navigation but enveloped in the melodious, melancholy sound of a piece of classical music, as absorbed by the music as by what was happening outside. It was an unreal situation, like something seen on television or in a film. After a few minutes of silence, fascinated and awed by the spectacle around me, and after trying to take some photographs I began to question the silent captain.

We were in the middle of two giant storms, and we had been sailing for several hours in monstrous 10–15 m waves and 60 knot winds (11–12 on the Beaufort scale); according to the captain, it was one of his worst crossings ever.

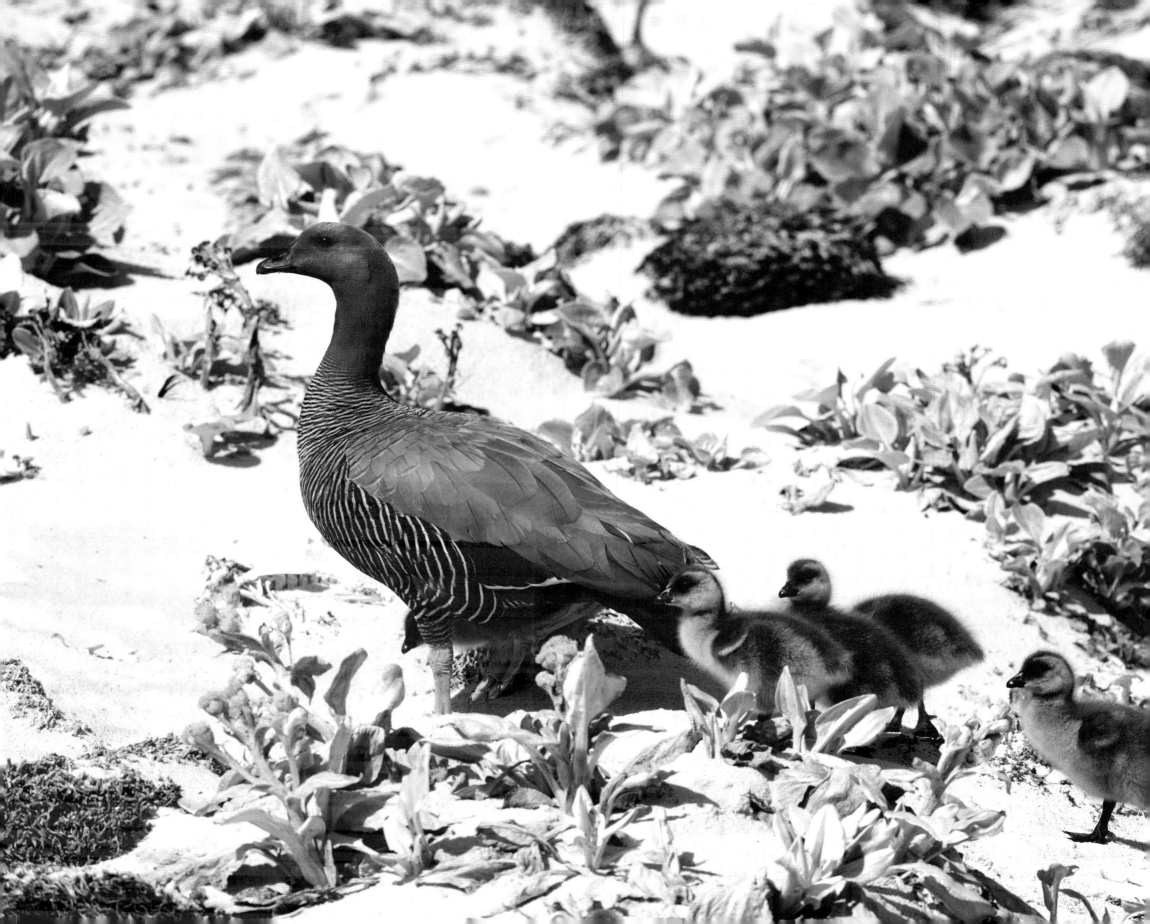

The hours passed very slowly, but when finally the wind dropped and the sea began to roar with less violence, I realized that the worst was over. A little later we reached Ushuaia, the southernmost city and port in the world, at the end of another real adventure.

To capture through images such wild places, such breathtaking landscapes, such extraordinary animals, but especially the strong emotions that we feel in such magical places is a difficult, if not impossible task. The images recall those moments of awe, wonder and sometimes anxiety that are so difficult to encapsulate and transmit, but it is important, or rather I believe that it is important, to try to convey the soul and the reality of those corners of our planet that have so much to say if we are willing to listen and to see. It is extraordinary to reflect that a still image of something that will never appear again is eternal. I keep thinking about icebergs, those wonderful sculptures of floating ice that vanish and are always reborn in different shapes and sizes, natural, evolving artworks.

But what is really important is to remember that what we do each day, in our daily lives, affects these worlds that are so far away from us, and that we must hope that the natural cycles that have ruled our planet until today will continue unchanged.

I always like to remember a great Masai proverb: *You must treat the Earth well. It was not given to you by your parents. It is loaned to you by your children.*

Upland geese with goslings on Saunders Island, Falkland Islands. These geese are unique to the Falkland Islands and continue to diverge from their continental cousin, the Magellan goose. The goslings feed independently from the start and once they leave the nest when they are about fifteen hours old they never return.

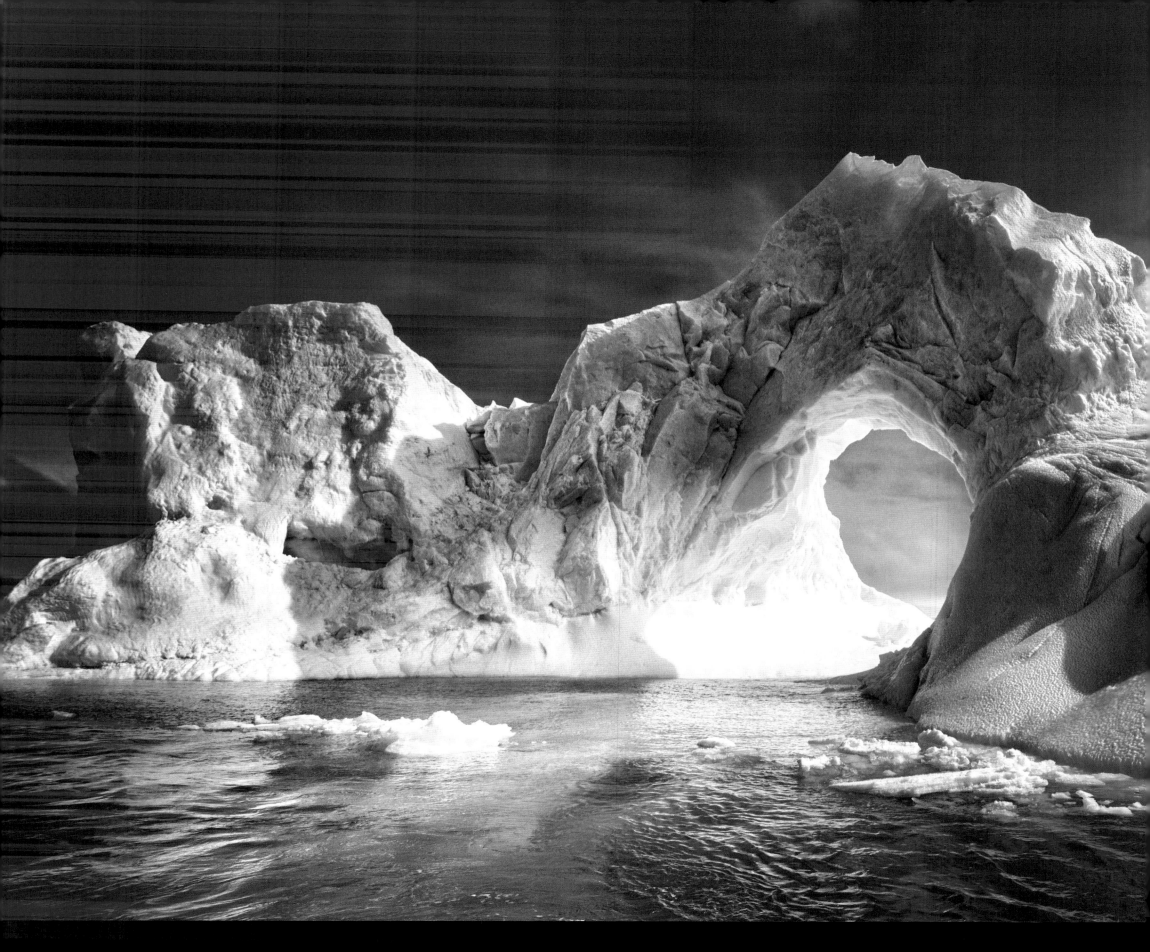

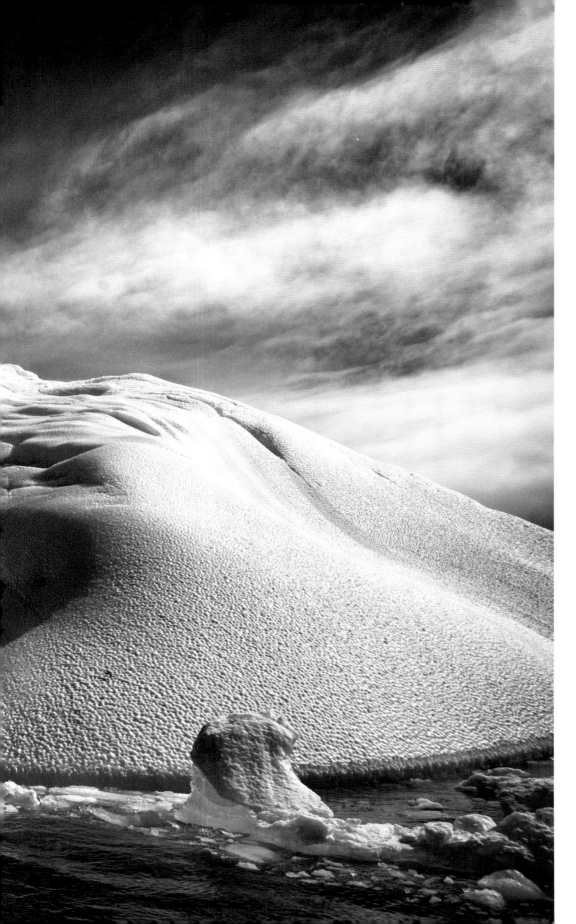

A wonderful arch in an iceberg near Paulet Island, a volcano composed of lava flows capped by a layer of cinders surrounding a small summit crater. Geothermal heat keeps part of the island ice-free.

King penguin, Fortuna Bay, South Georgia.

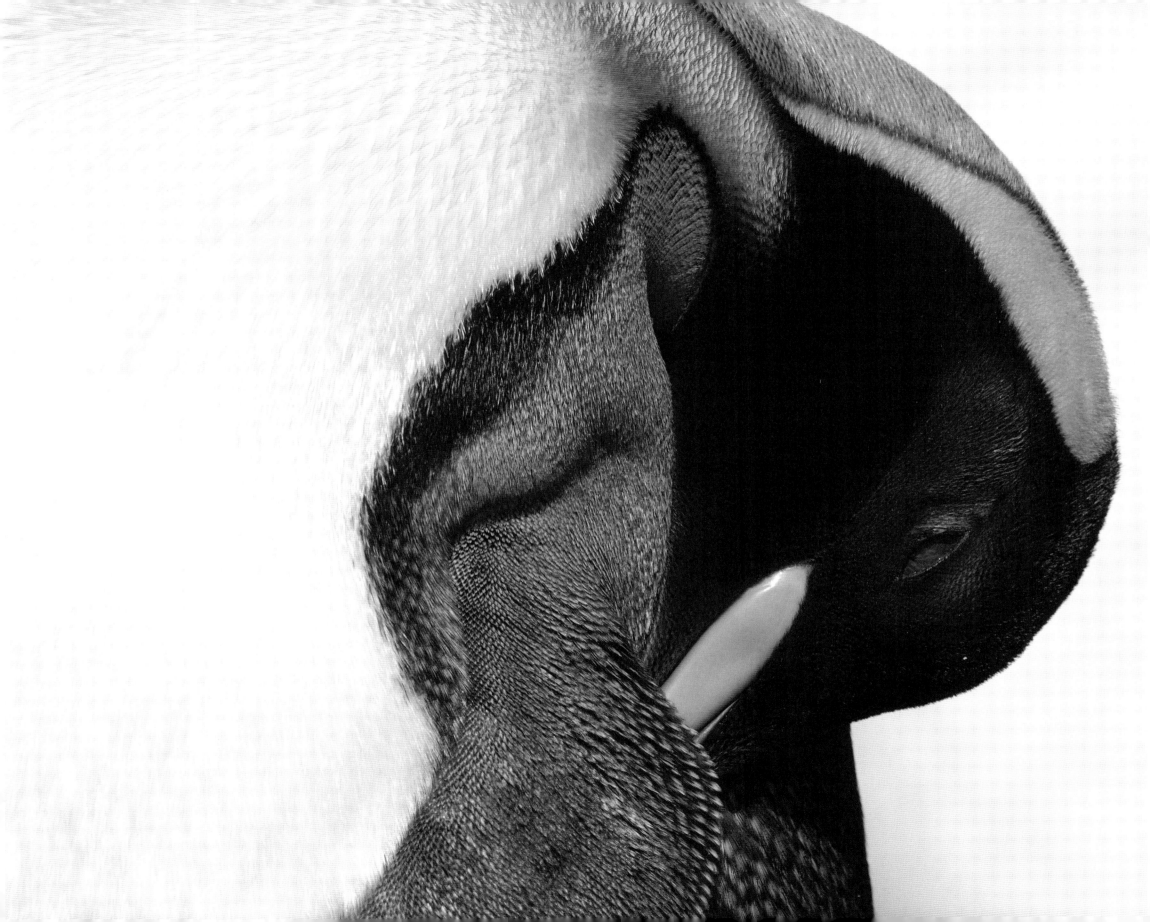

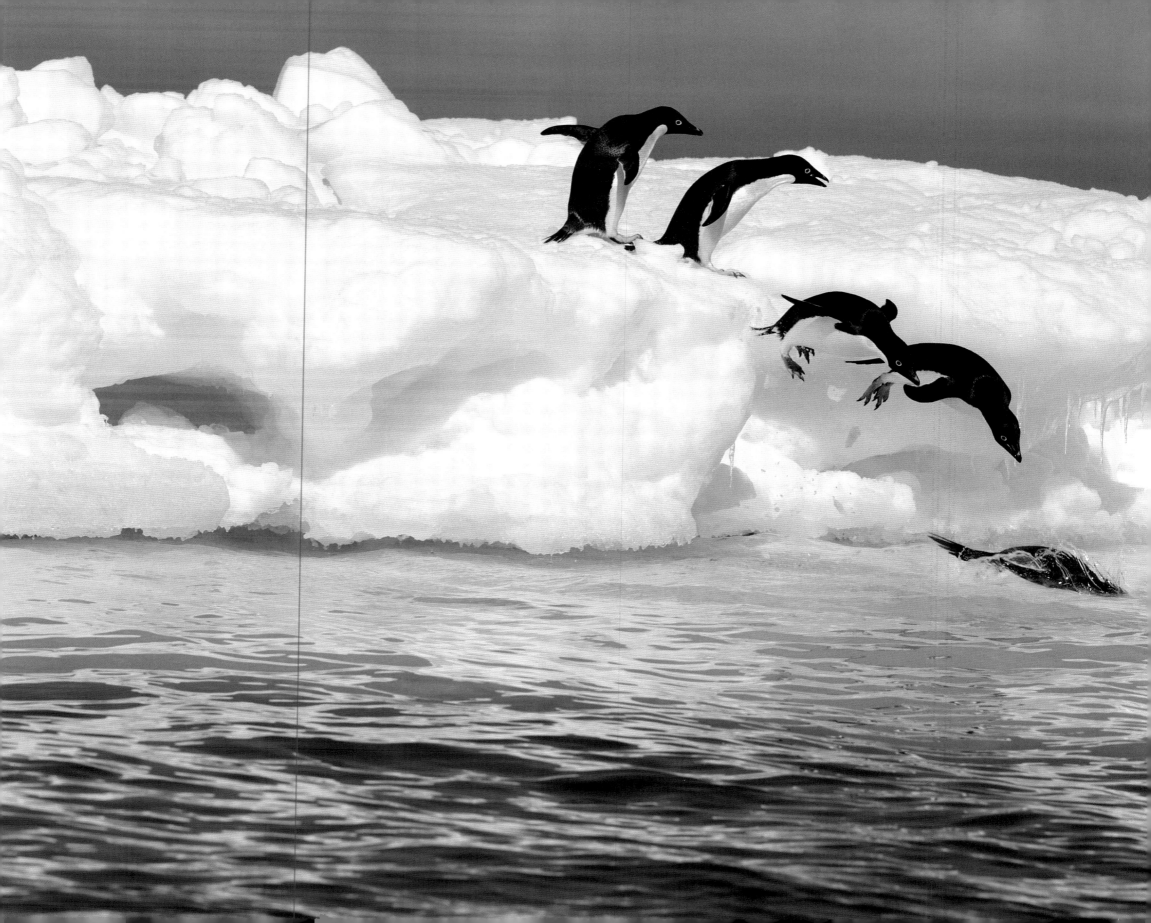

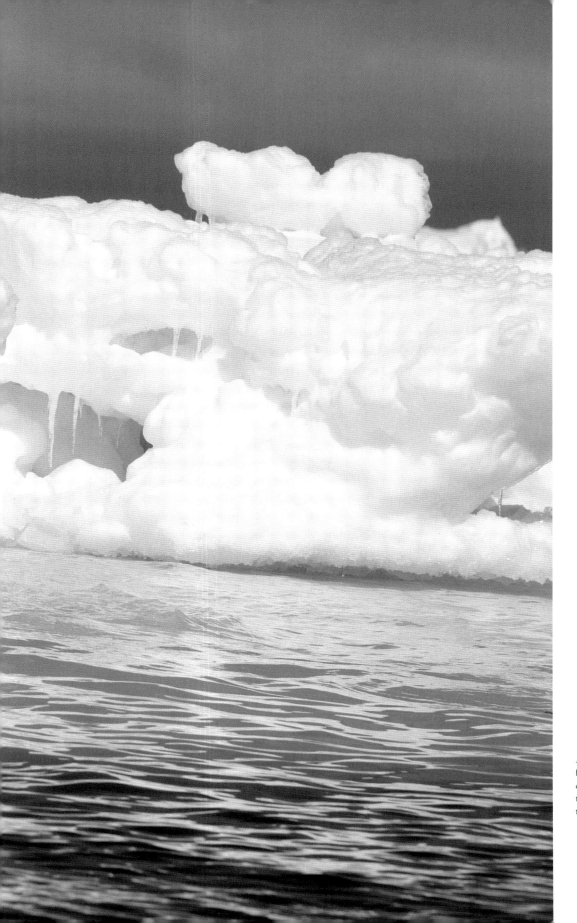

Adélie penguins, Brown Bluff. Penguins are in great danger, especially from leopard seals, when they dive into the sea to go fishing. They congregate on the edge until the first one dives or is pushed in, when the others follow rapidly. The odds of survival are much greater for those in the middle of the group.

Chinstrap penguin, Hydrurga Rocks, Antarctica. Chinstrap penguins are very aggressive, even with humans. They get their name from the thin black band round the bottom of their head, making them look as though they are wearing a helmet. The have tightly packed feathers which provide a waterproof coat; blubber provides insulation; and the blood vessels in their flippers and legs are structured to conserve heat.

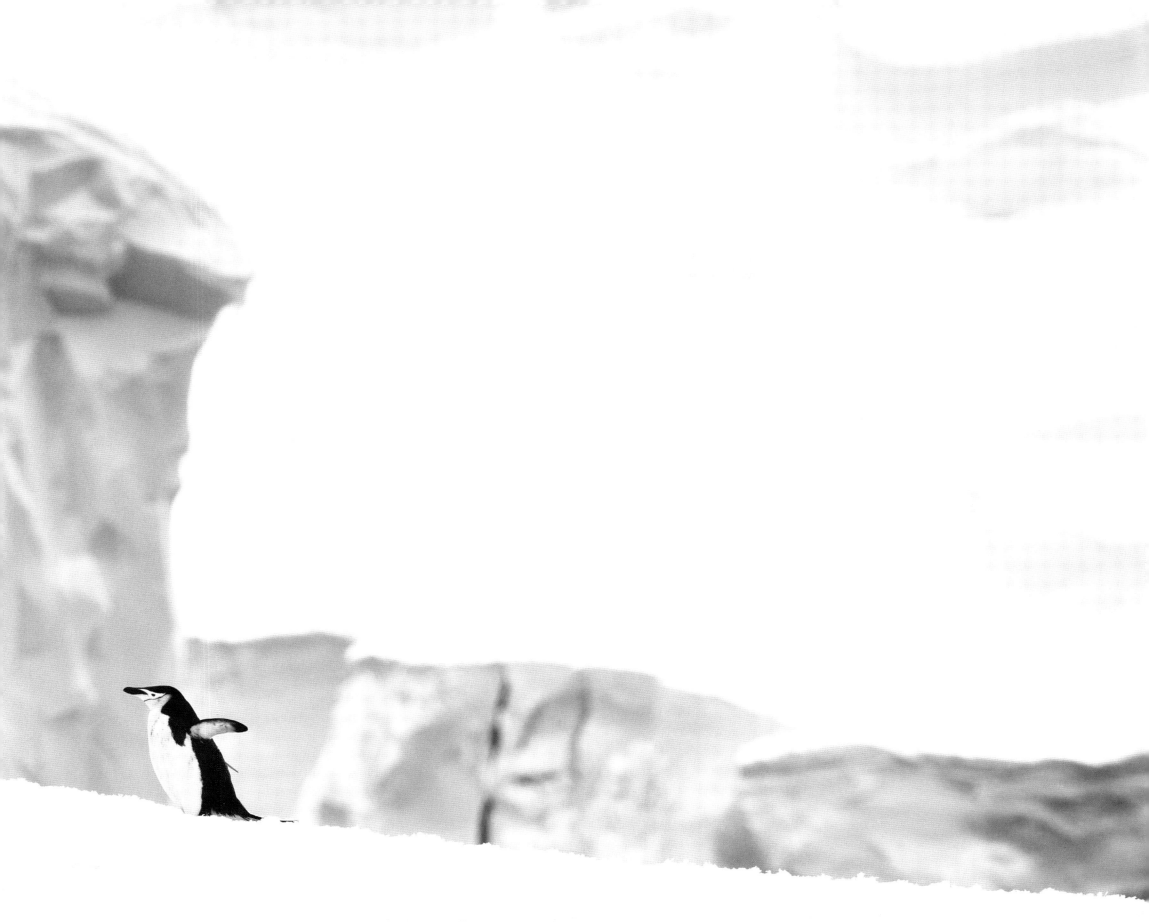

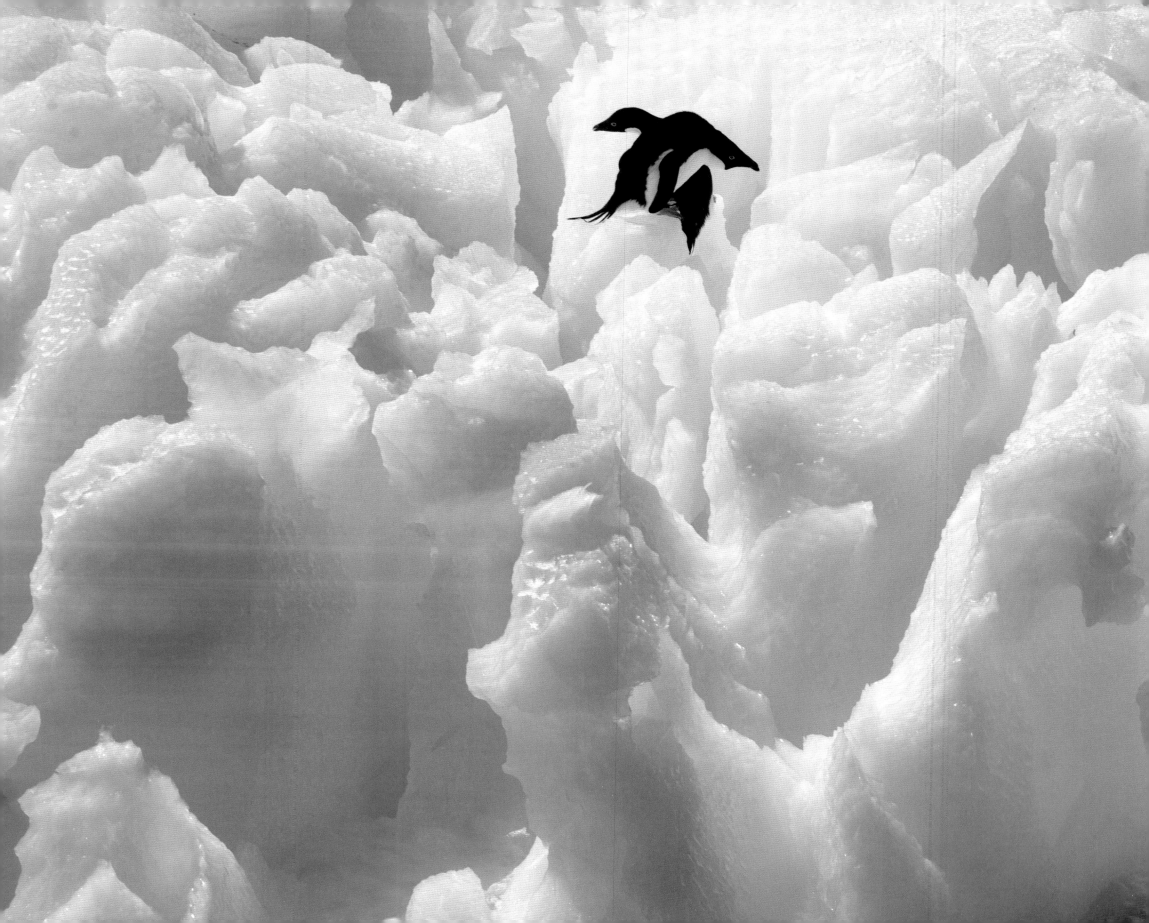

Adélie penguins on the ice in Antarctic Sound. Antarctic Sound was discovered in 1902 by the Swedish South Polar Expedition on the *Antarctic* under the command of Otto Nordenskjöld.

Overleaf:
Chinstrap penguins at sea off the South Orkney Islands. Chinstrap penguins live on the isolated islands and icebergs in sub-Antarctic areas and Antarctica. They often slide on the ice rather than walking, which helps them conserve energy. They can dive to about 70 m for food.

Chinstrap penguins on Hydrurga Rocks, Antarctica.

Overleaf:
King penguins, off Salisbury Plain, South Georgia.

51

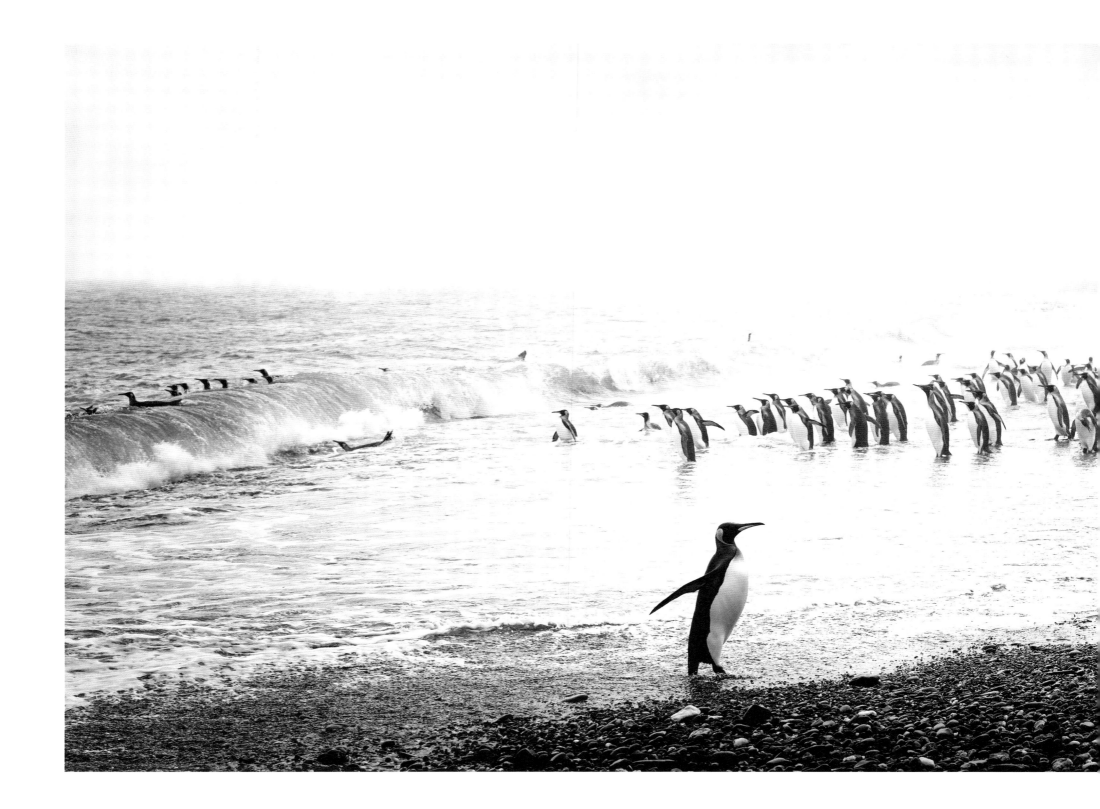

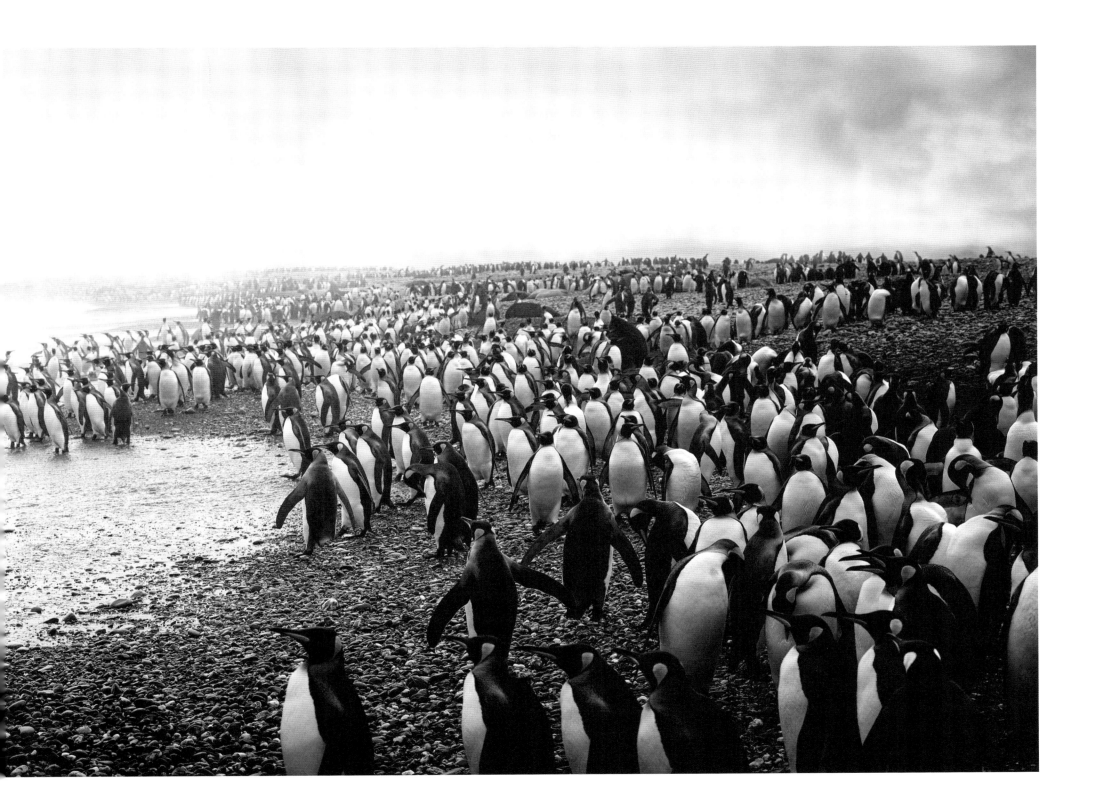

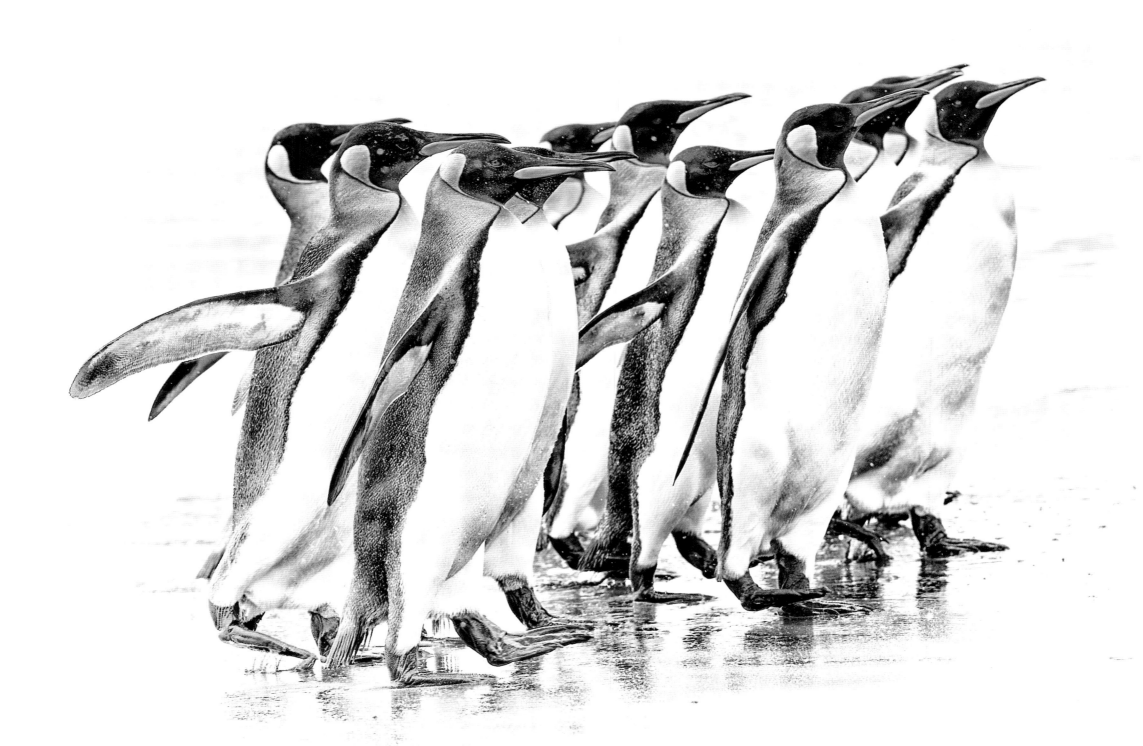

King penguins, Fortuna Bay, South Georgia.

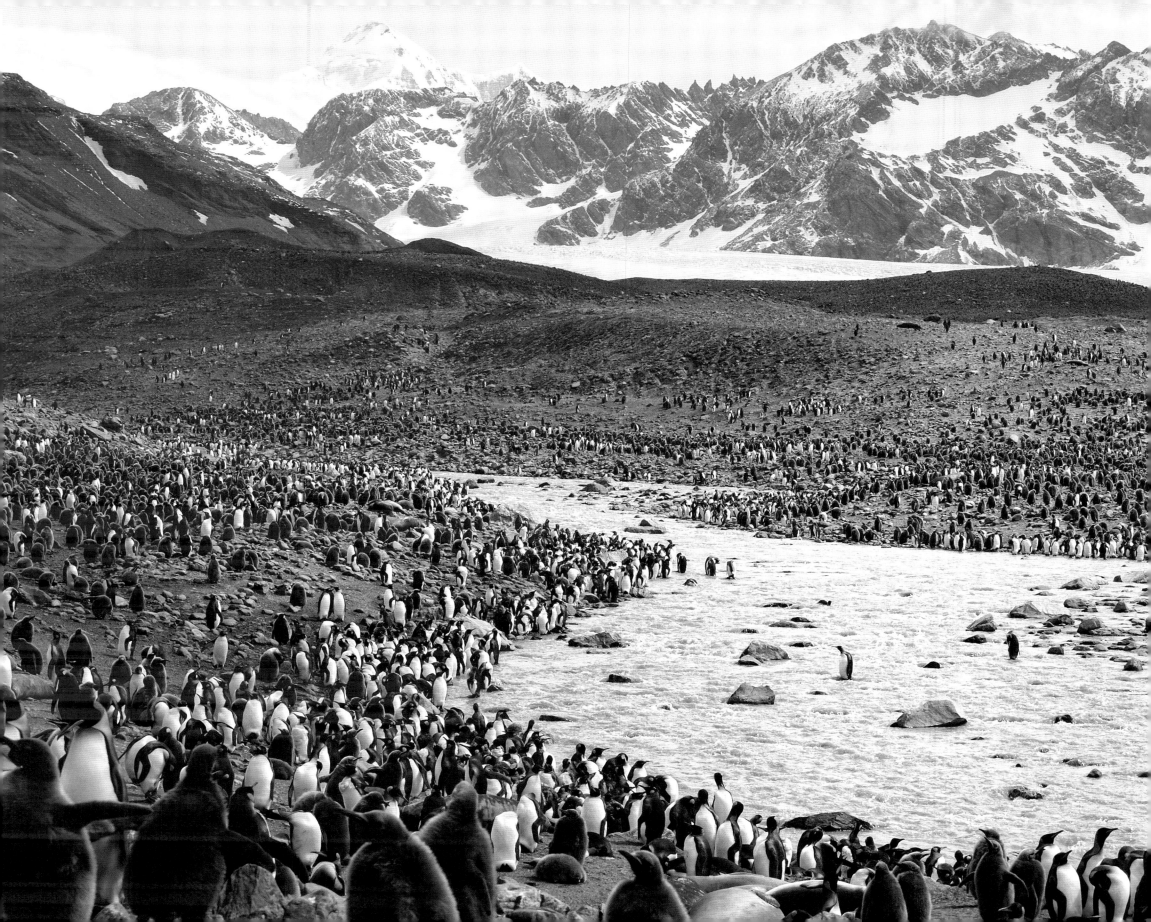

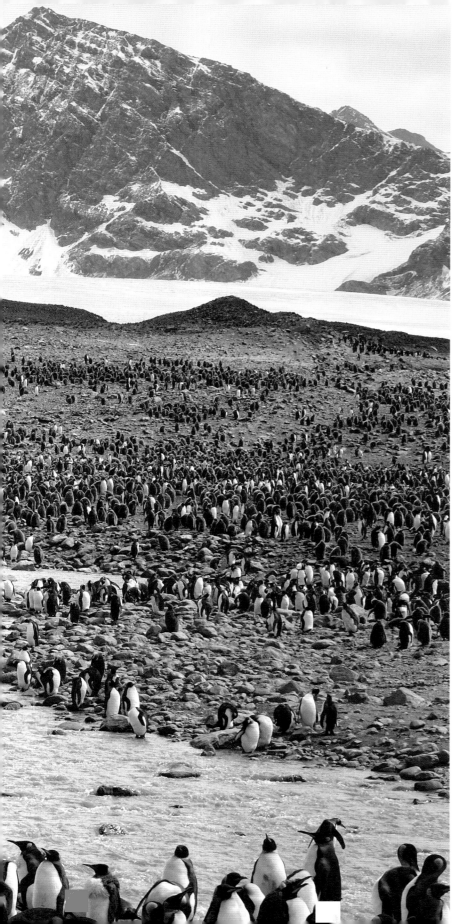

King penguin colony, St. Andrews Bay, South Georgia. There are some 300,000 penguins and chicks. They do not migrate and rear on average one chick every two years. The chicks remain dependent on their parents for more than a year.

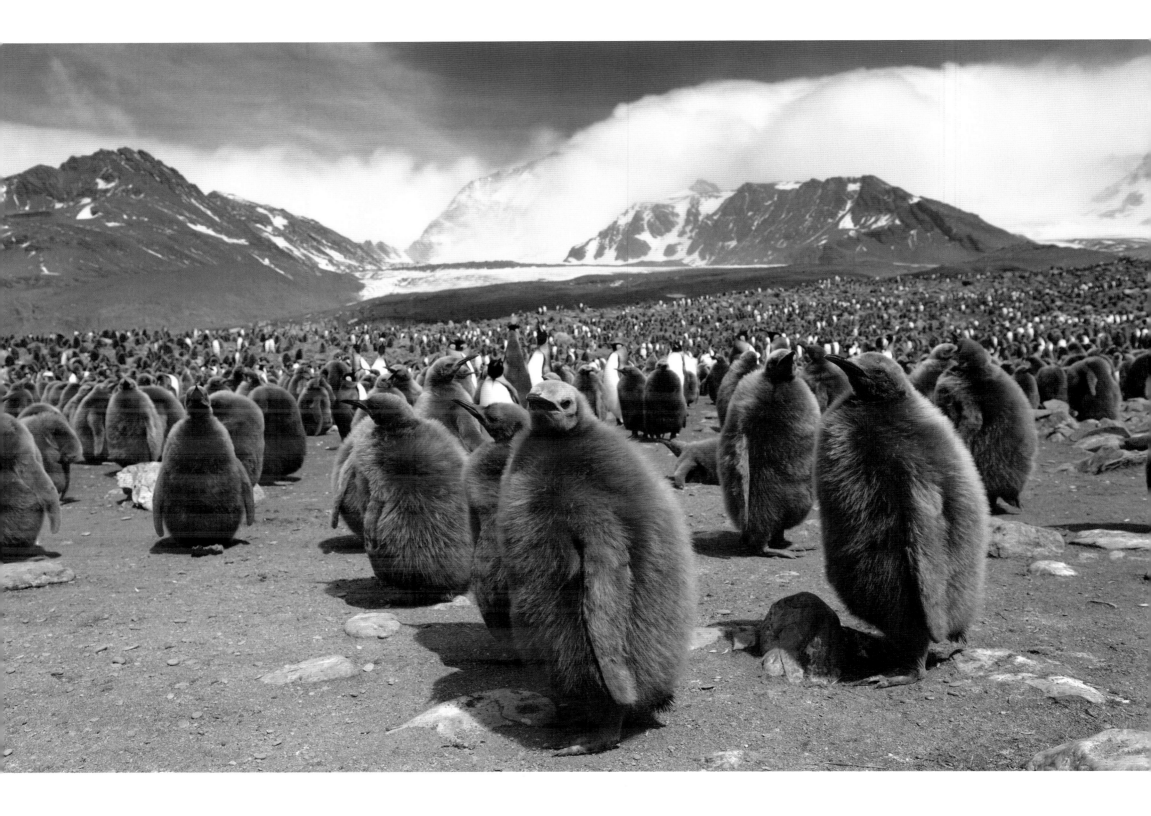

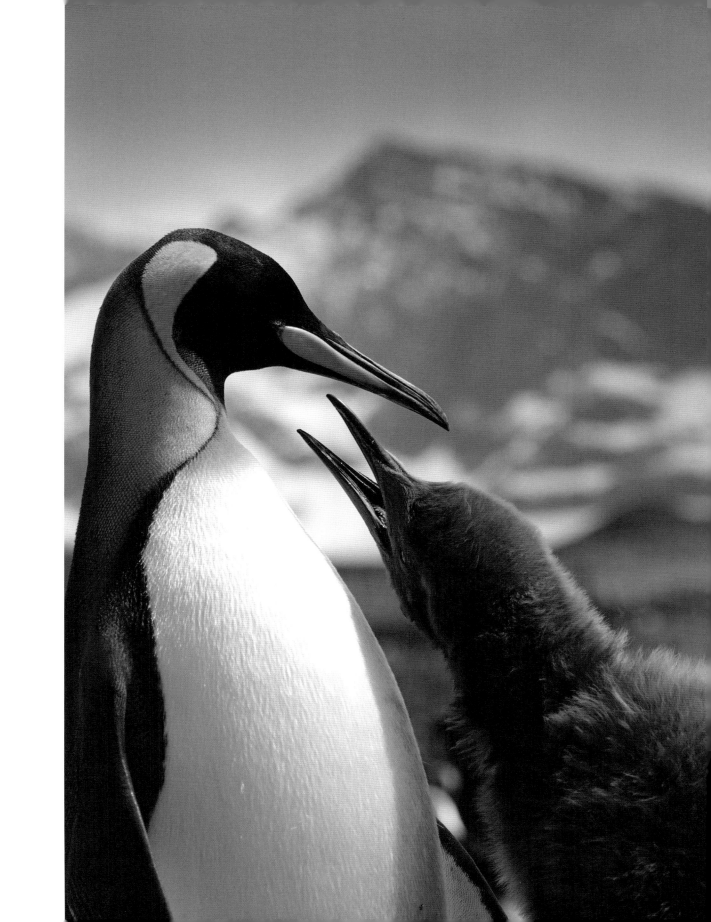

Opposite:
King penguin chicks, St. Andrews Bay, South Georgia. King penguins
frequently change partners for each breeding cycle rather than
pairing for life. They moult before breeding which means that,
like juveniles, they cannot fish for food, and so have to live
on food reserves.

Right:
King penguin chick begging for food.

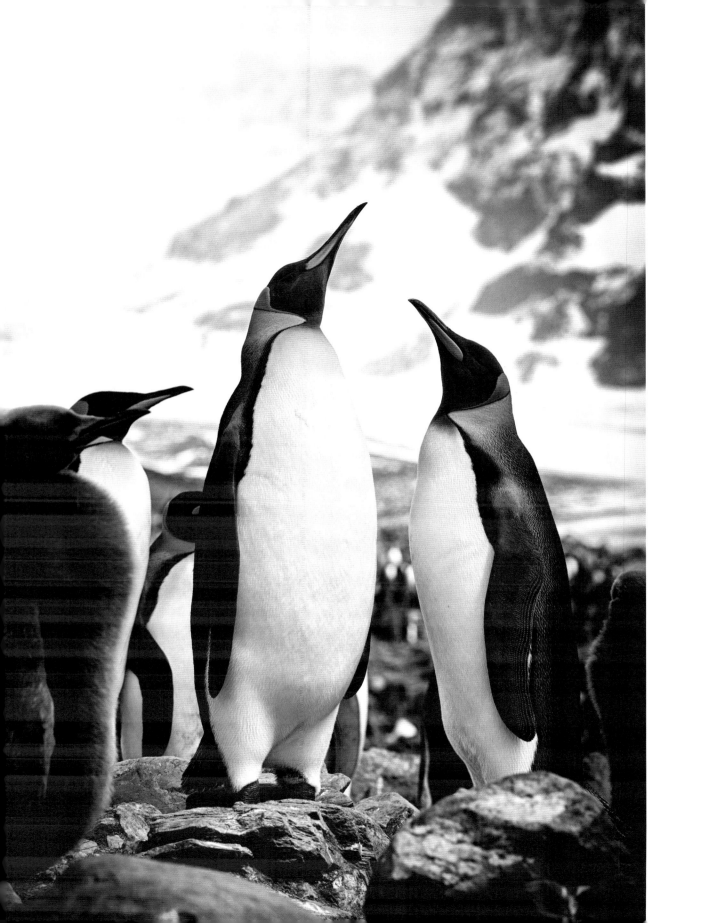

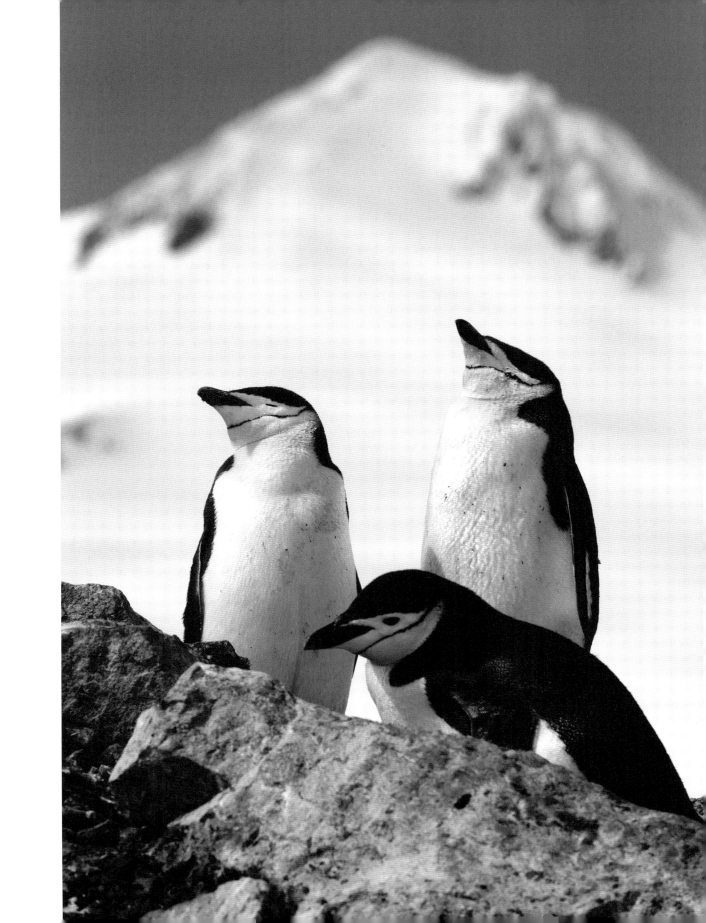

Opposite:
King penguins, St. Andrews Bay, South Georgia. The King penguin has the longest breeding cycle of all birds. The chicks are born with only a thin covering of down and so depend on their parents for warmth and food. It takes 12 to 14 months for a chick to fledge.

Right:
Chinstrap penguins, Half Moon Island, Antarctica.

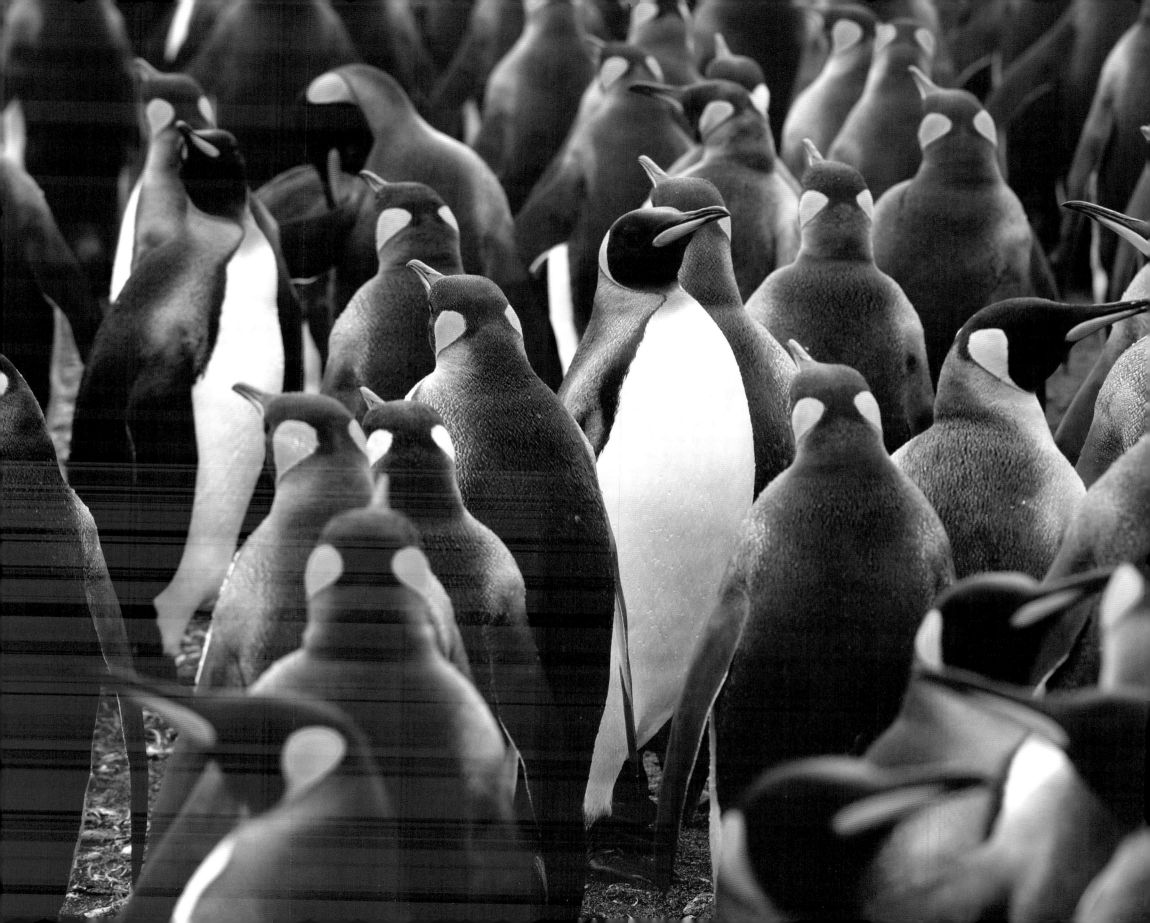

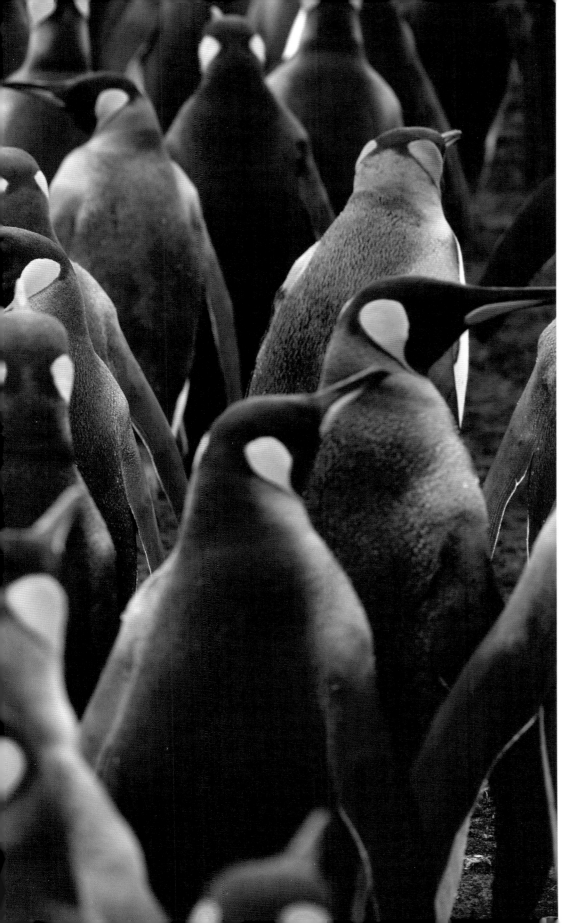

Opposite:
King penguin colony, St. Andrews Bay, South Georgia.

Overleaf left and right:
King cormorants, New Island, Falkland Islands. King cormorants breed on gentle cliff-top slopes at over a hundred sites on the Falklands sharing their colonies with Rockhopper penguins and Black-browed albatrosses. They remain around the Falklands throughout the year. They lay two to four eggs around November in nests made of mud and vegetation. They hatch in December and the chicks fledge in February. They are in decline.

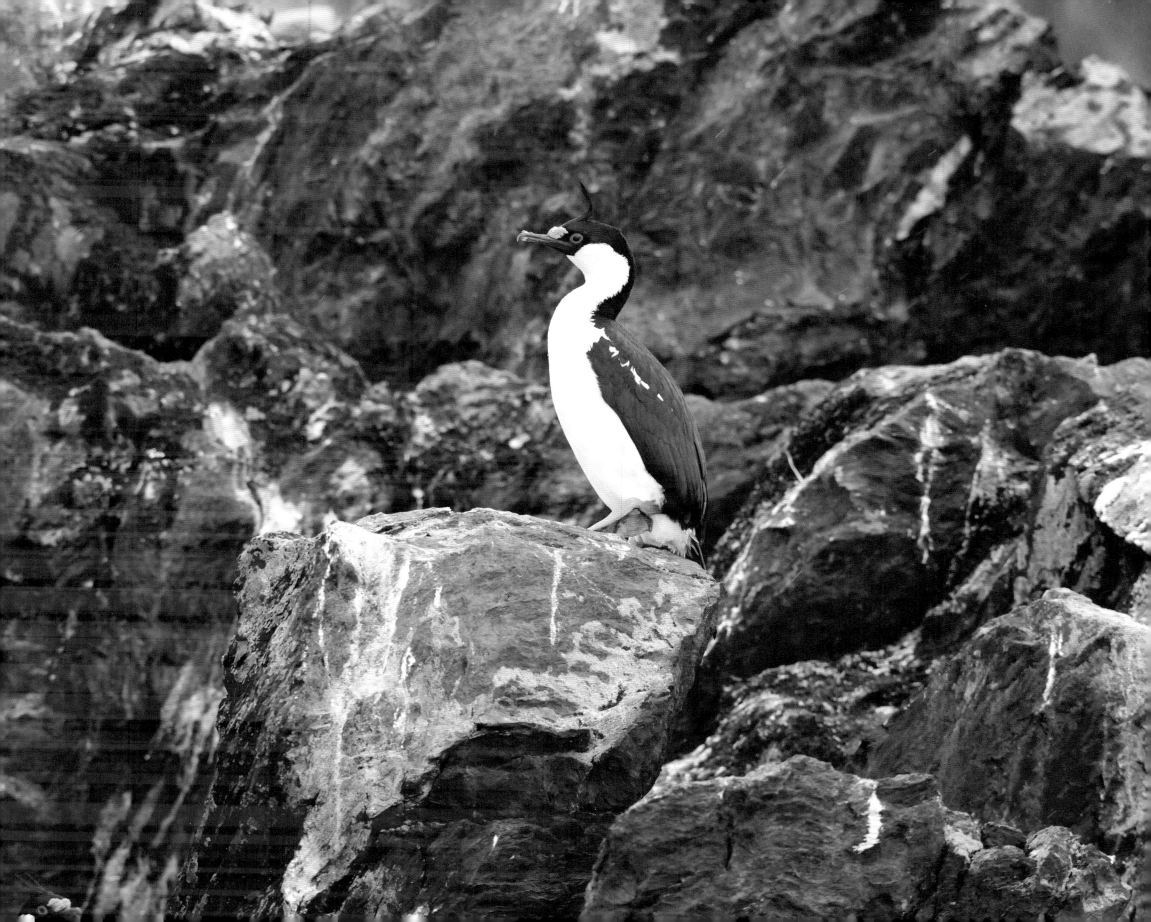

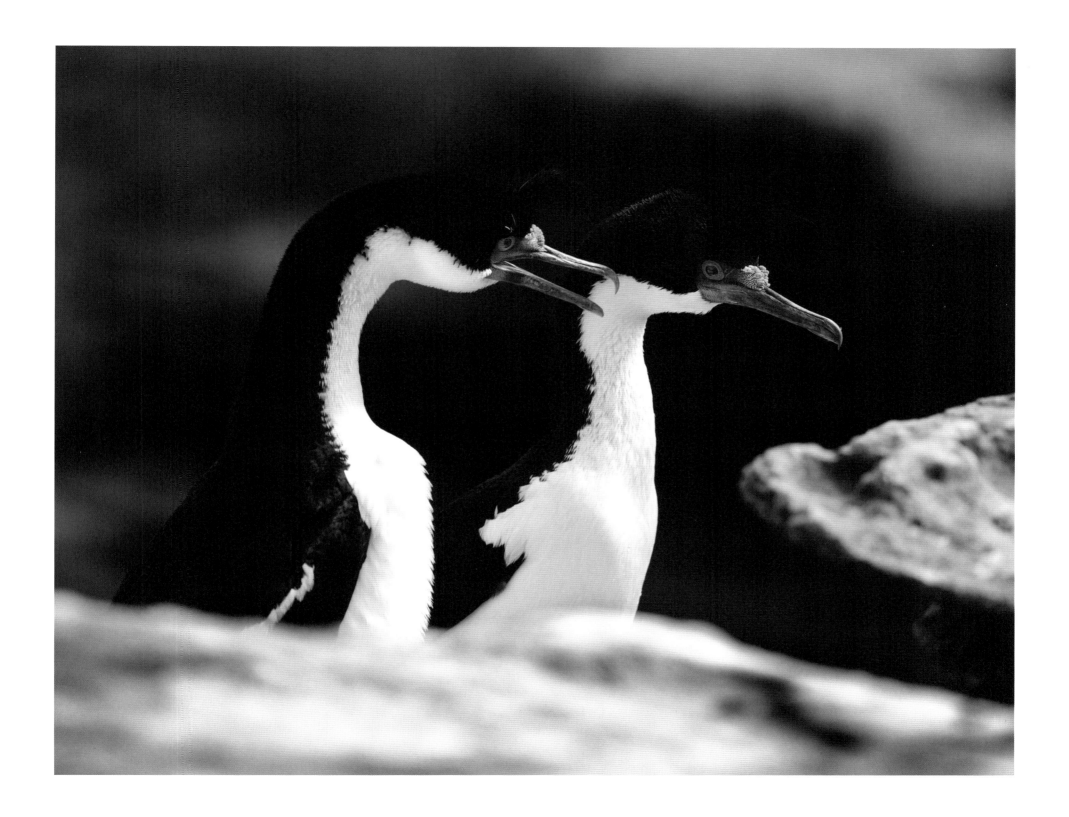

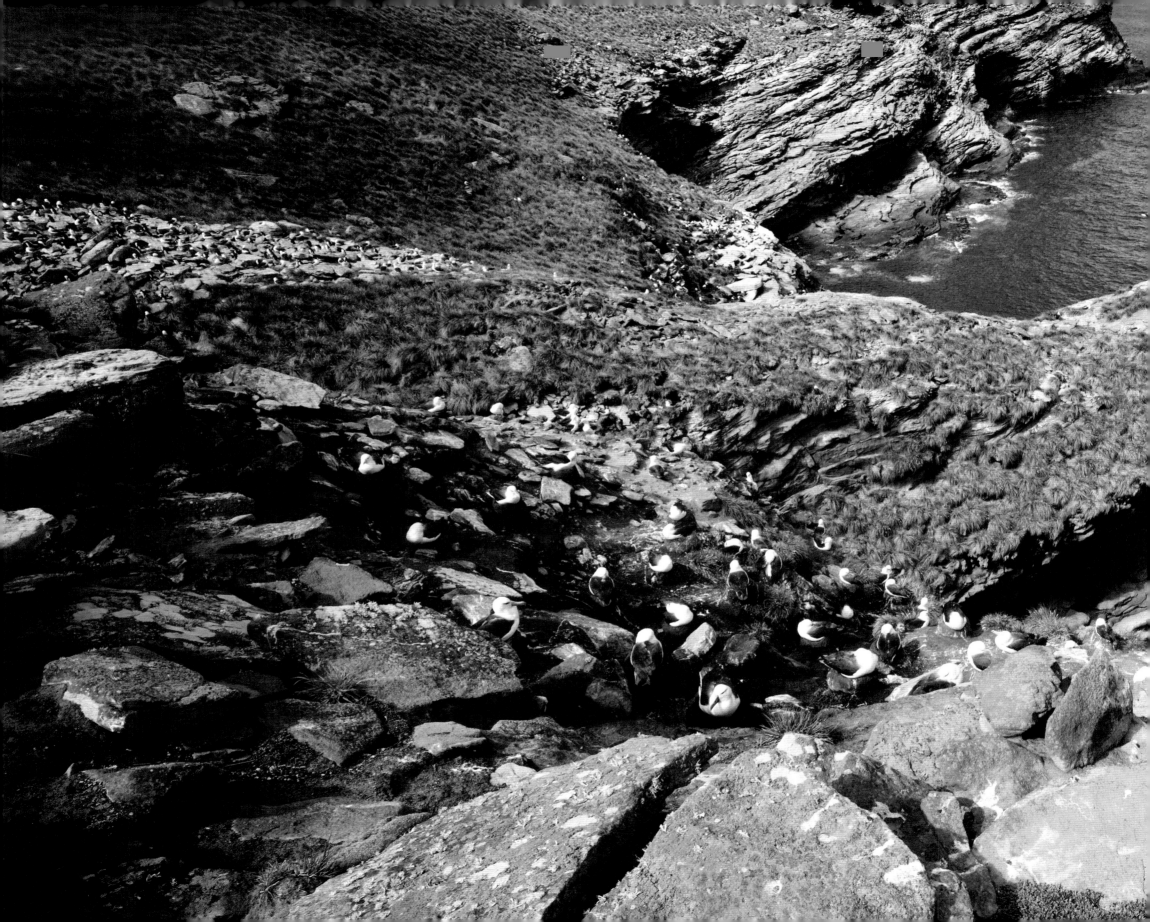

Black-browed albatrosses, Westpoint Cove, Westpoint Island, north-western Falkland Islands.

Fur seal, Cooper Bay, South Georgia. Antarctic fur seals were hunted to near extinction by American and British sealers in the eighteenth and nineteenth centuries. It is thought that all the fur seals alive today descend from a small colony that survived on Bird Island, South Georgia.

Overleaf:
Tabular iceberg near Antarctic Sound. Tabular icebergs have cliff-like sides and a flat top. They usually occur by calving from an ice shelf.

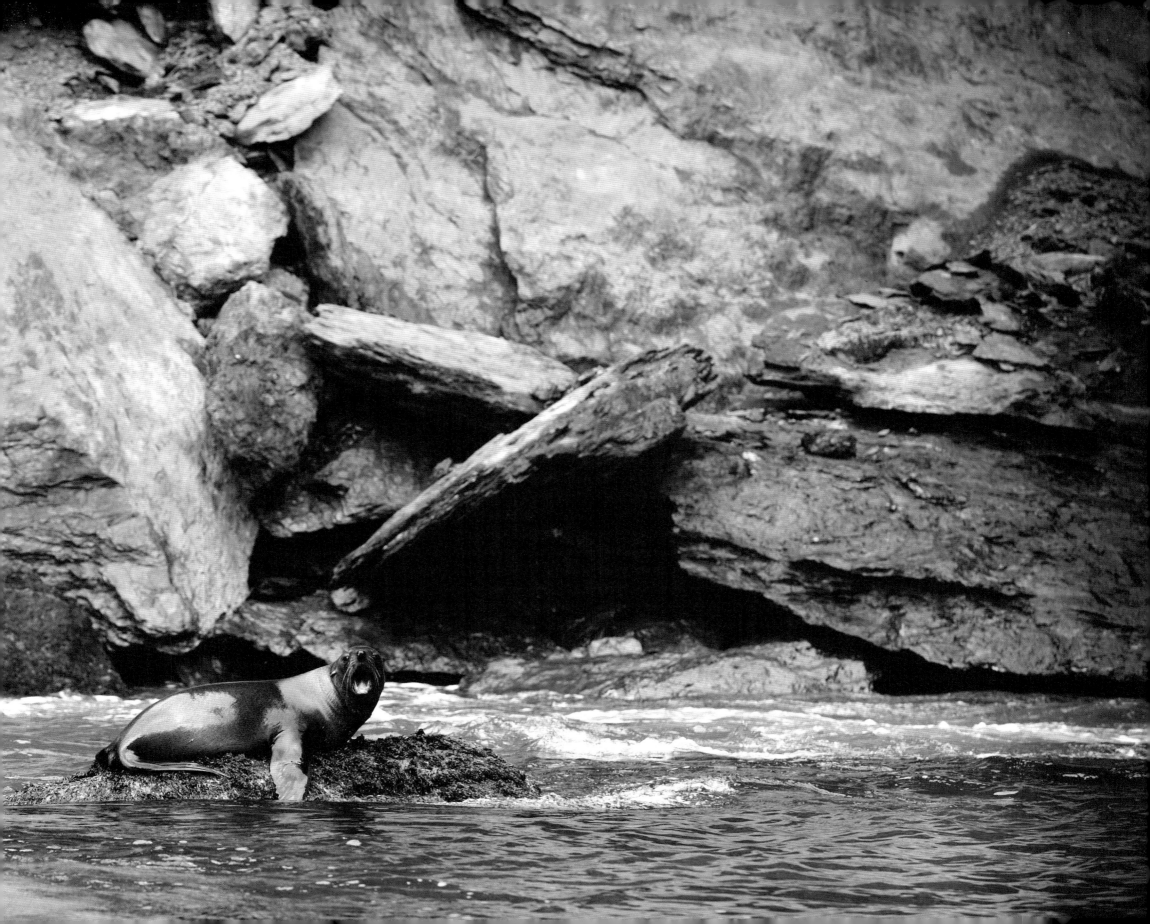

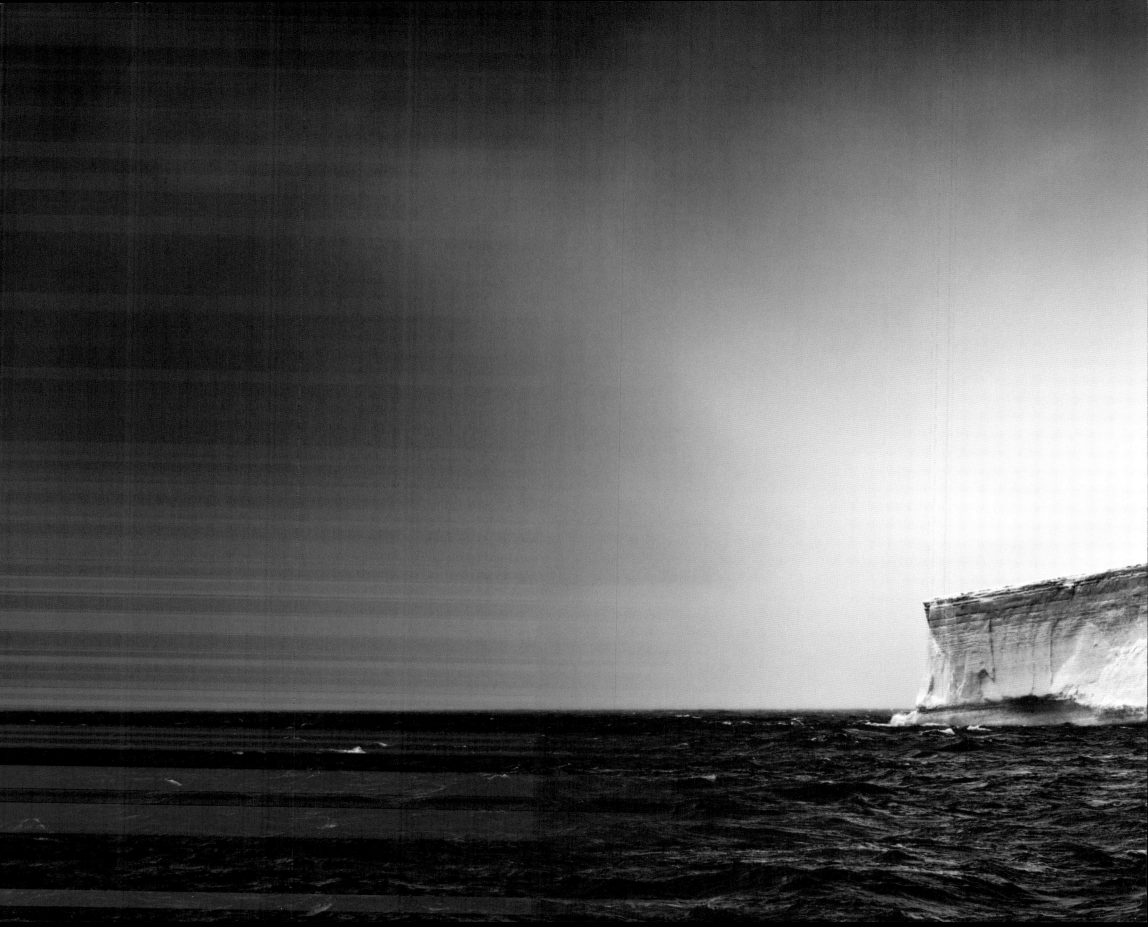

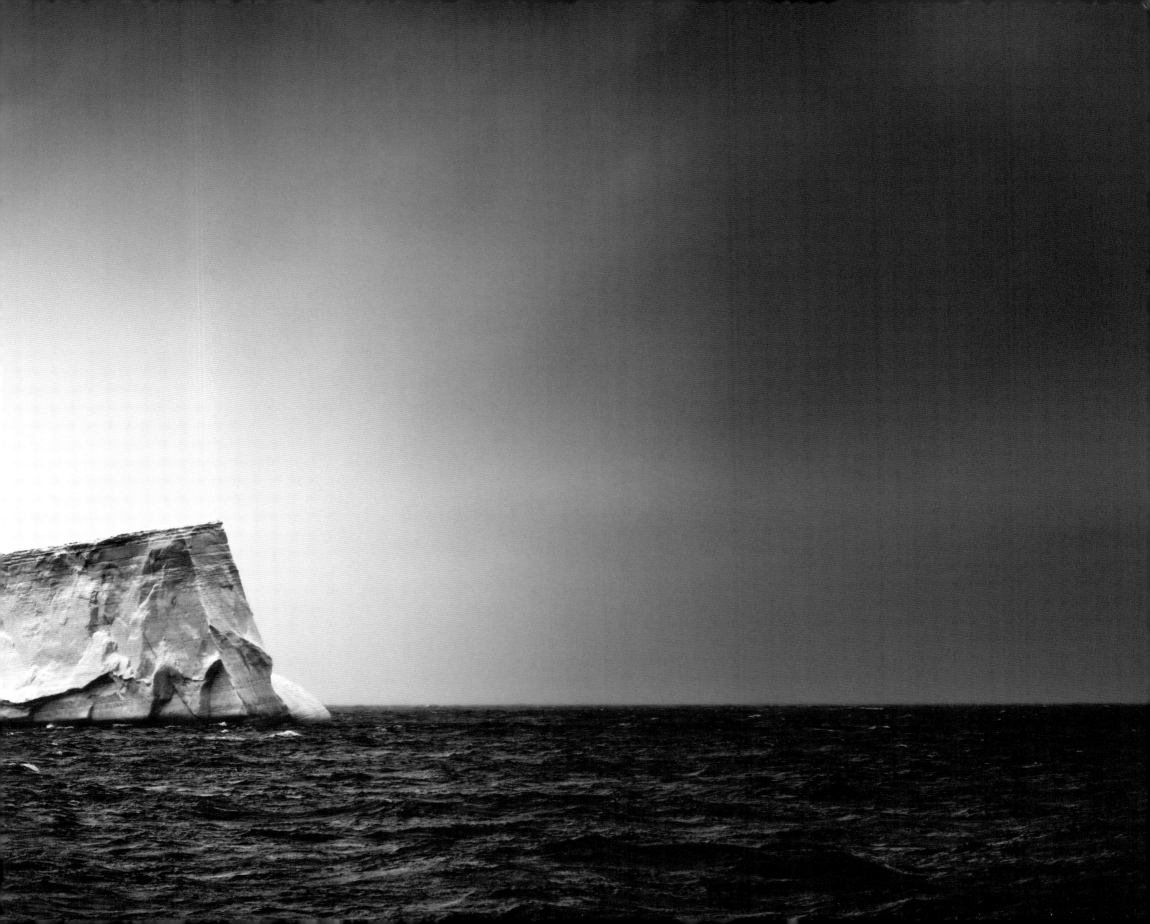

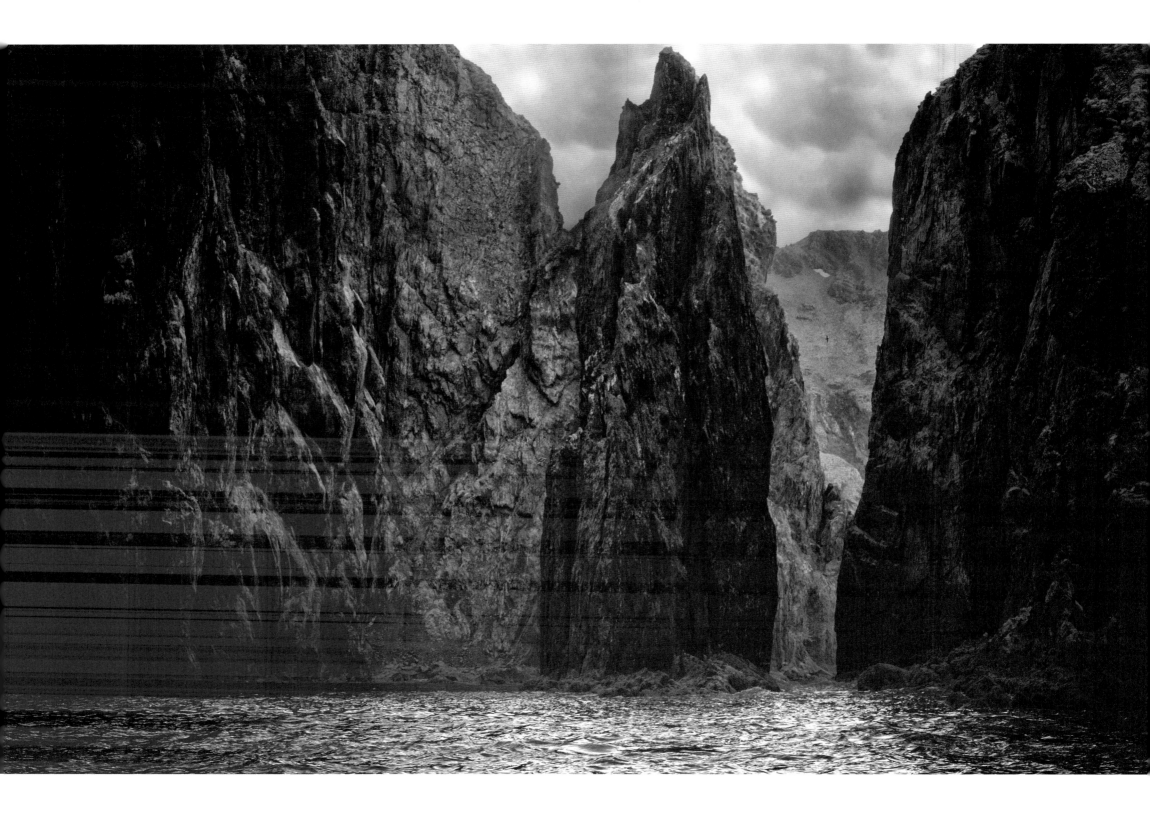

Cooper Bay, South Georgia, named after the nearby Cooper Island,
which was discovered by Captain James Cook in 1775.

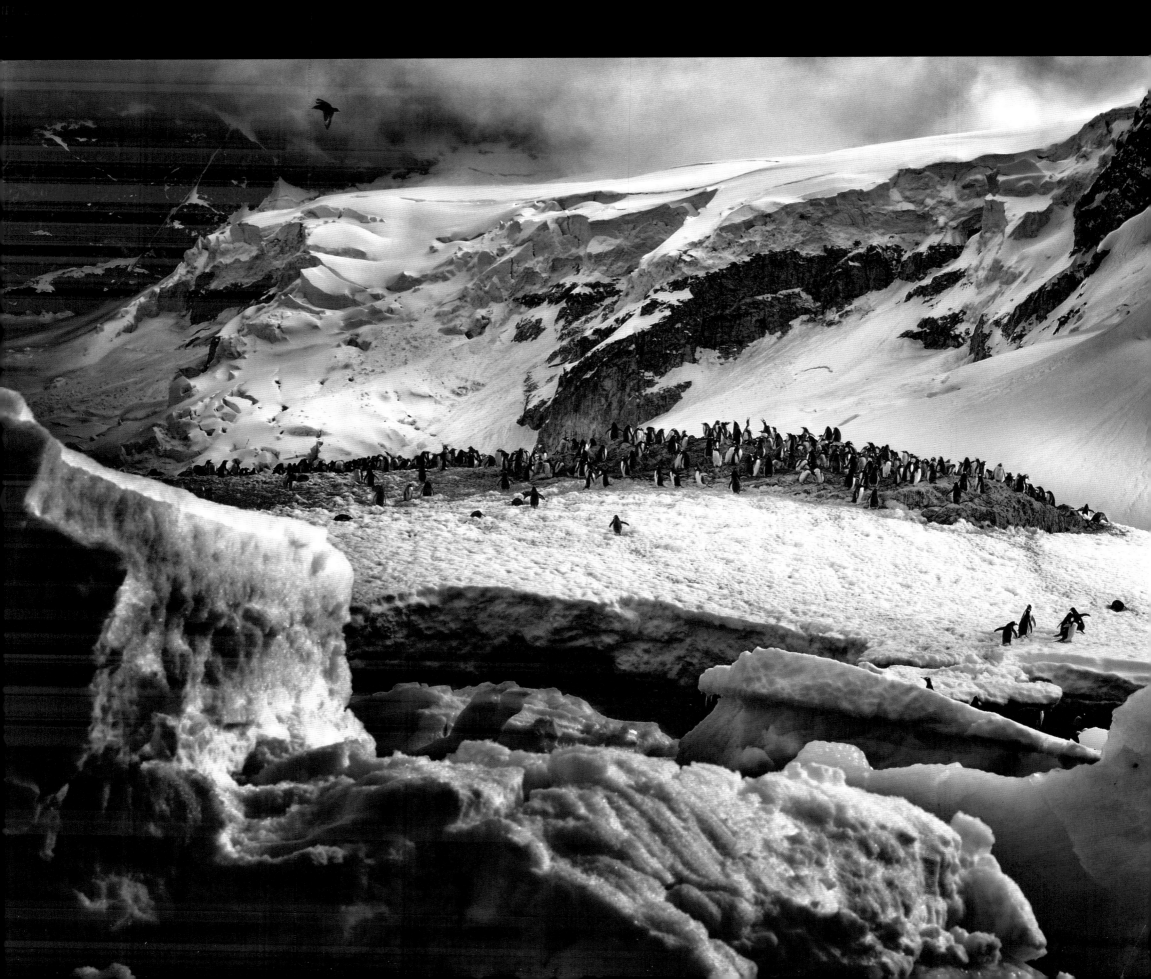

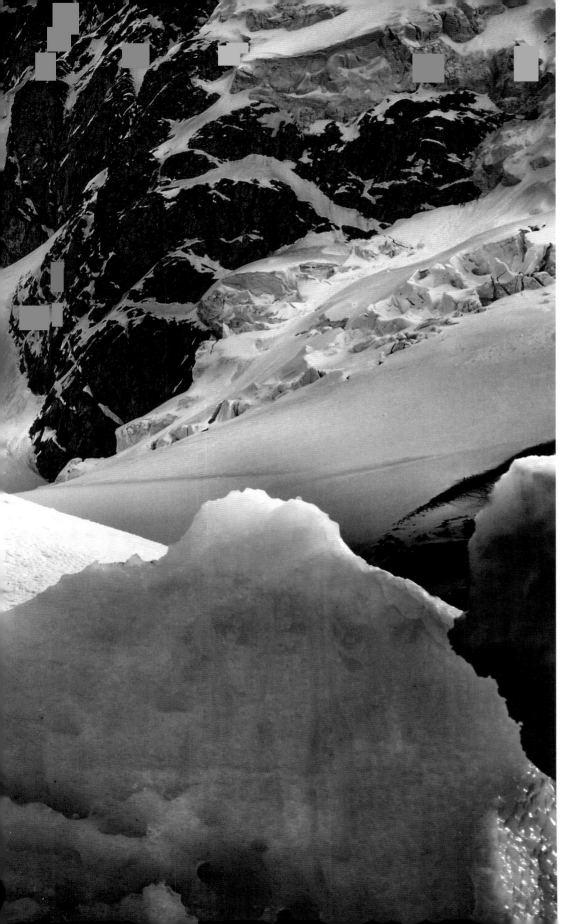

Gentoo penguins on an ice-capped island in Gerlache Strait, Antarctica, first charted by Adrien de Gerlache in 1897.

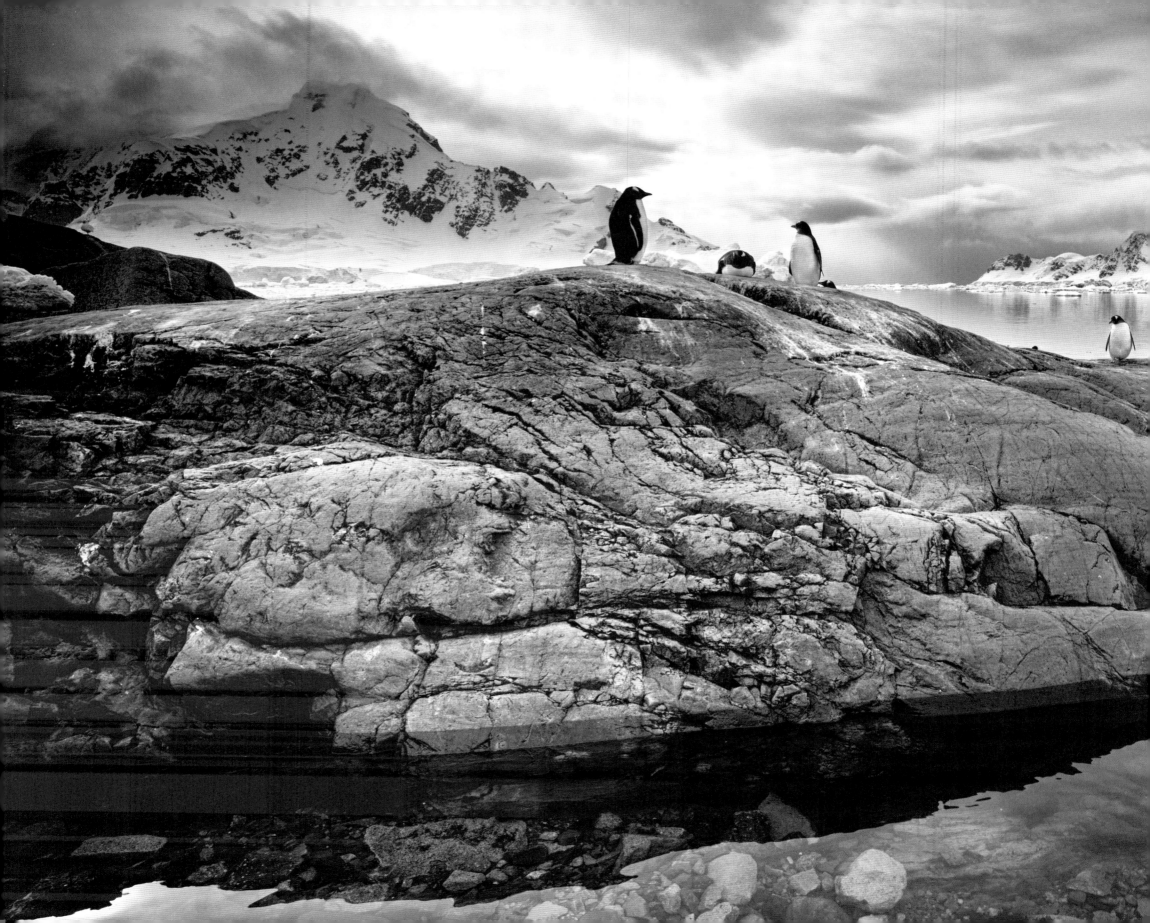

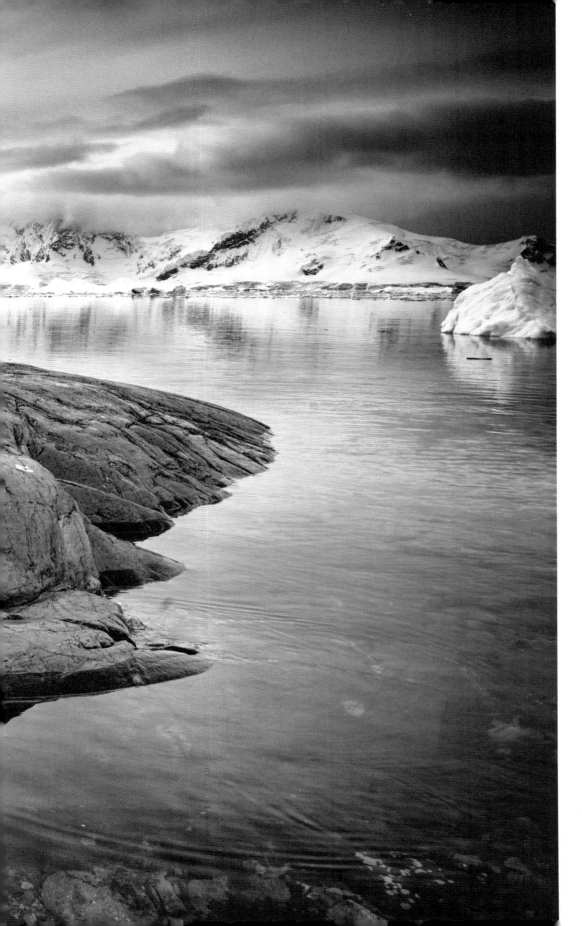

Gentoo penguins, Paradise Harbour, Antarctica.

Elephant seal, St. Andrews Bay, South Georgia.

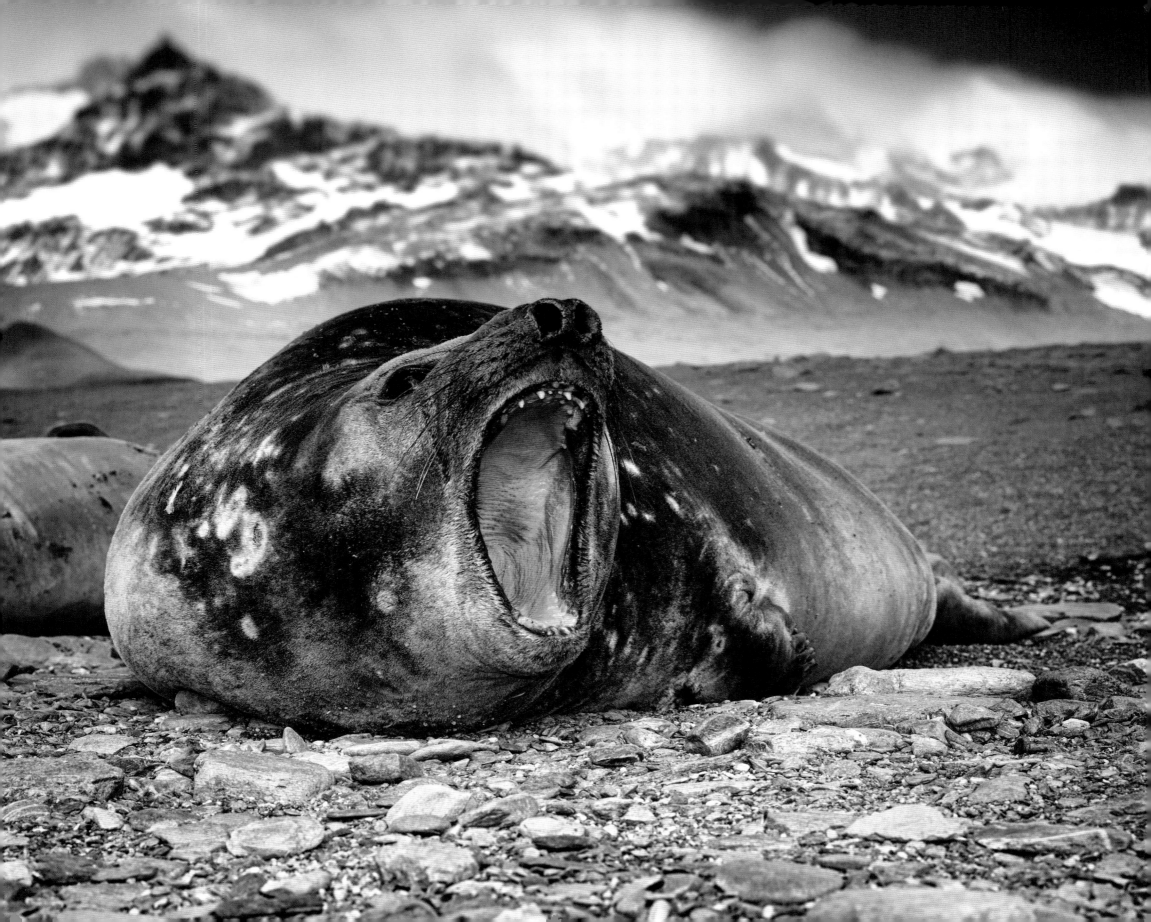

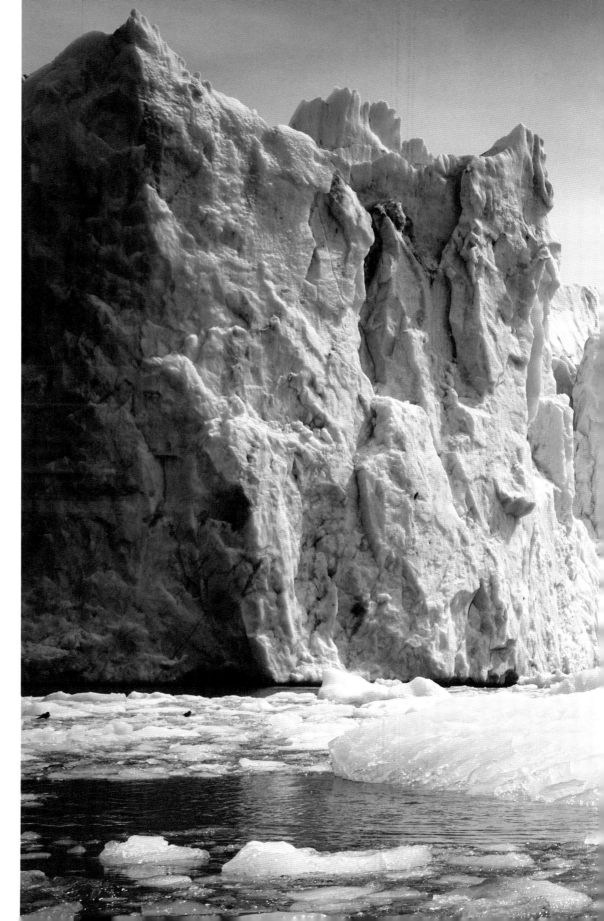

Ross Glacier, Royal Bay, South Georgia.

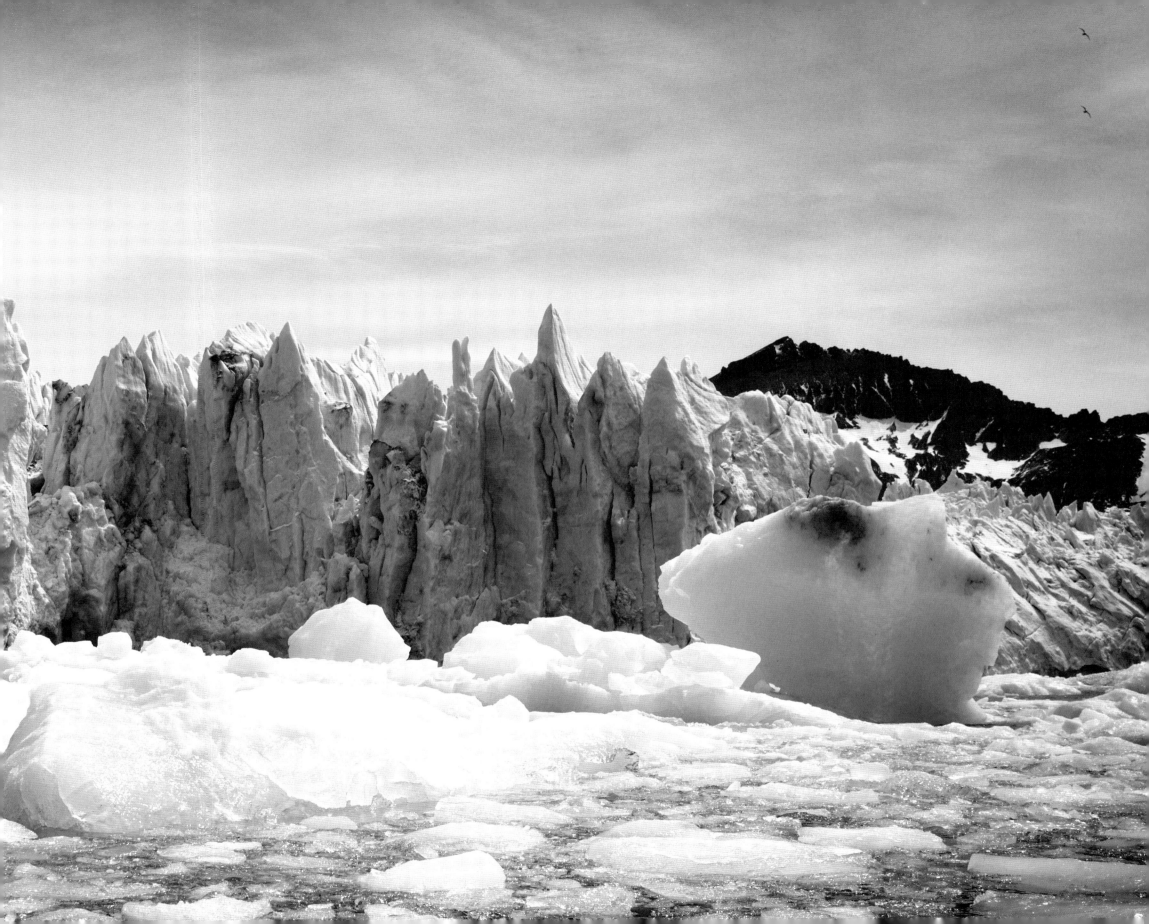

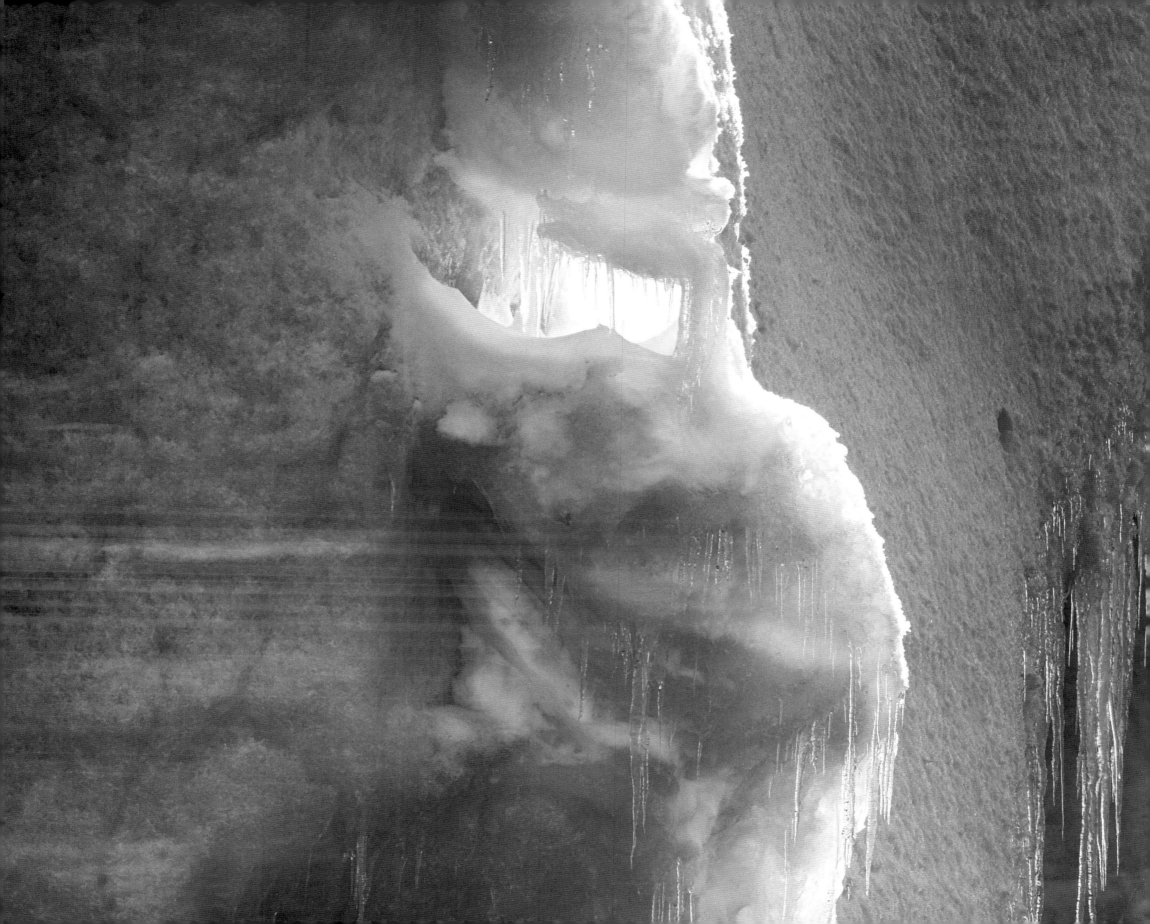

Ice mask, Erebus and Terror Gulf, Antarctica.

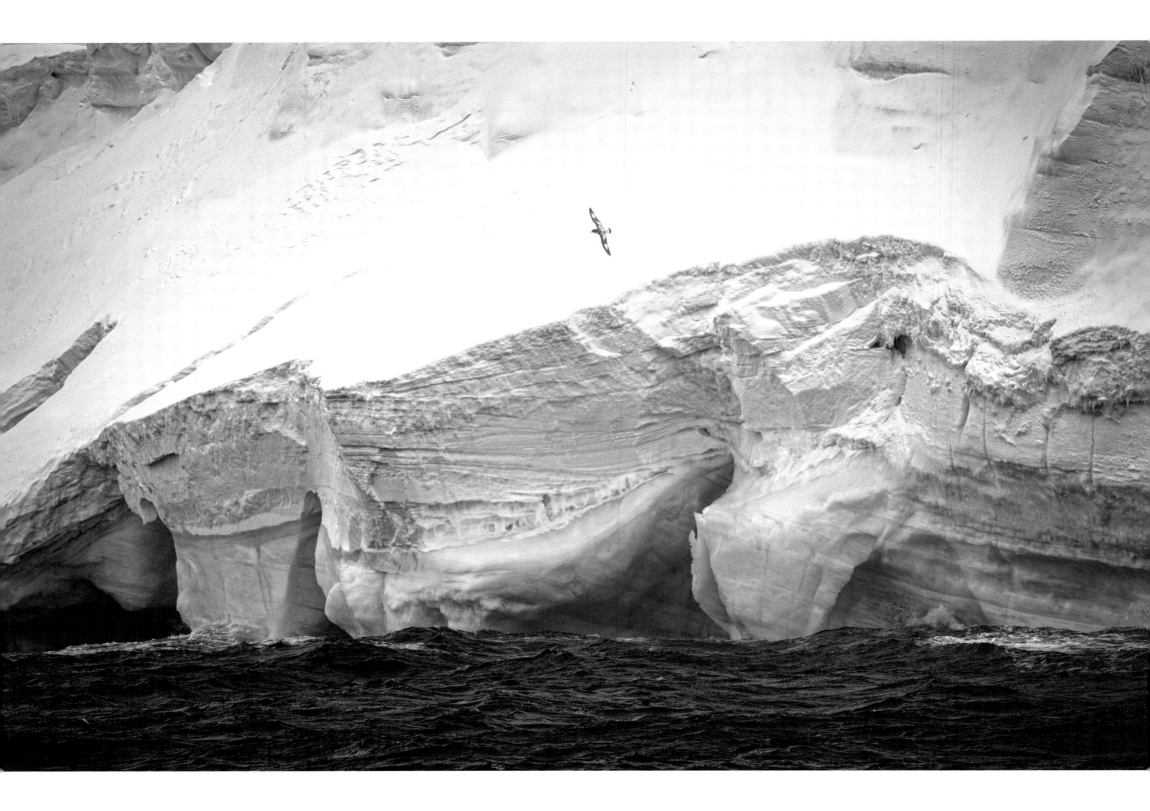

Cape petrel and iceberg, at sea towards the South Orkney Islands.

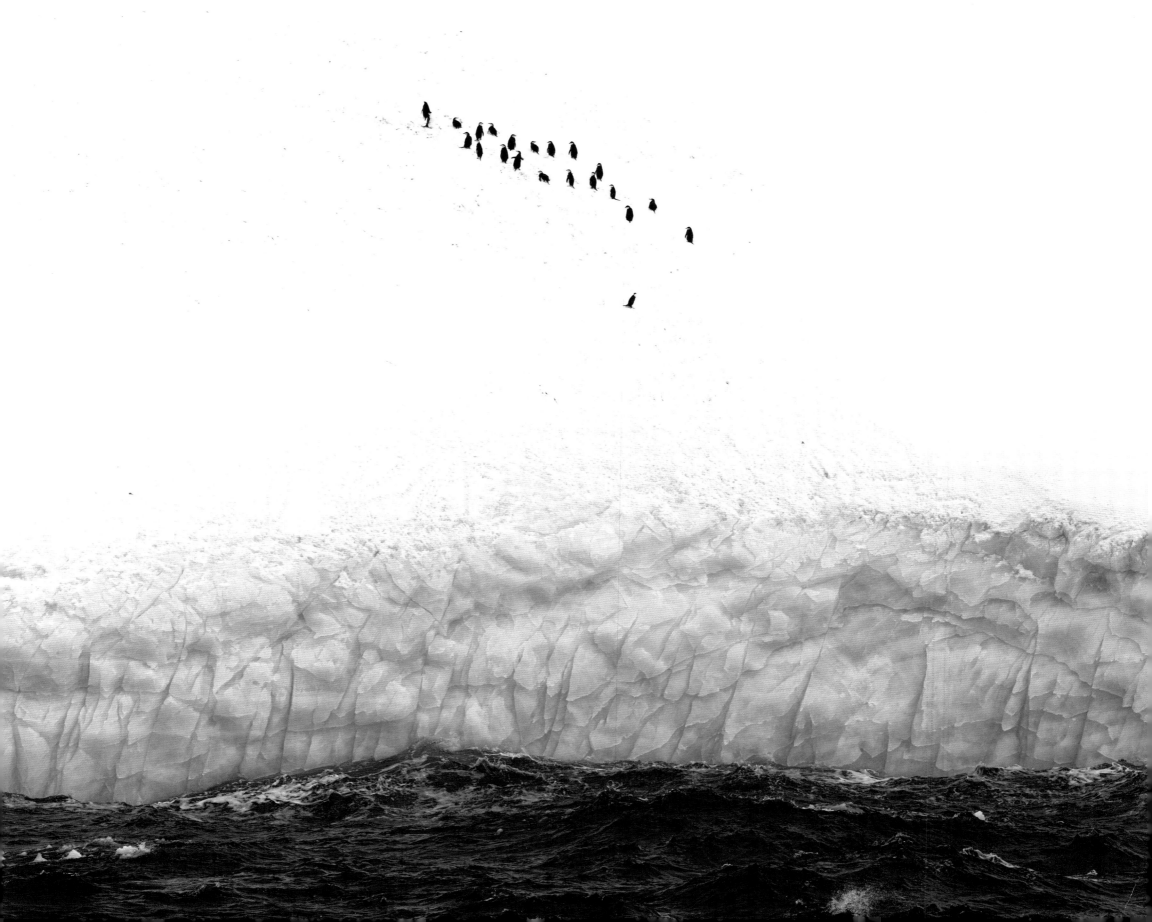

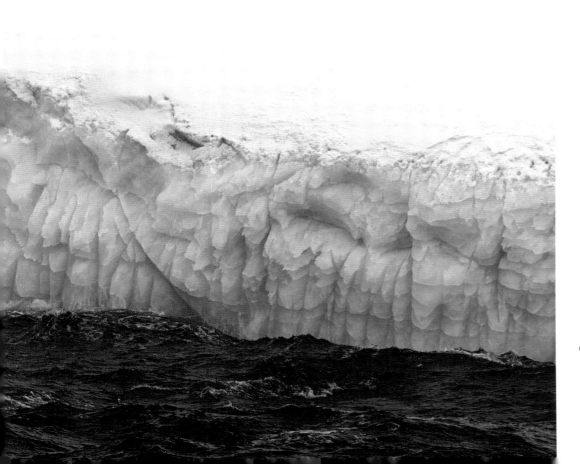

Chinstrap penguins on an iceberg in the Southern Ocean.

Chinstrap penguins on an iceberg in the Southern Ocean.

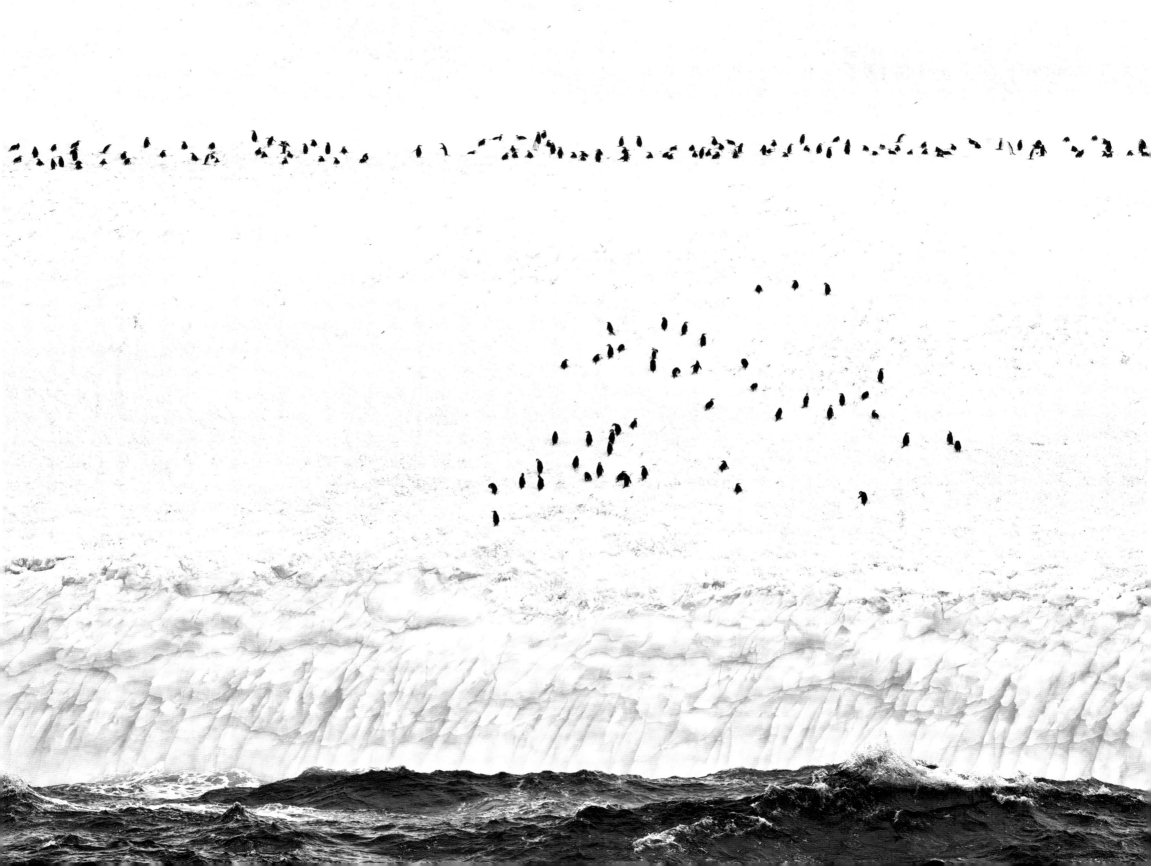

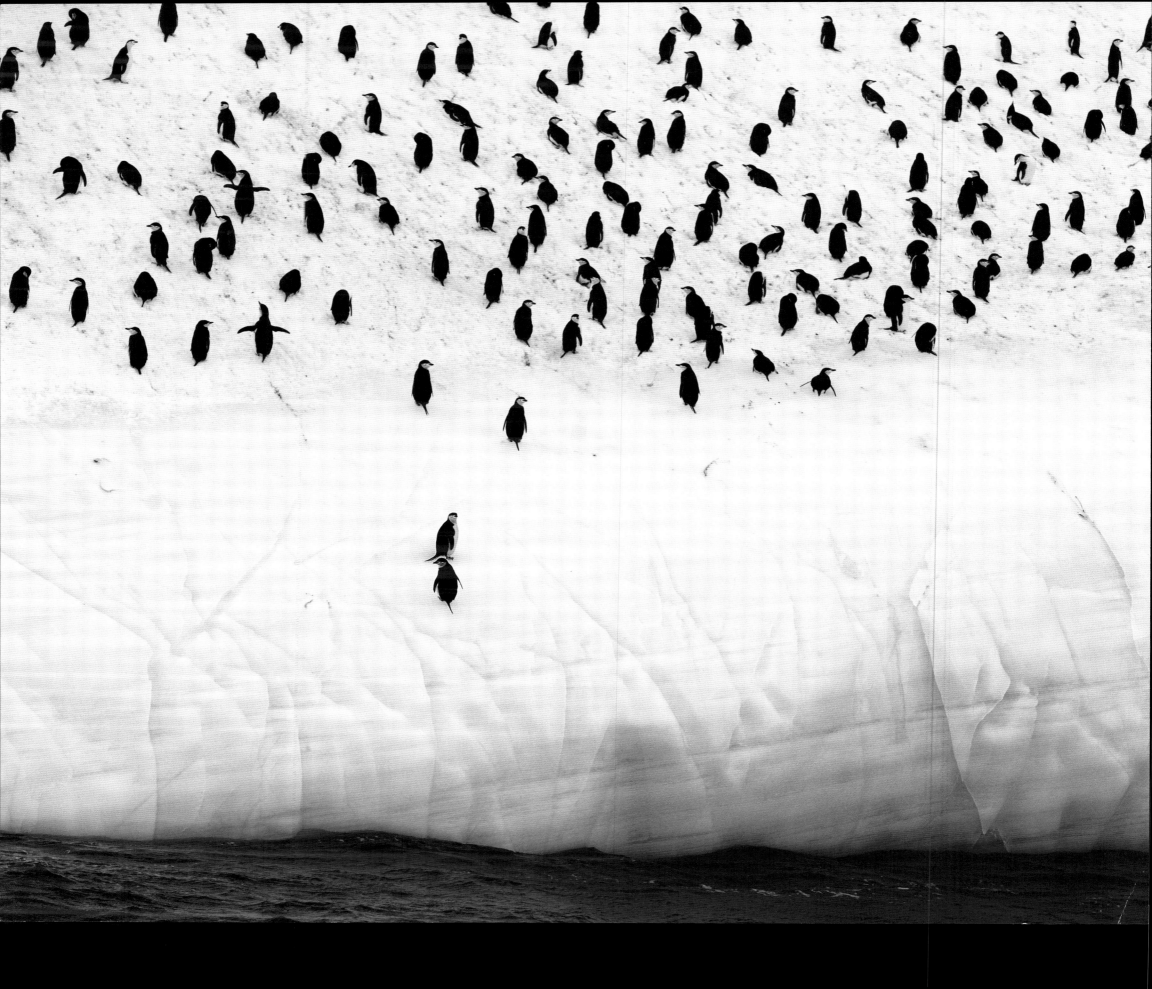

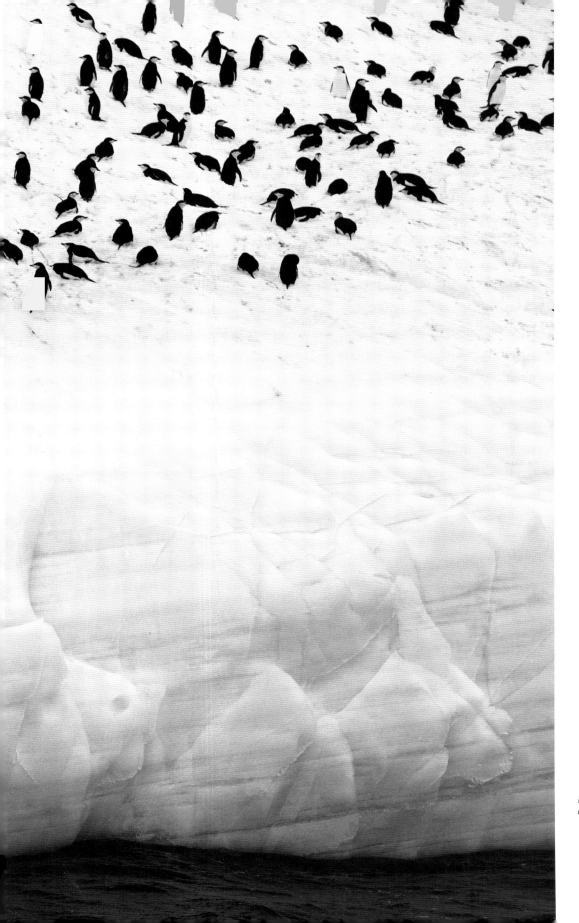

Left and overleaf:
Chinstrap penguins on an iceberg in the Southern Ocean.

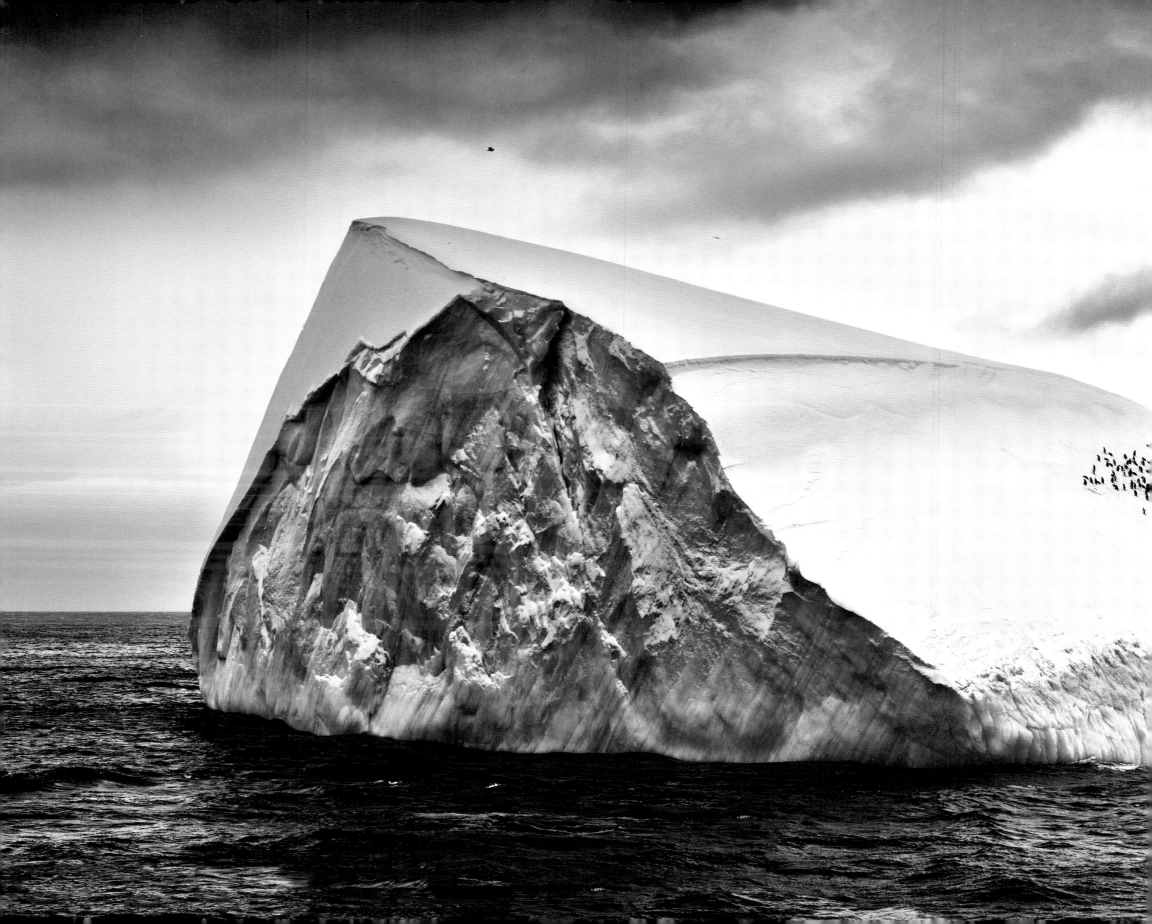

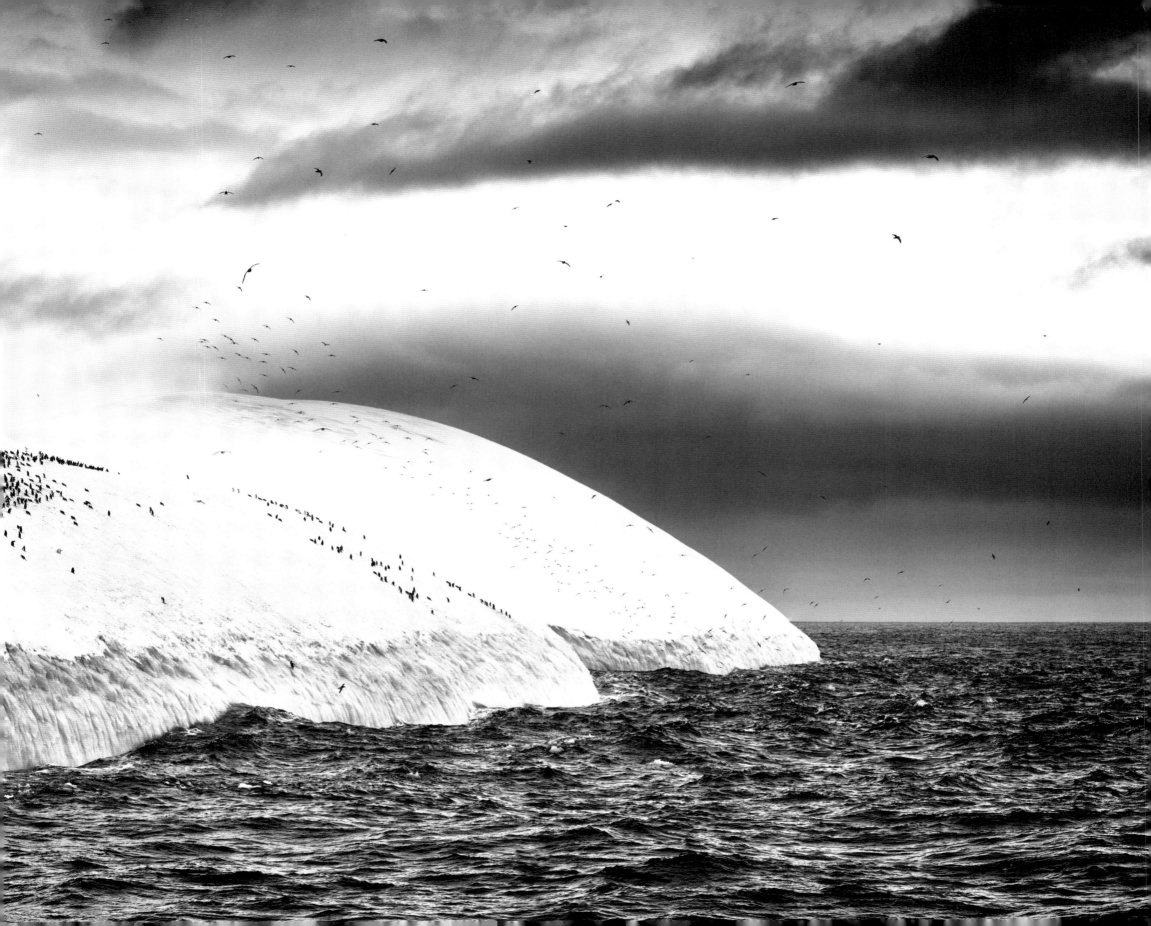

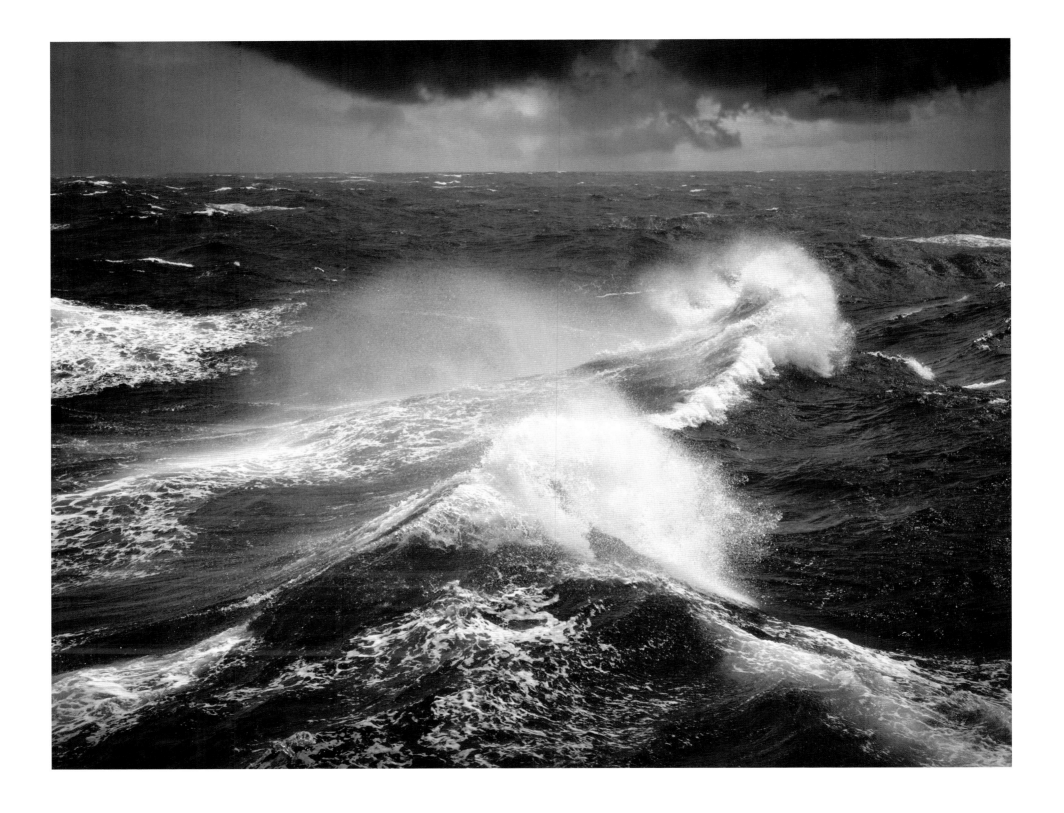

A storm in the Southern Ocean. Sailors refer to the latitudes from 40° to 70° south as the 'Roaring Forties', the 'Furious Fifties' and the 'Screaming Sixties' because the easterly winds that circulate around the globe are virtually unimpeded by land masses.

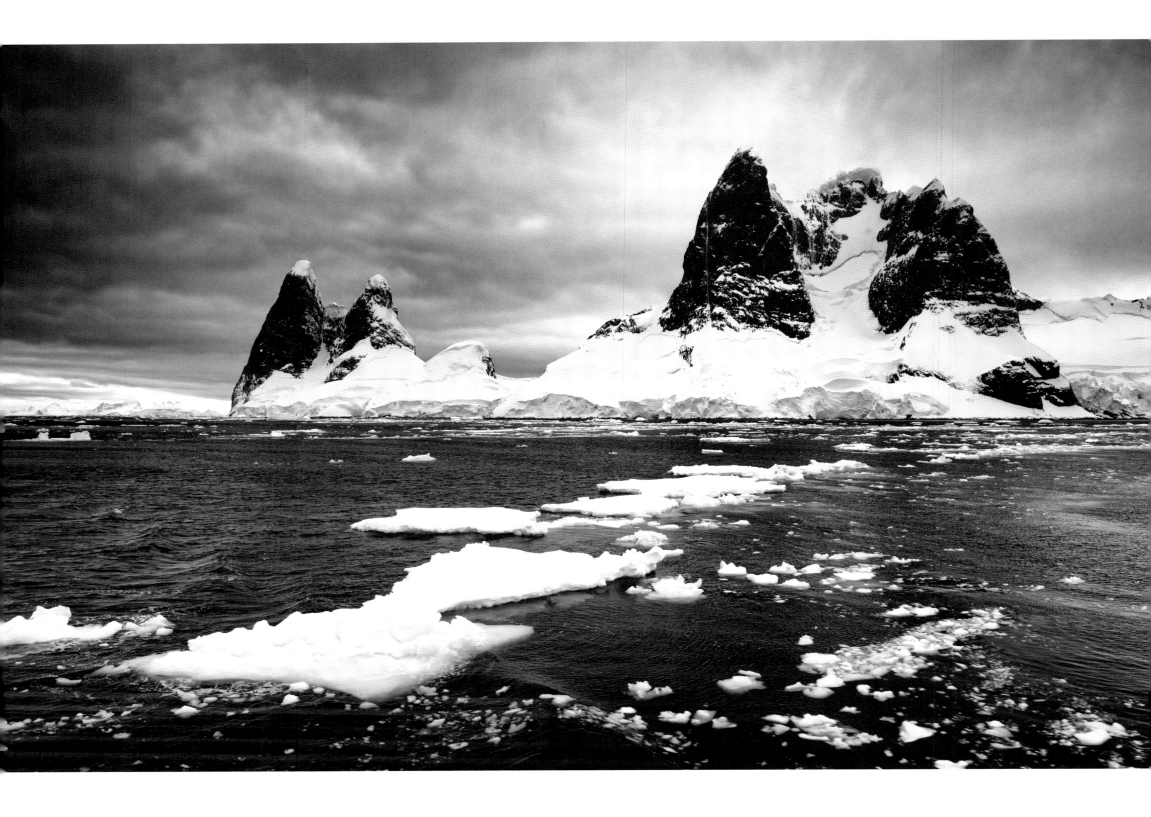

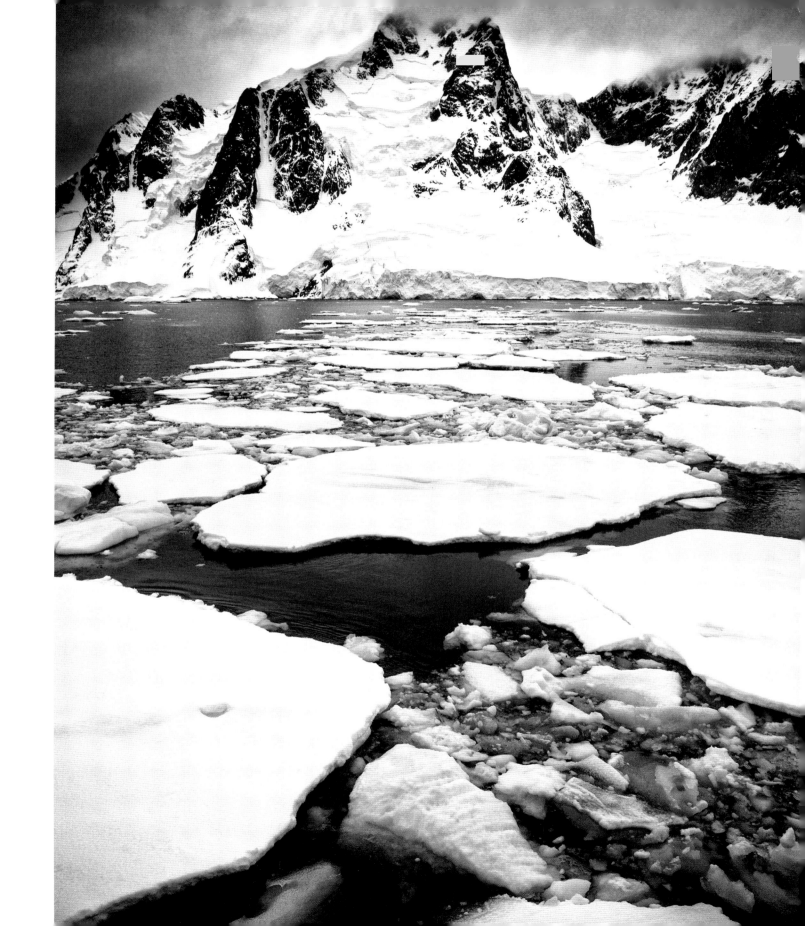

Opposite and right:
Lemaire Channel, Antarctica.

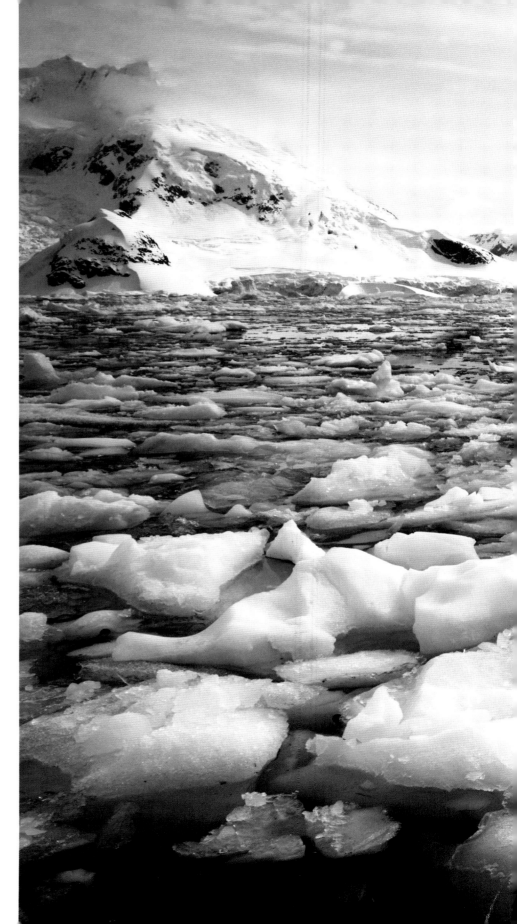

Lemaire Channel, Antarctica.

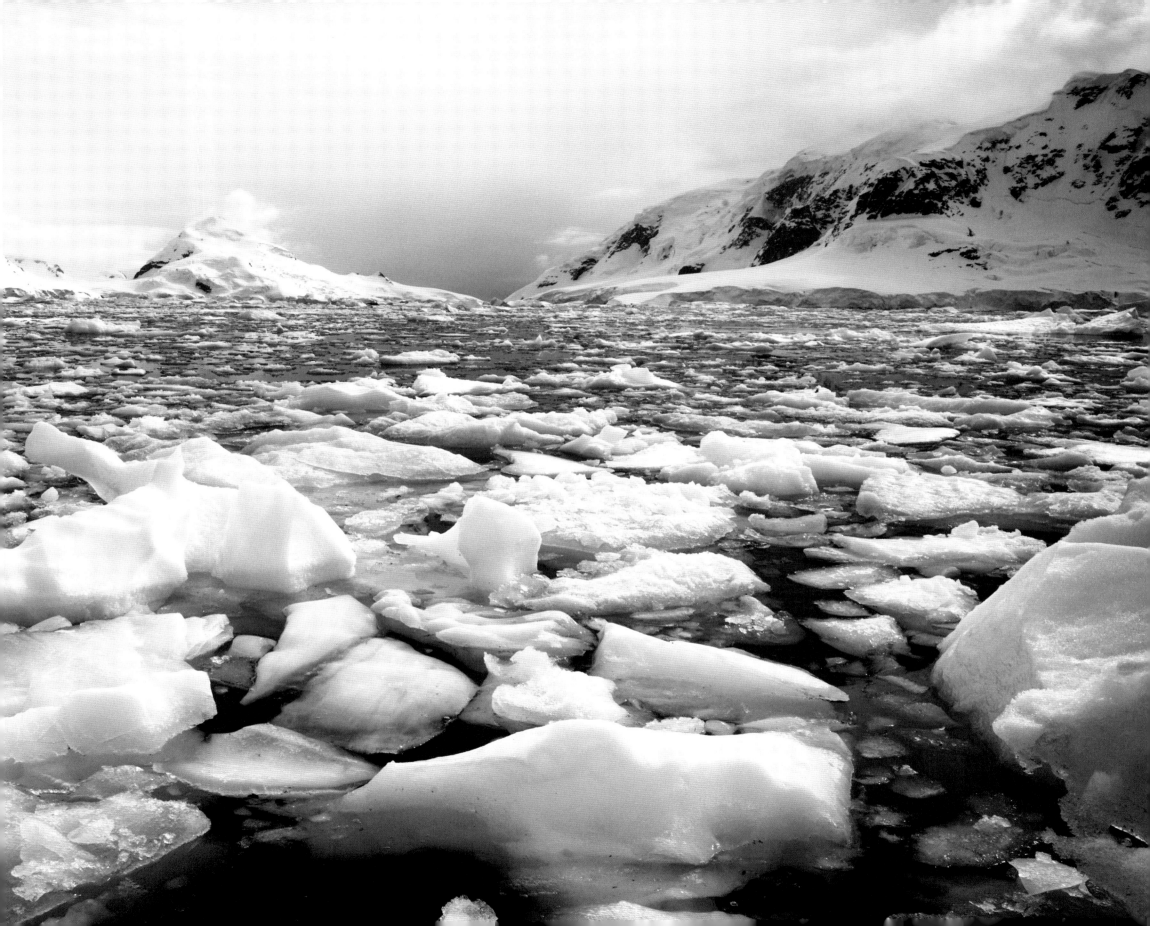

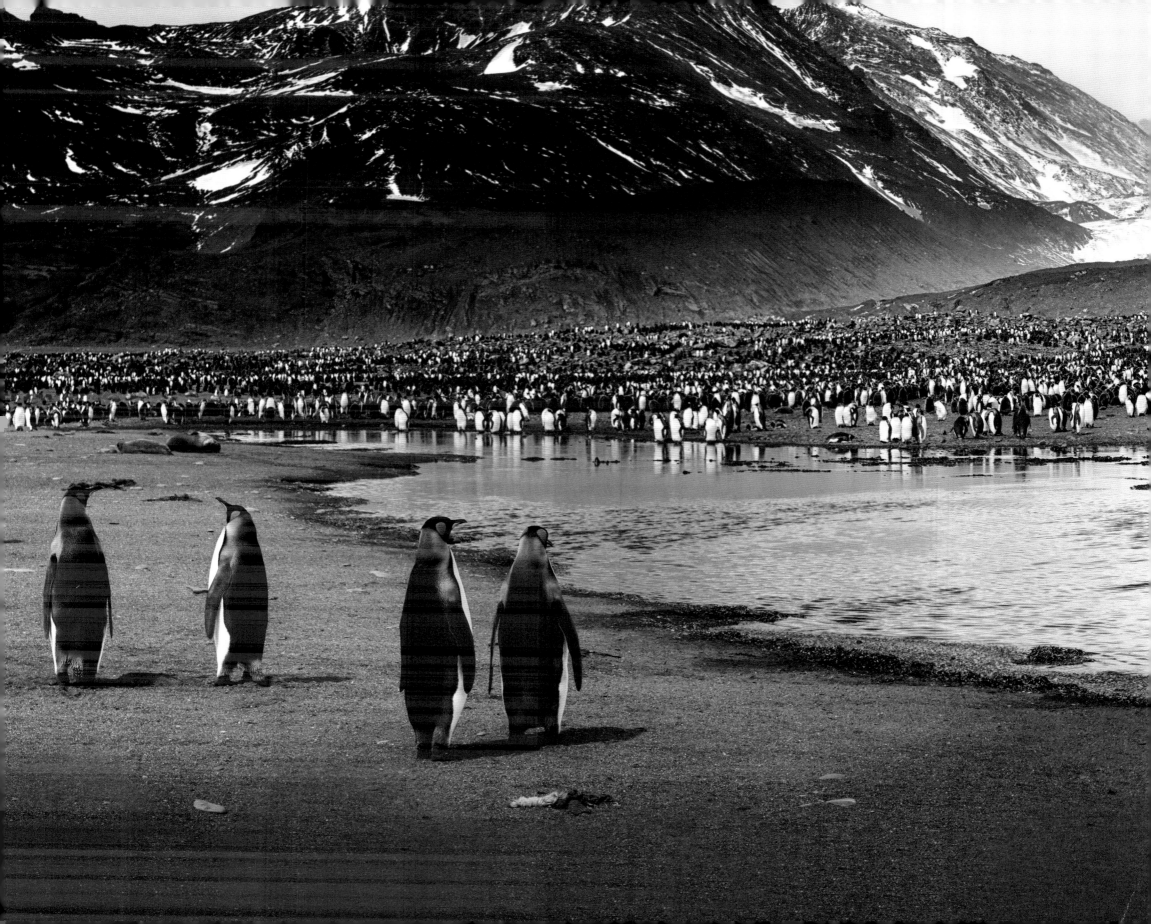

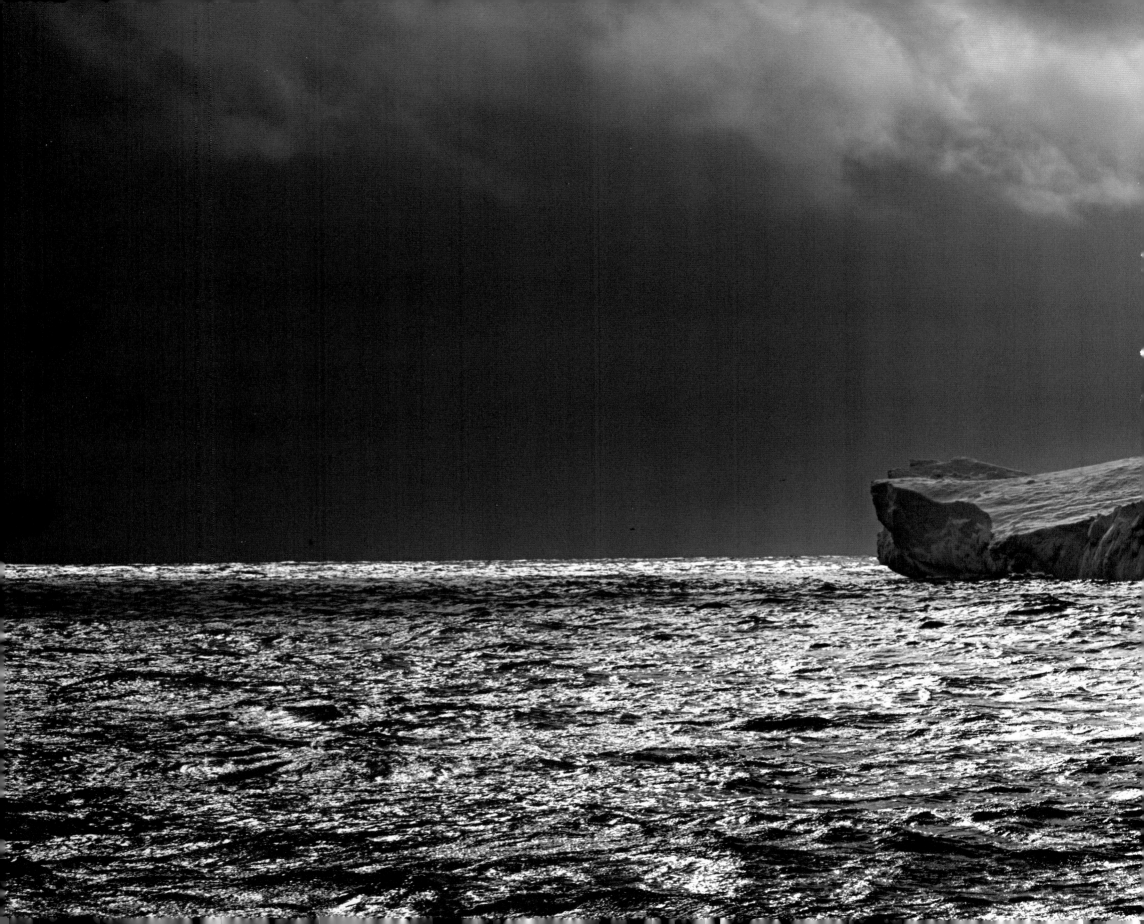

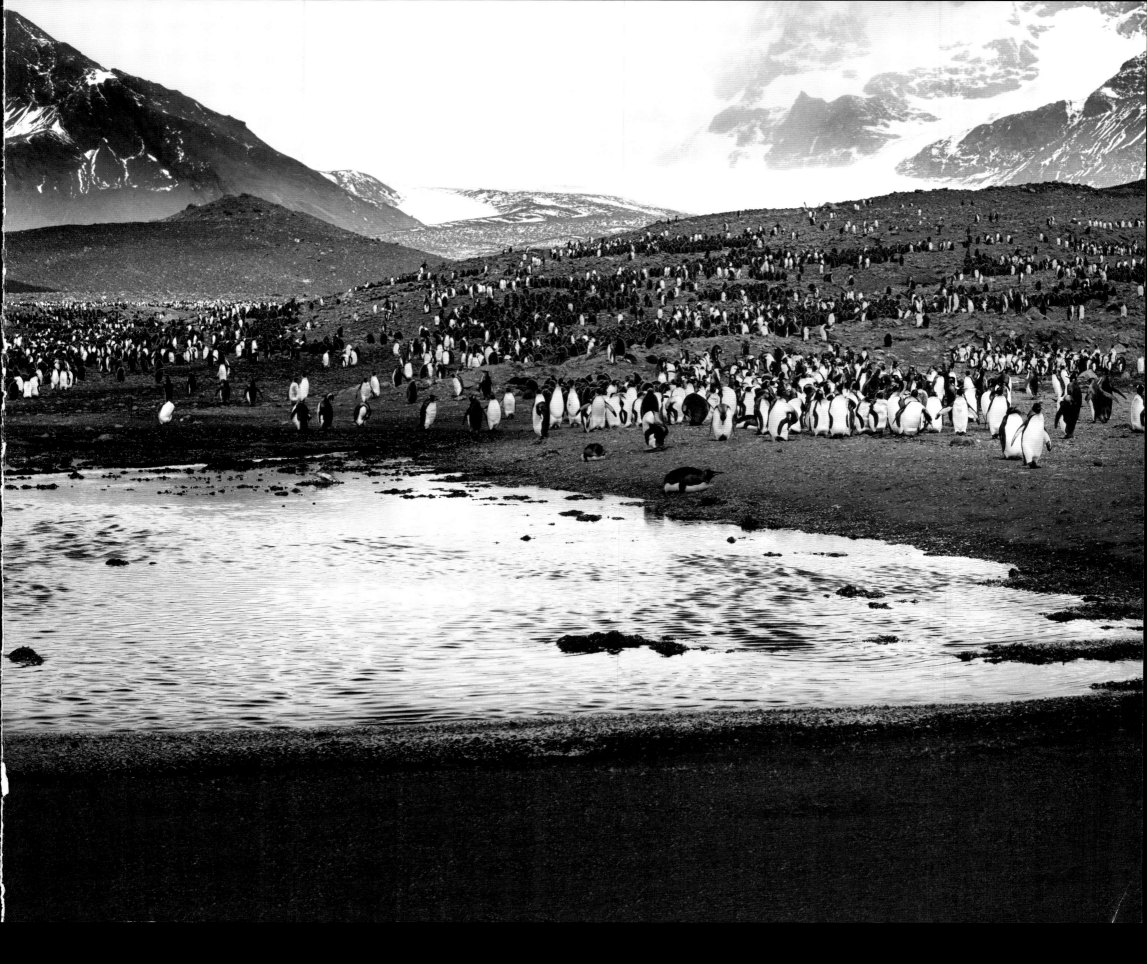

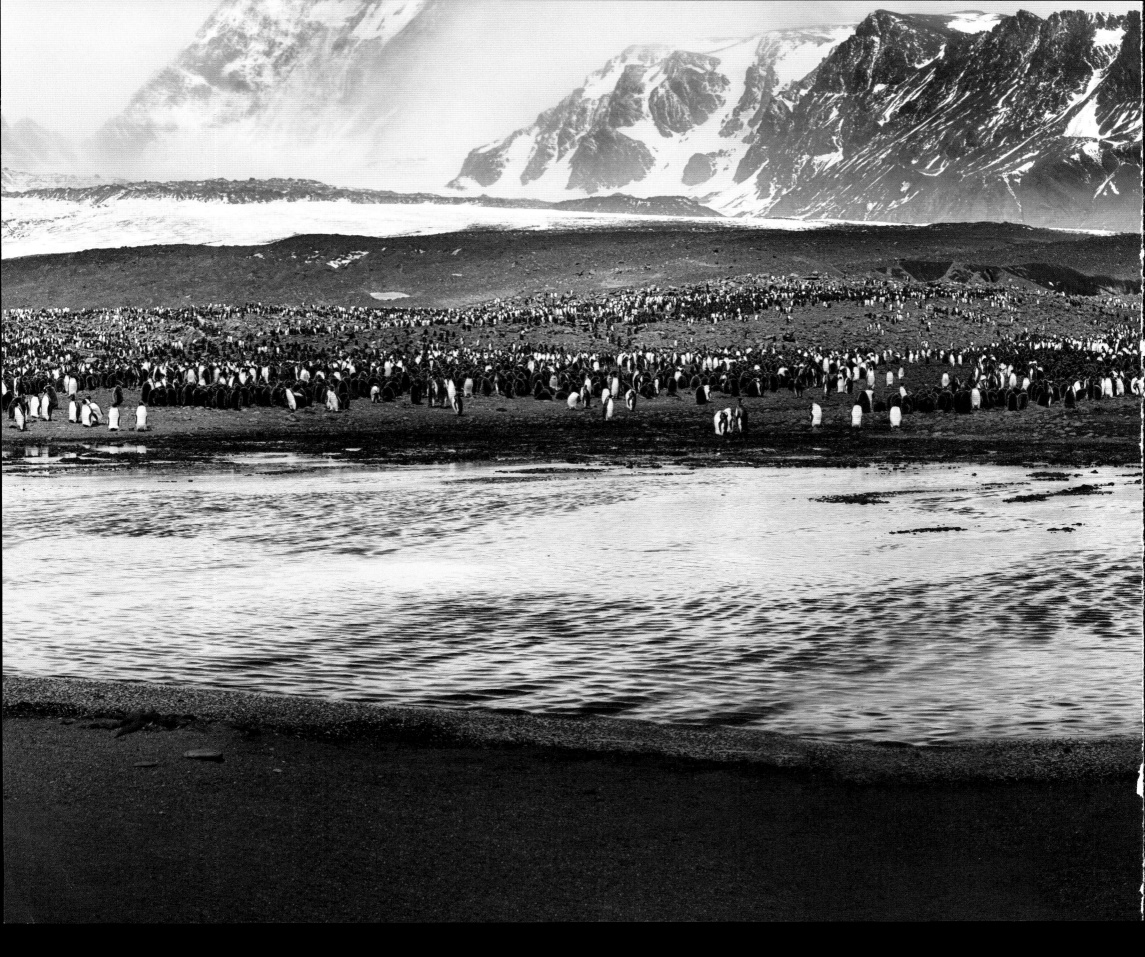

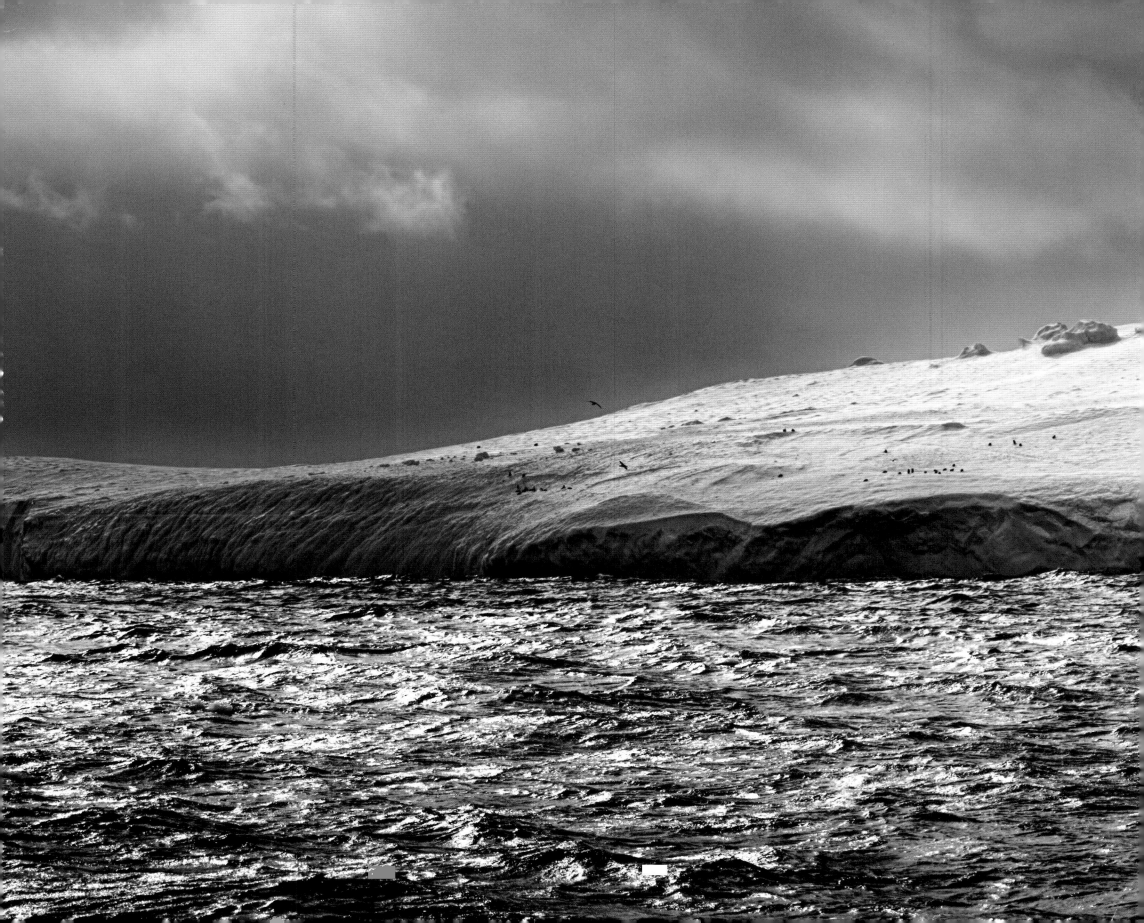

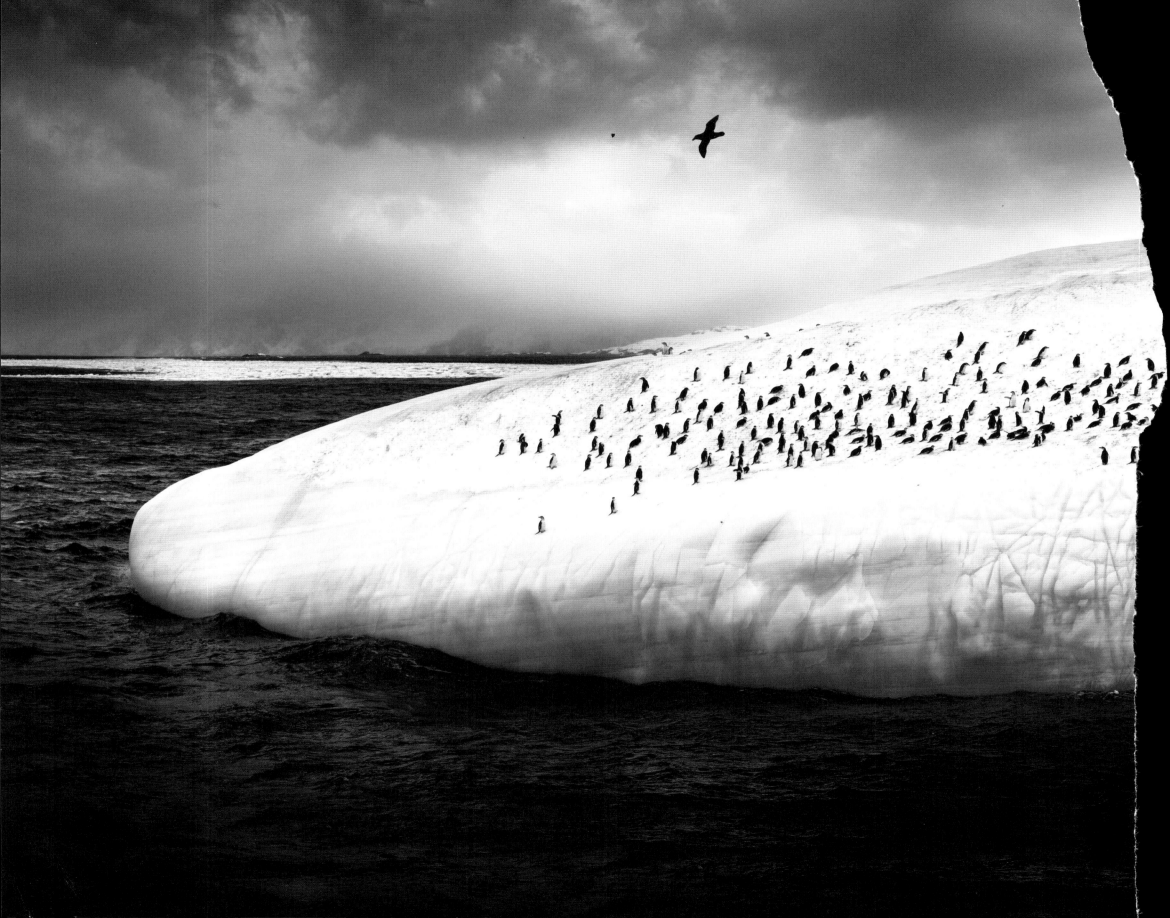

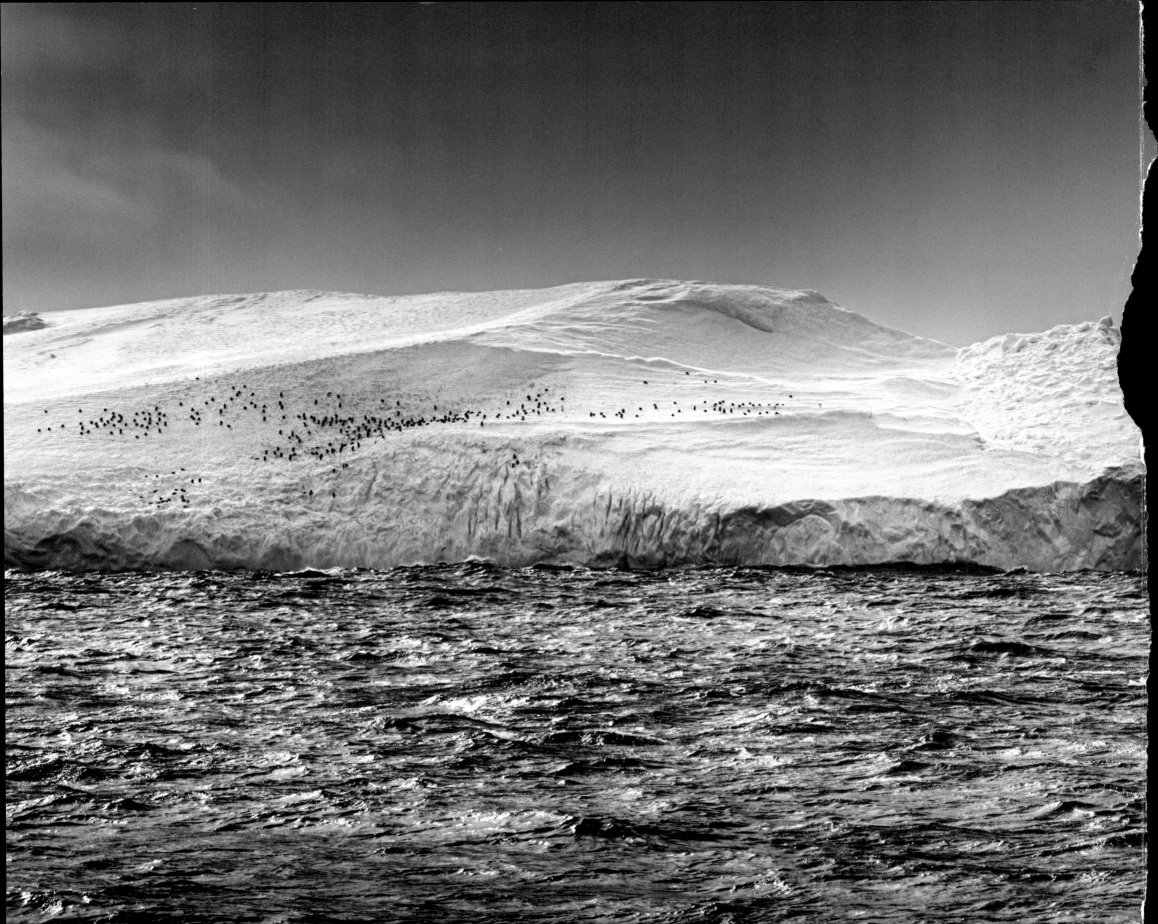

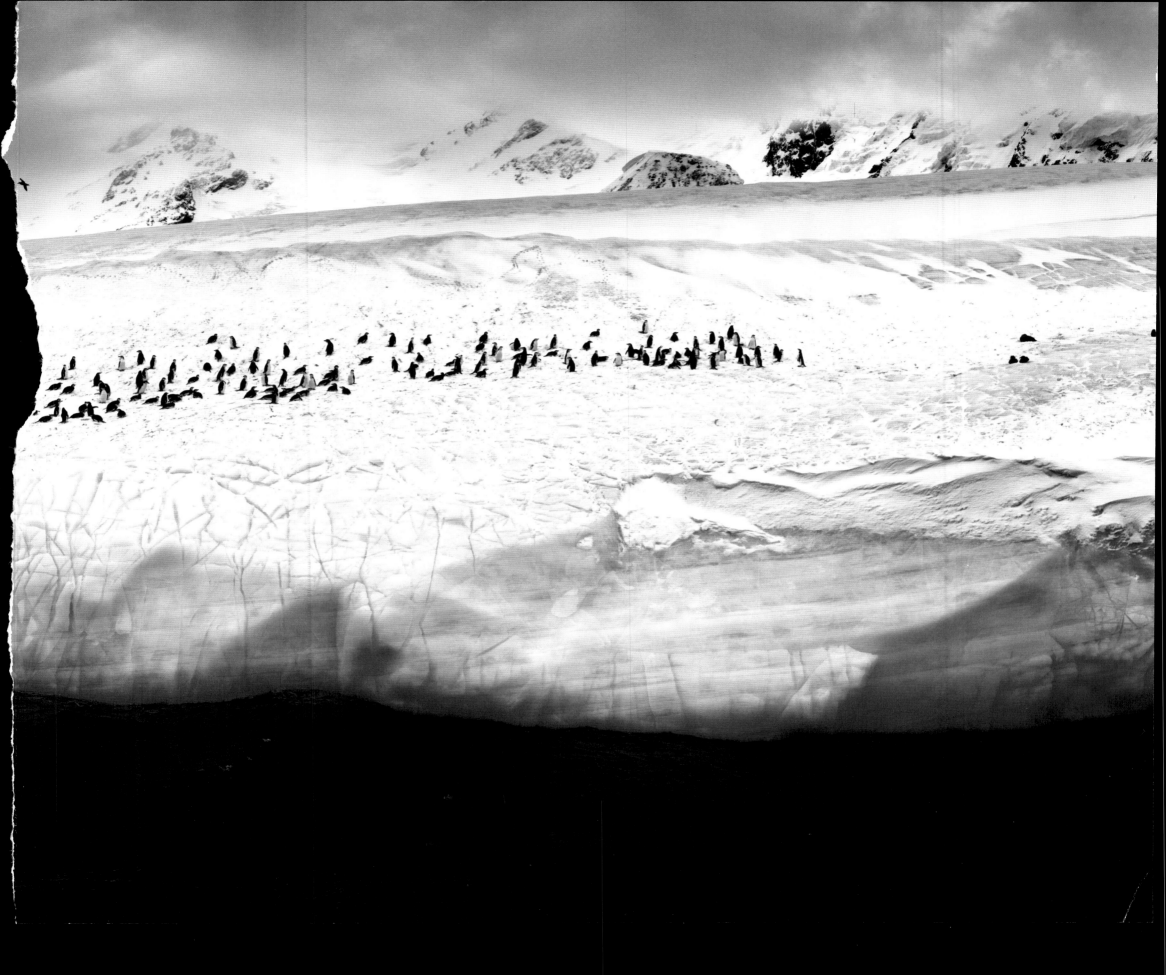

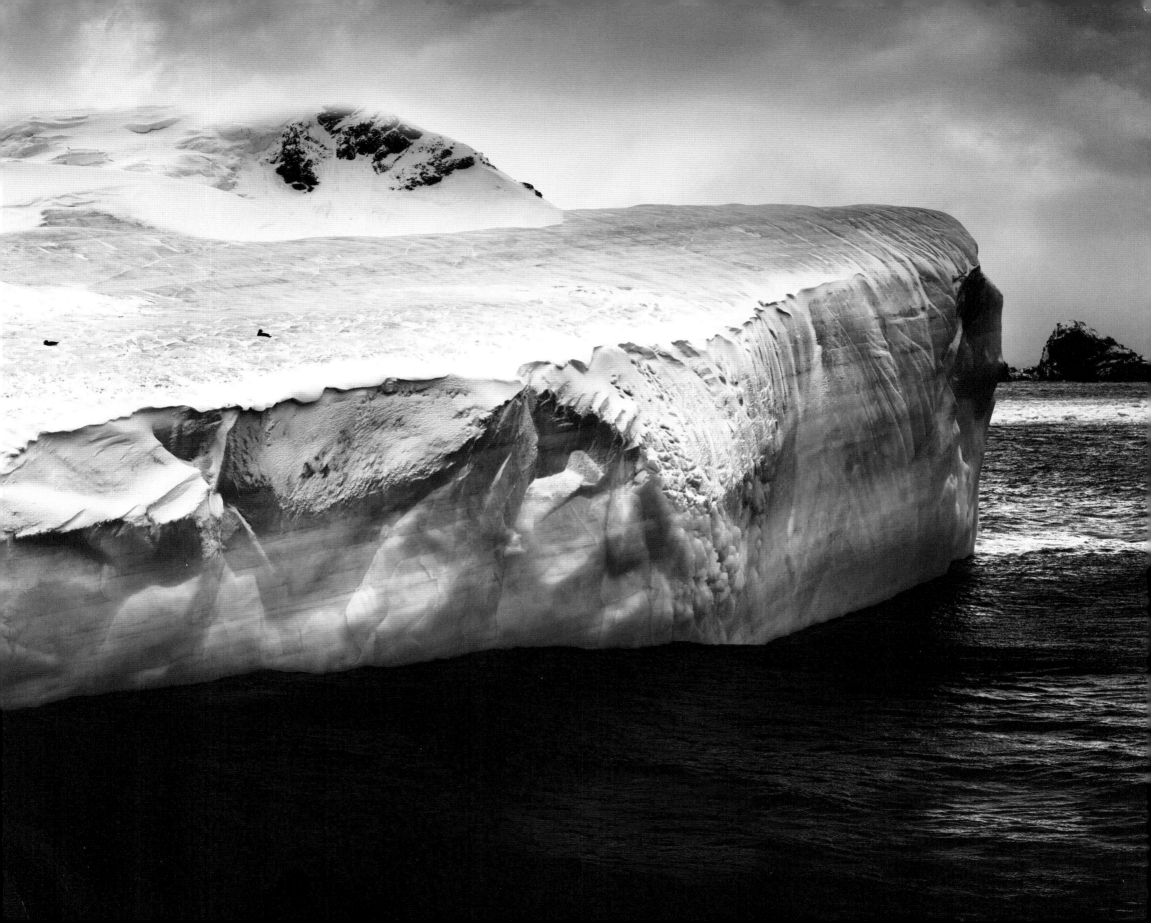

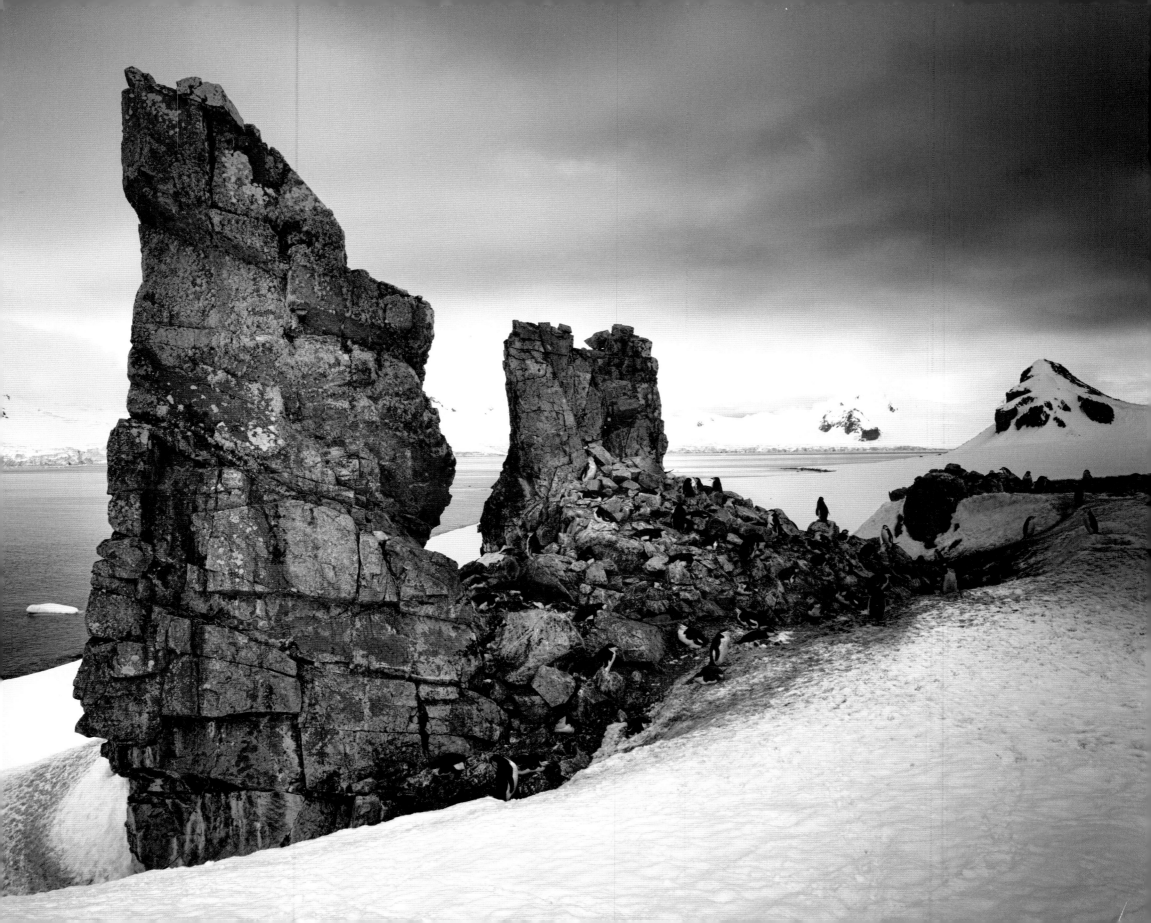

Pages 100–102:
King penguin colony, St. Andrews Bay, South Georgia.

Pages 103–106:
Massive iceberg with penguins, Southern Ocean. Icebergs can occur
throughout the year throughout the ocean. Some have draughts of up
to several hundred metres. Smaller icebergs, iceberg fragments and
sea ice also pose problems for ships. The deep continental shelf has a
floor of glacial deposits that varies widely over short distances.

Pages 107–109:
Iceberg with Chinstrap penguins, Southern Ocean.

Opposite:
A colony of Chinstrap penguins perched on ledges among rocky
spires of Half Moon Island, Antarctica. The exposed rocks are
covered with bright orange lichen. A small colony of Kelp gulls and
some Arctic terns were nesting on one of the outcrops, while skuas
patrolled the skies on the lookout for unguarded penguin eggs.

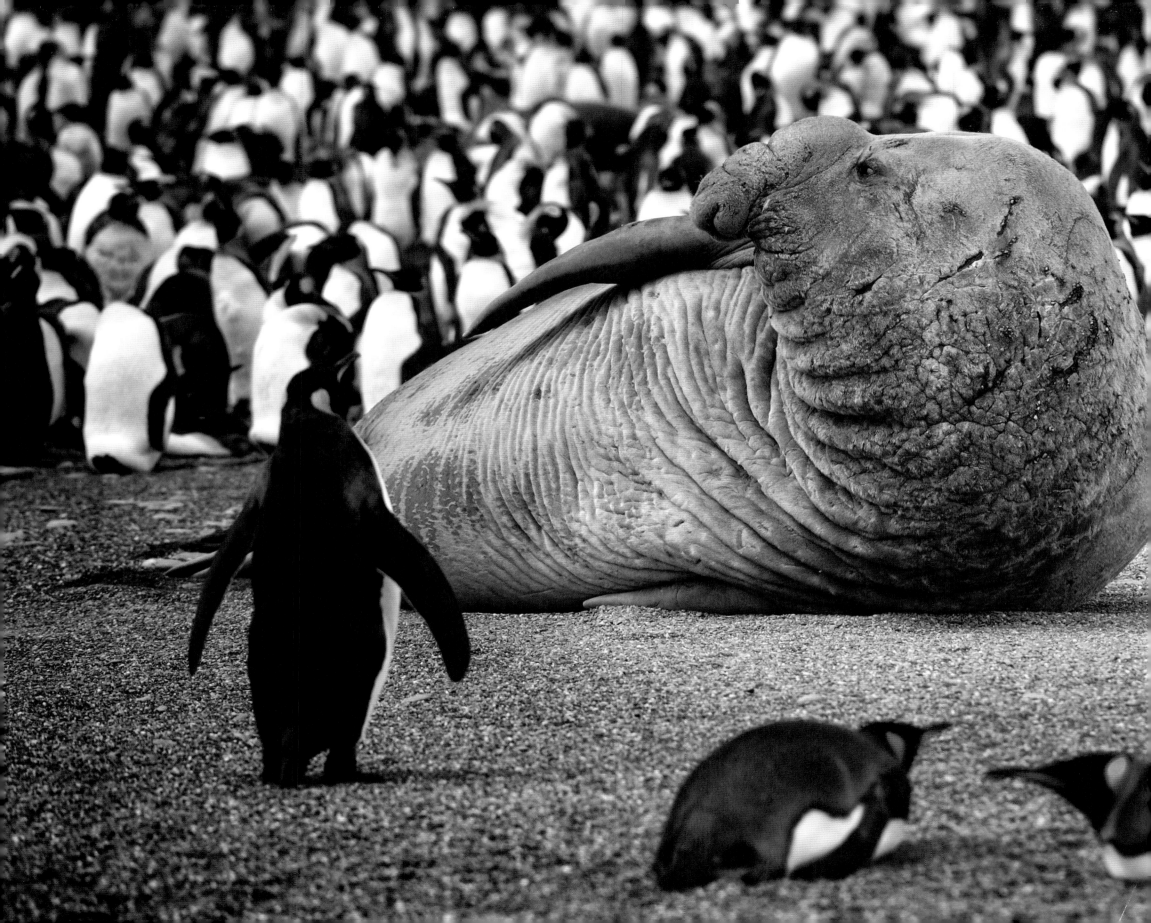

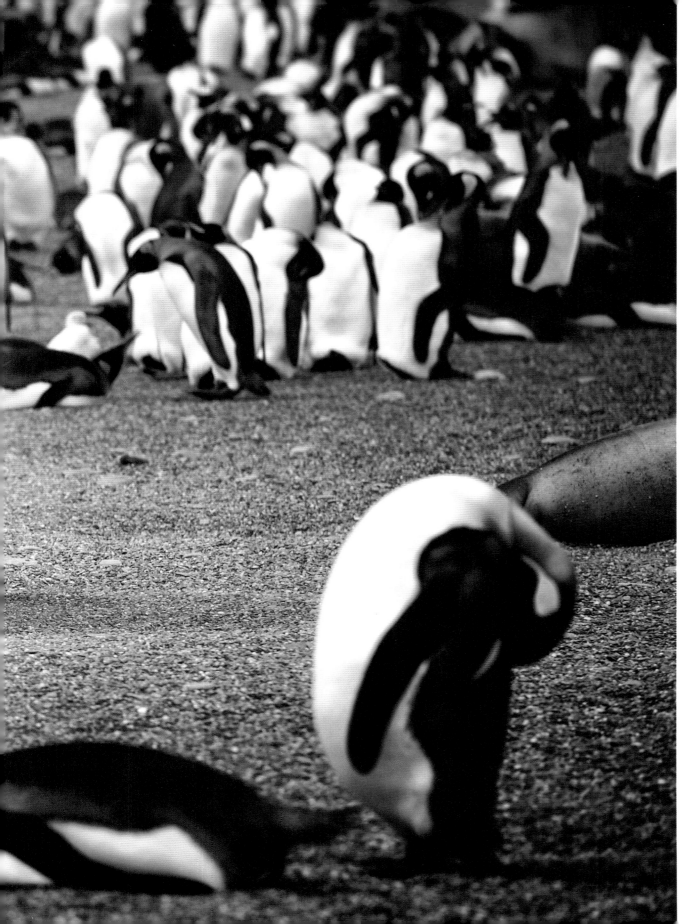

An Elephant seal bull surrounded by King penguins
on the beach at St. Andrews Bay, South Georgia.

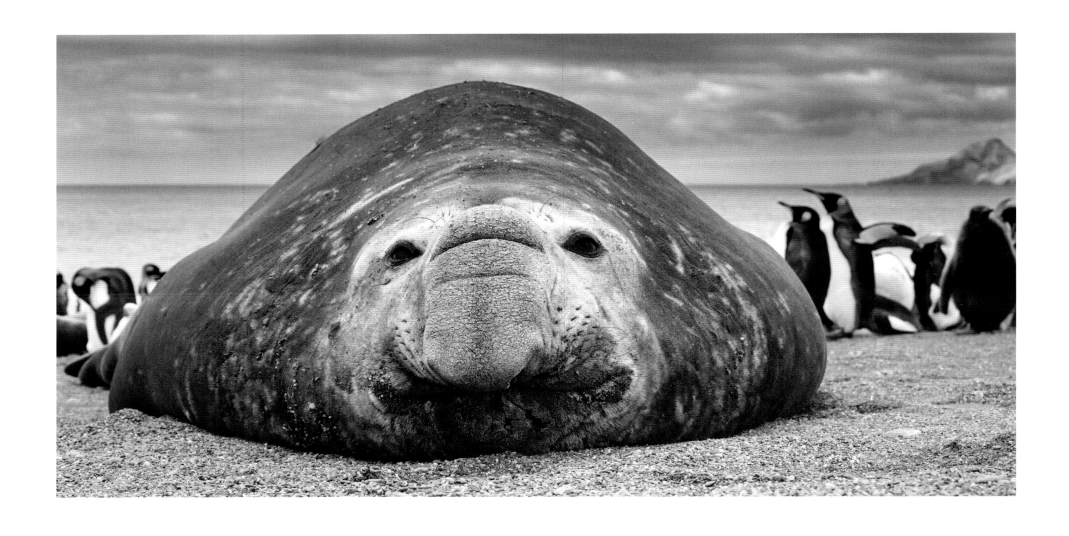

Above and opposite:
Elephant seal bull at St. Andrews Bay, South Georgia.

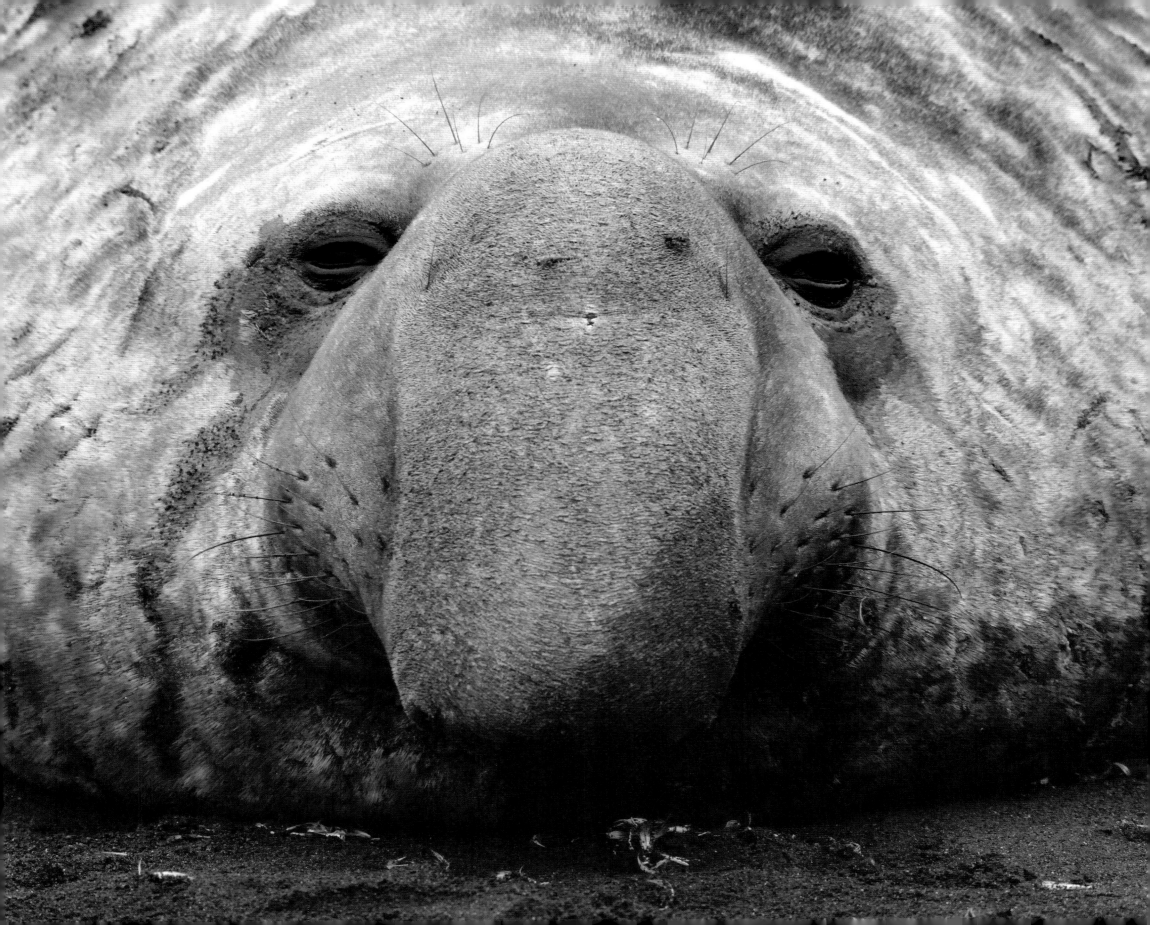

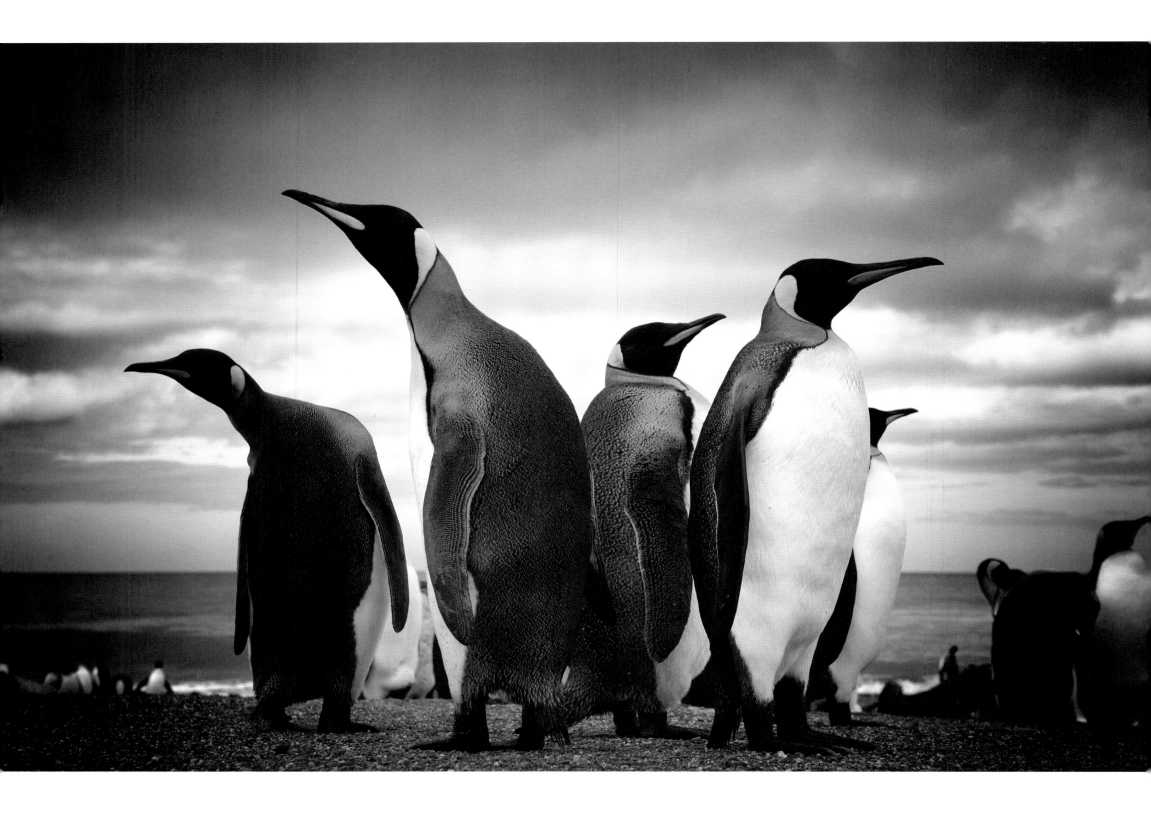

King penguins patrolling every direction, St. Andrews Bay,
South Georgia.

Adélie penguin in close-up, Paulet Island, Antarctica.

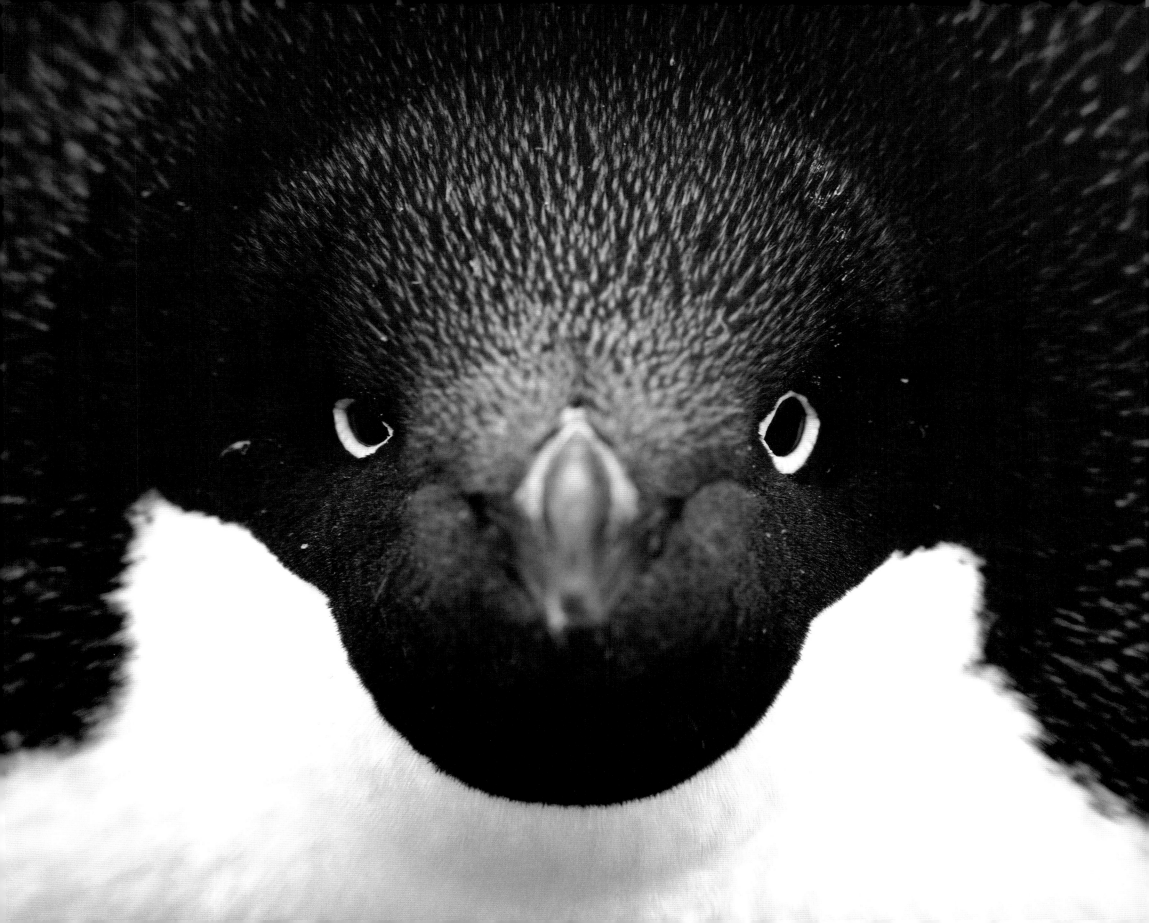

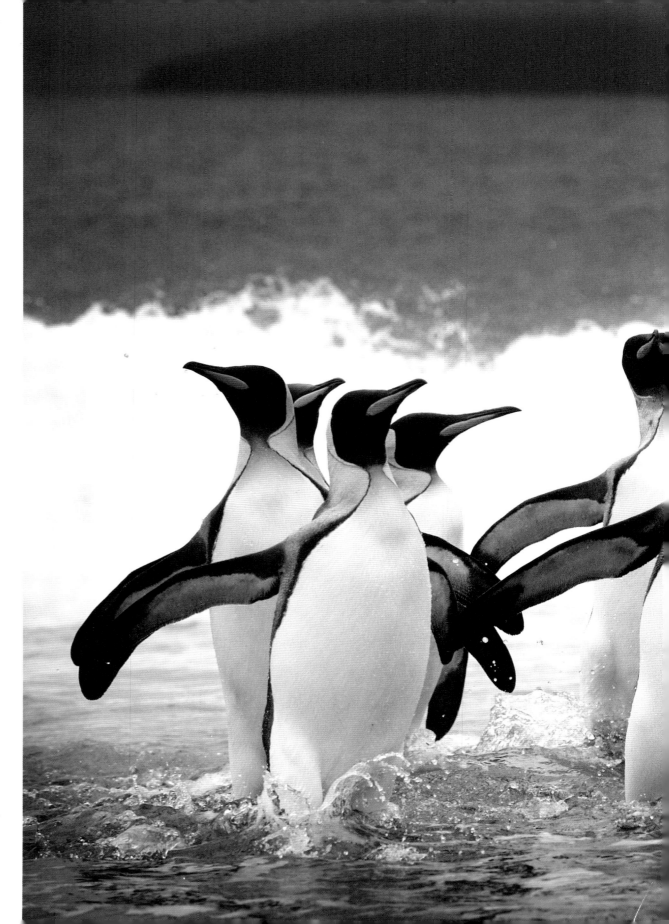

King penguins landing on the beach, Salisbury Plain, South Georgia.

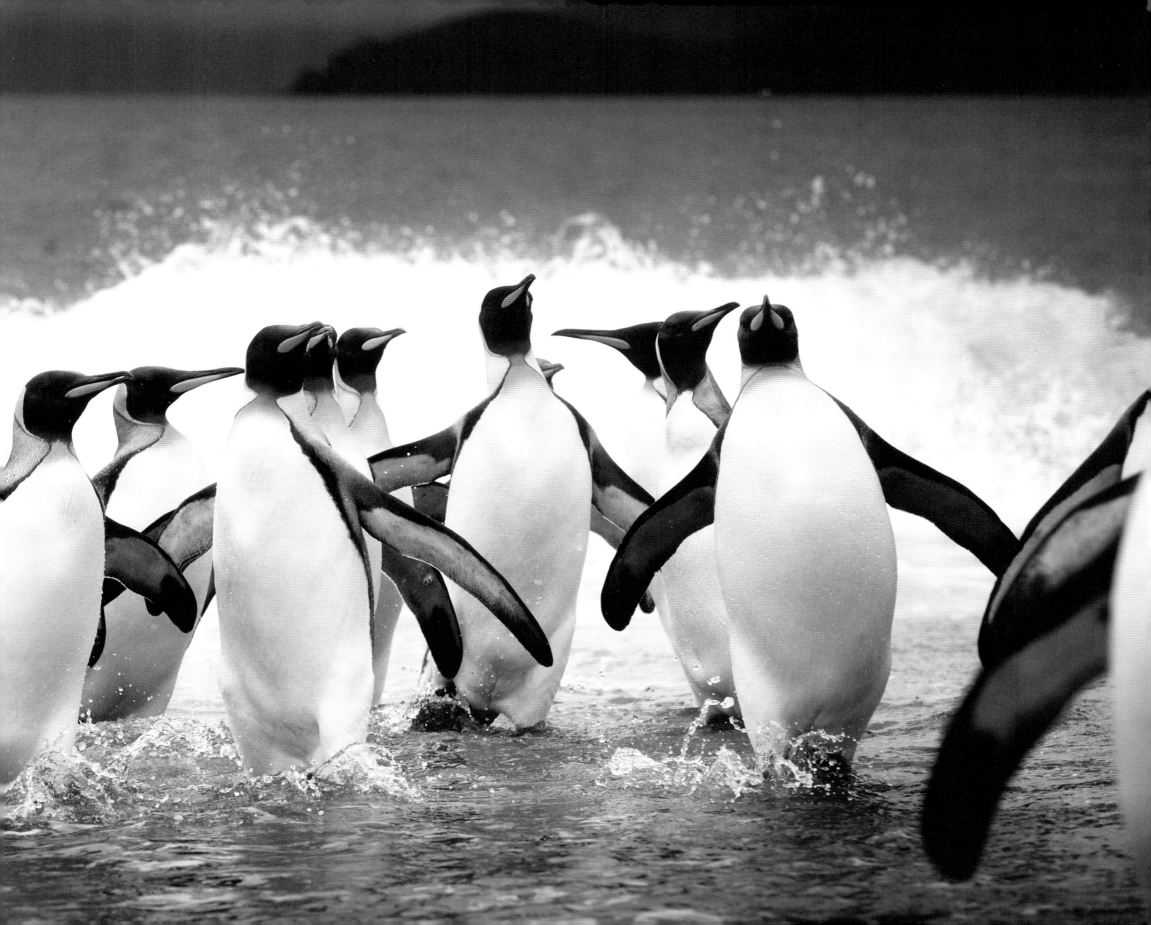

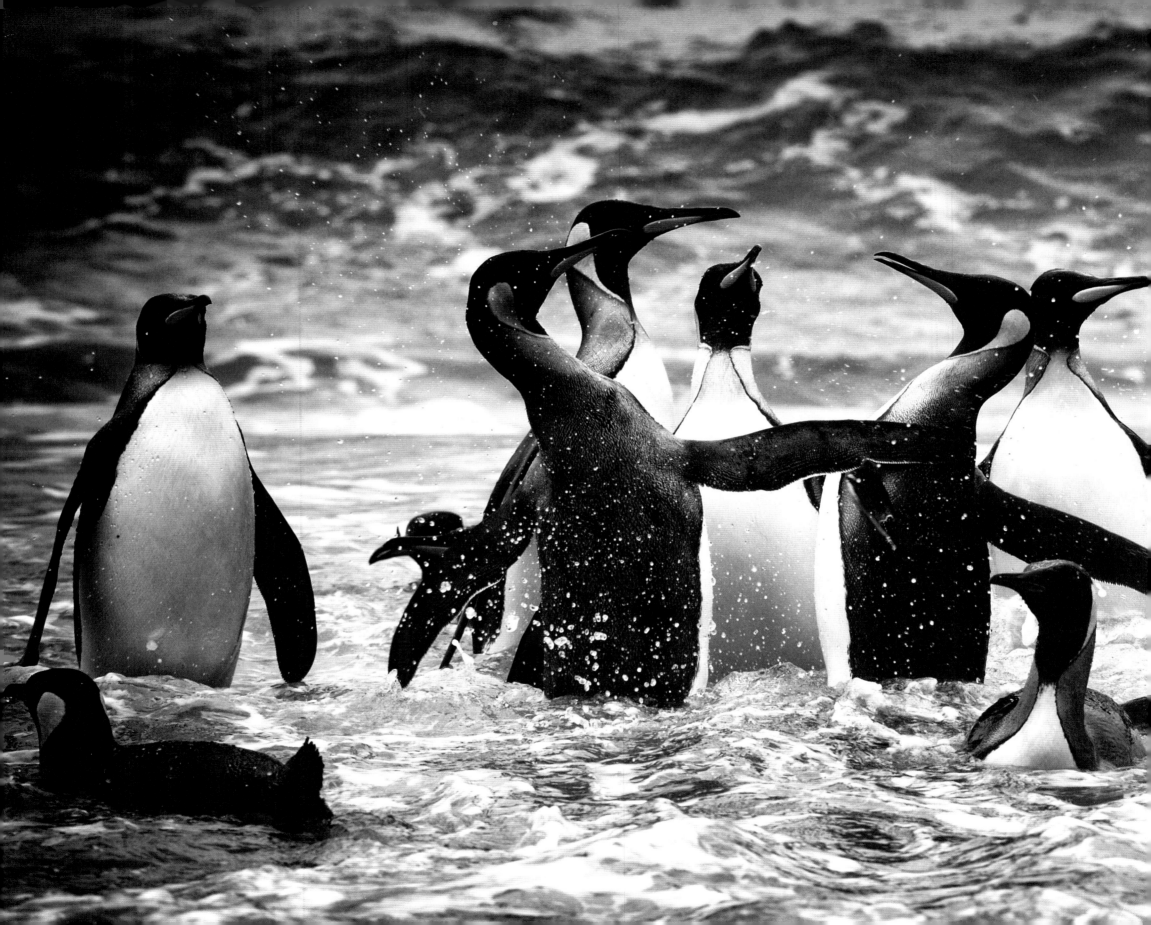

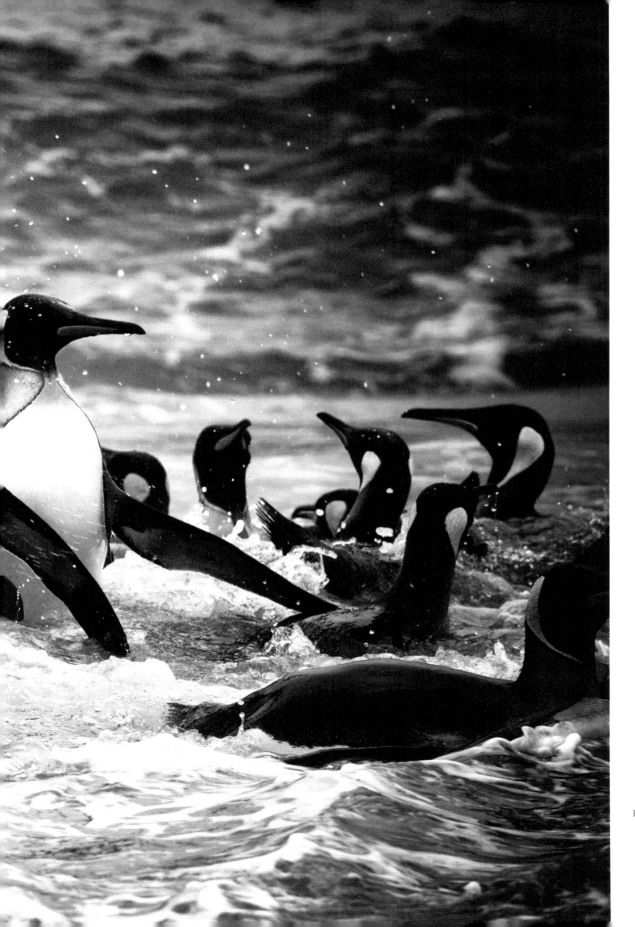

King penguins landing on the beach, Salisbury Plain, South Georgia.

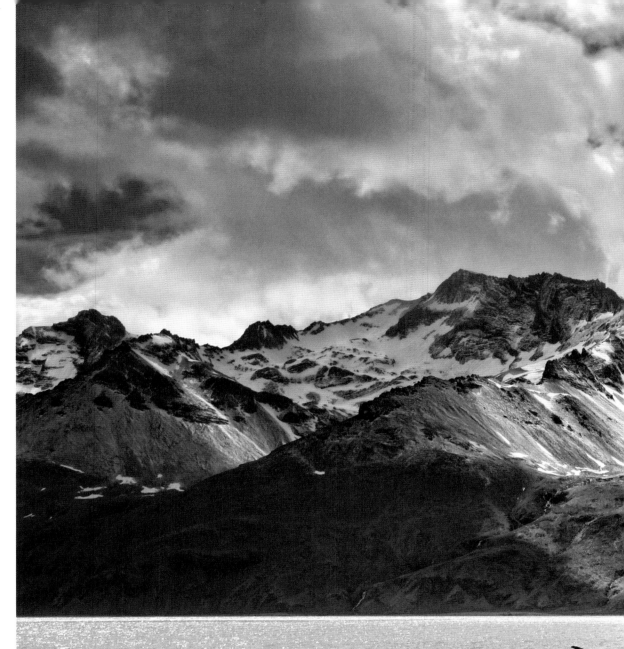

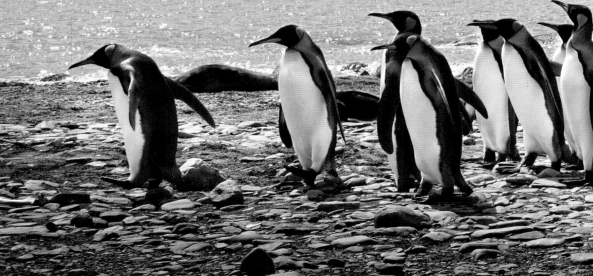

March of the King penguins,
Fortuna Bay, South Georgia.

Overleaf:
Colony of King penguins,
St. Andrews Bay, South Georgia.

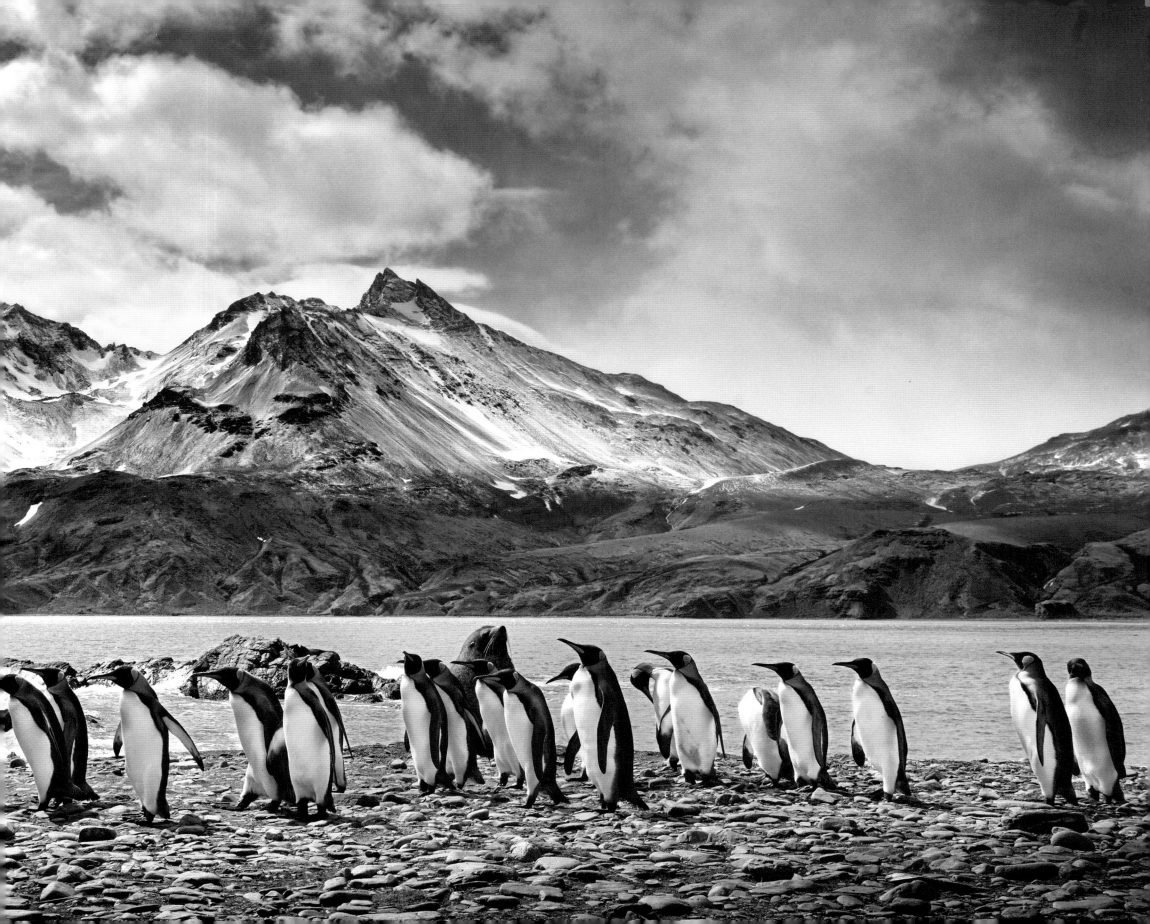

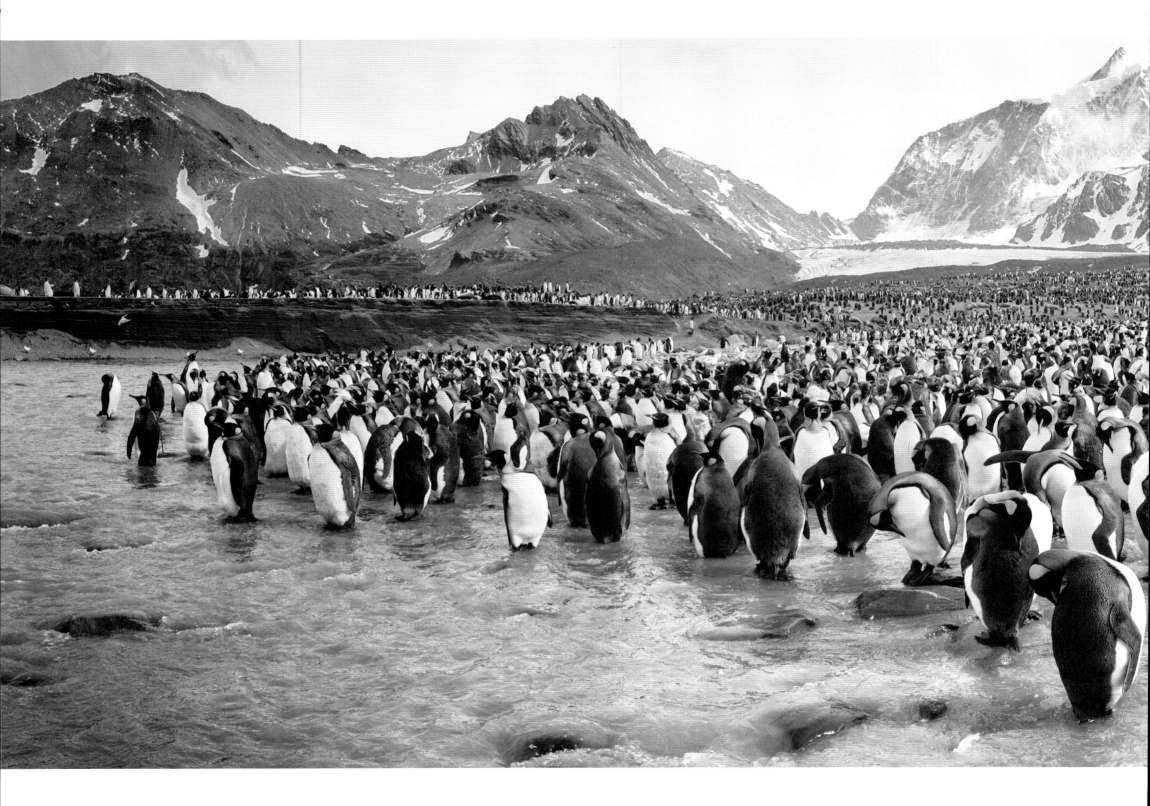

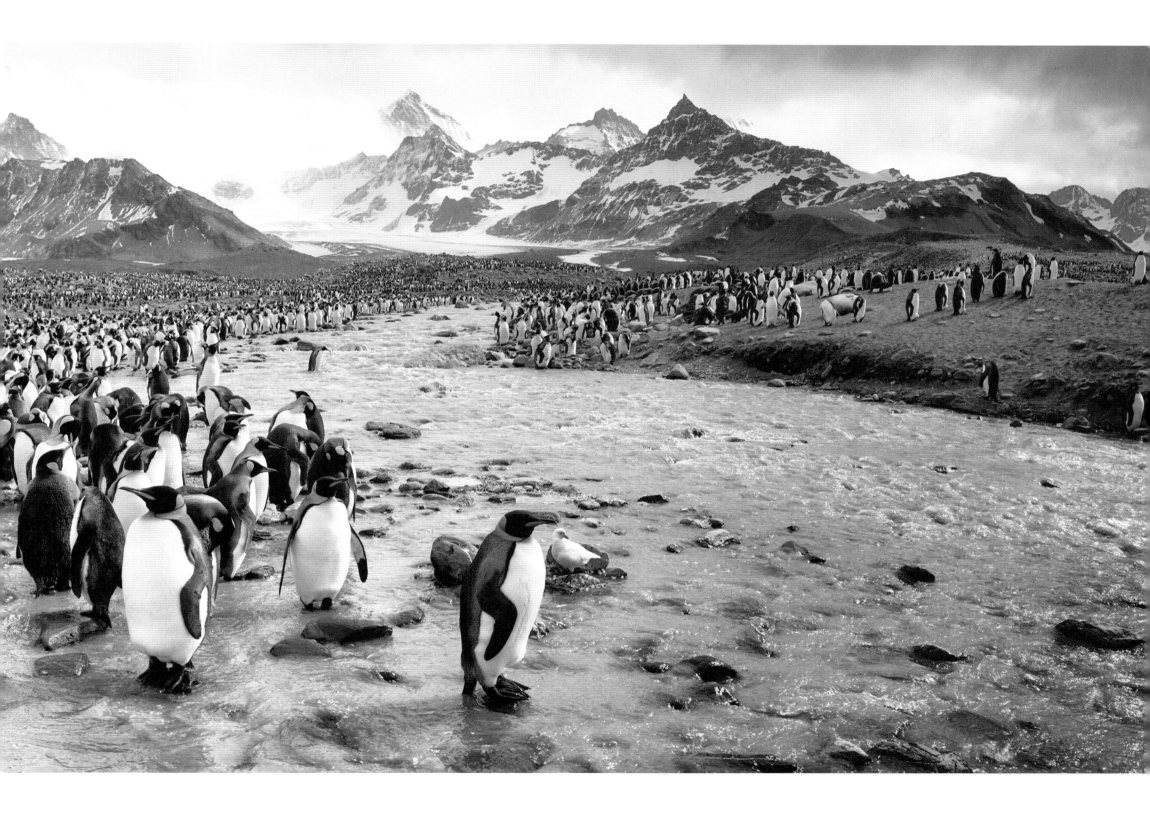

King penguins, Salisbury Plain, South Georgia.

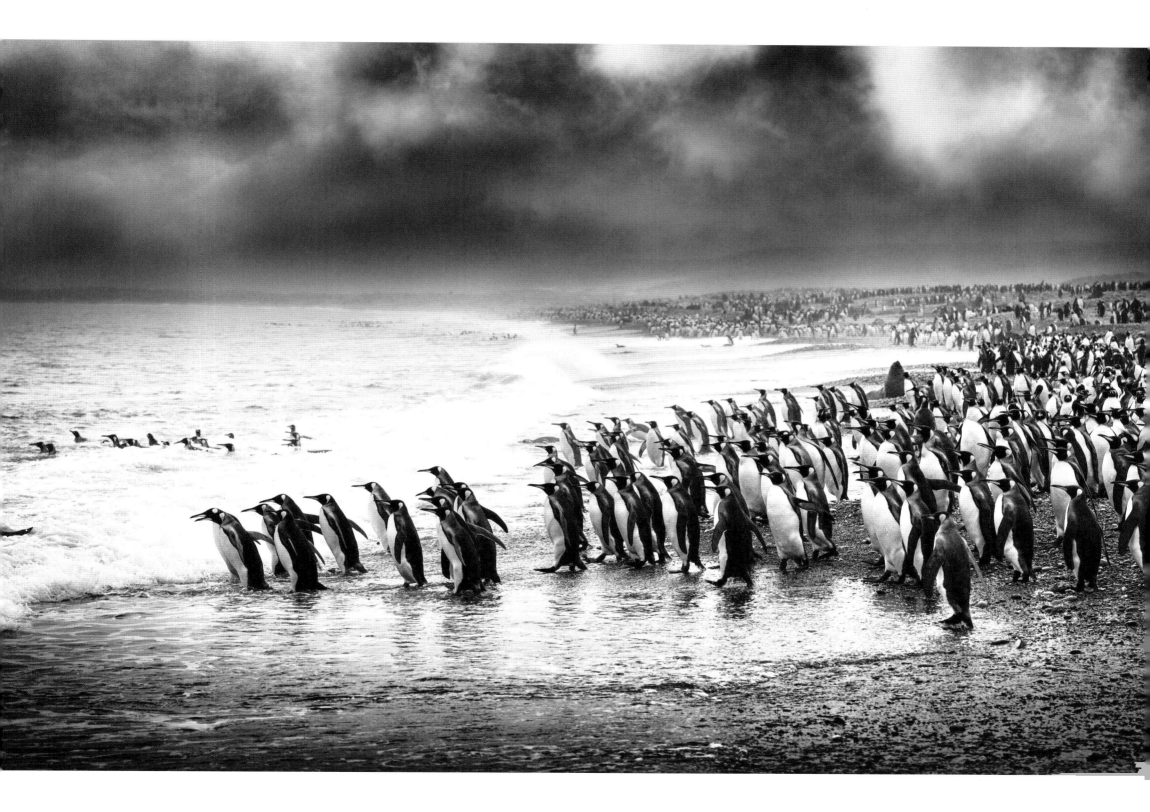

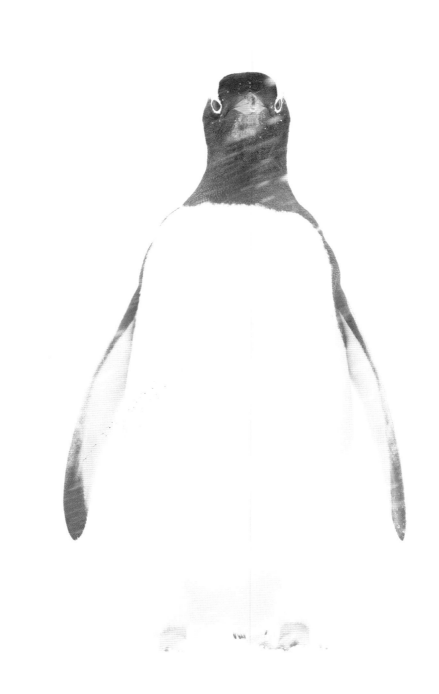

Gentoo penguin in a storm, Hydrurga Rocks, Antarctica.

King penguins facing up to each other, South Georgia.

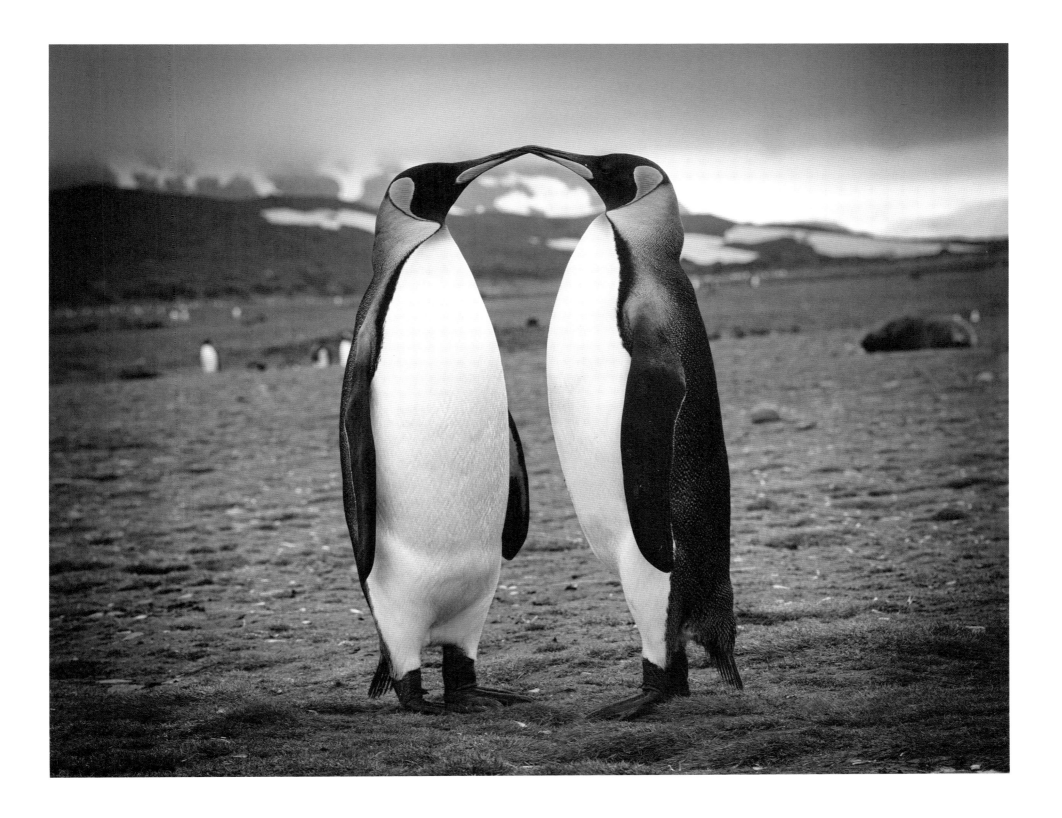

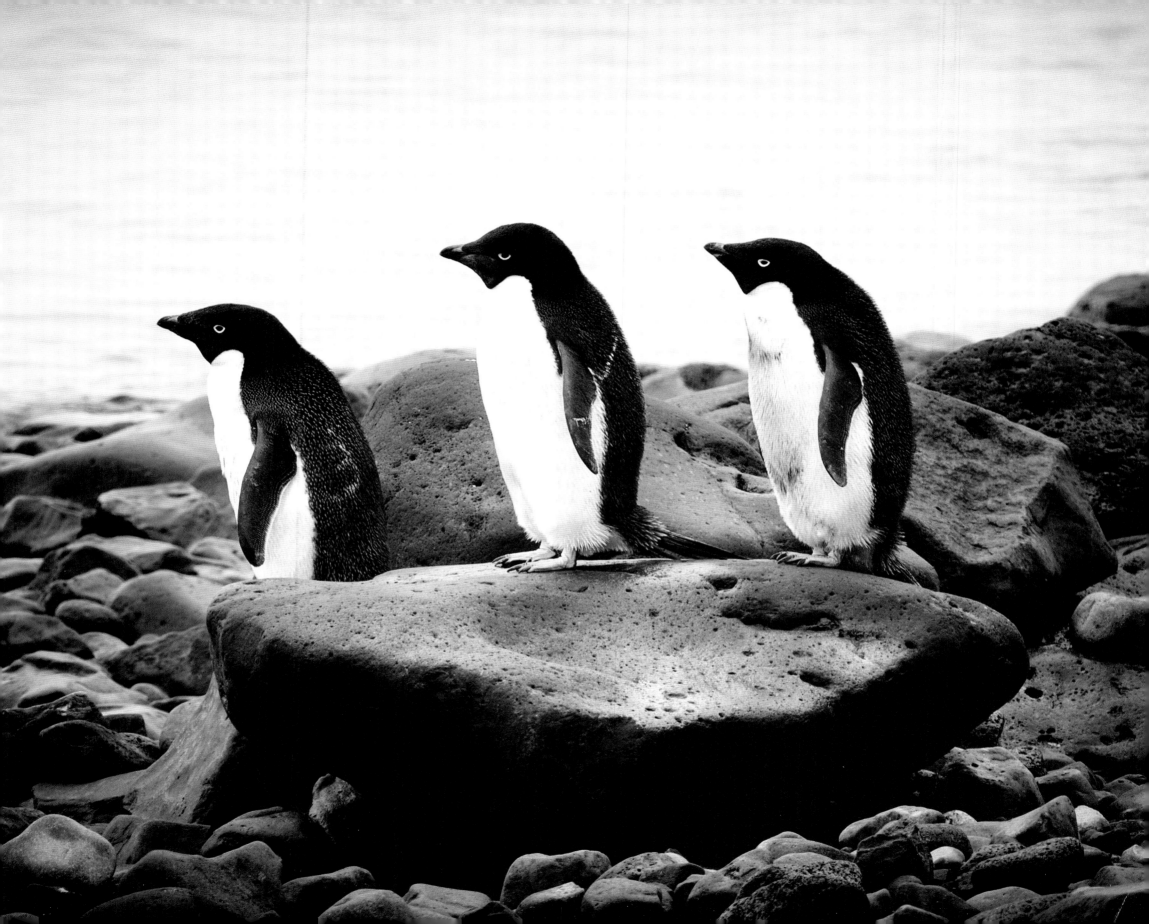

Adélie penguins on Brown Bluff.

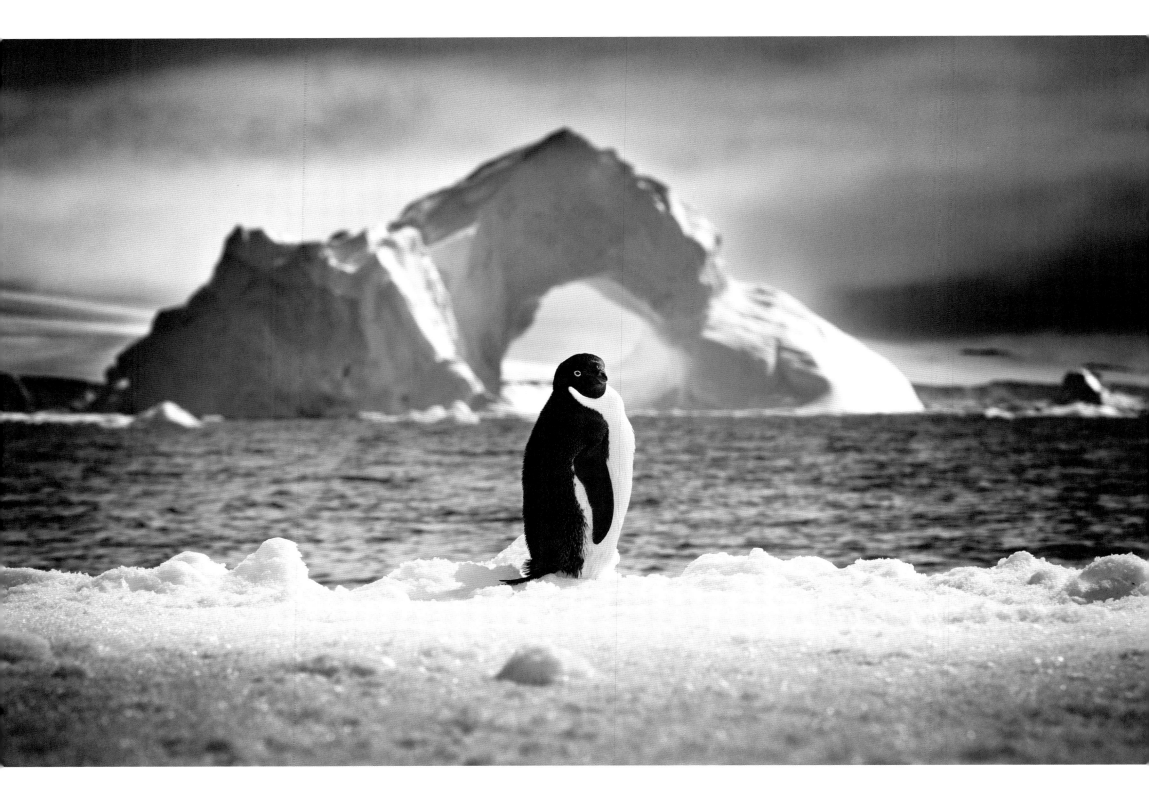

Adélie penguin on an ice floe with a beautiful arch iceberg in
the background.

Fortuna Bay, South Georgia.

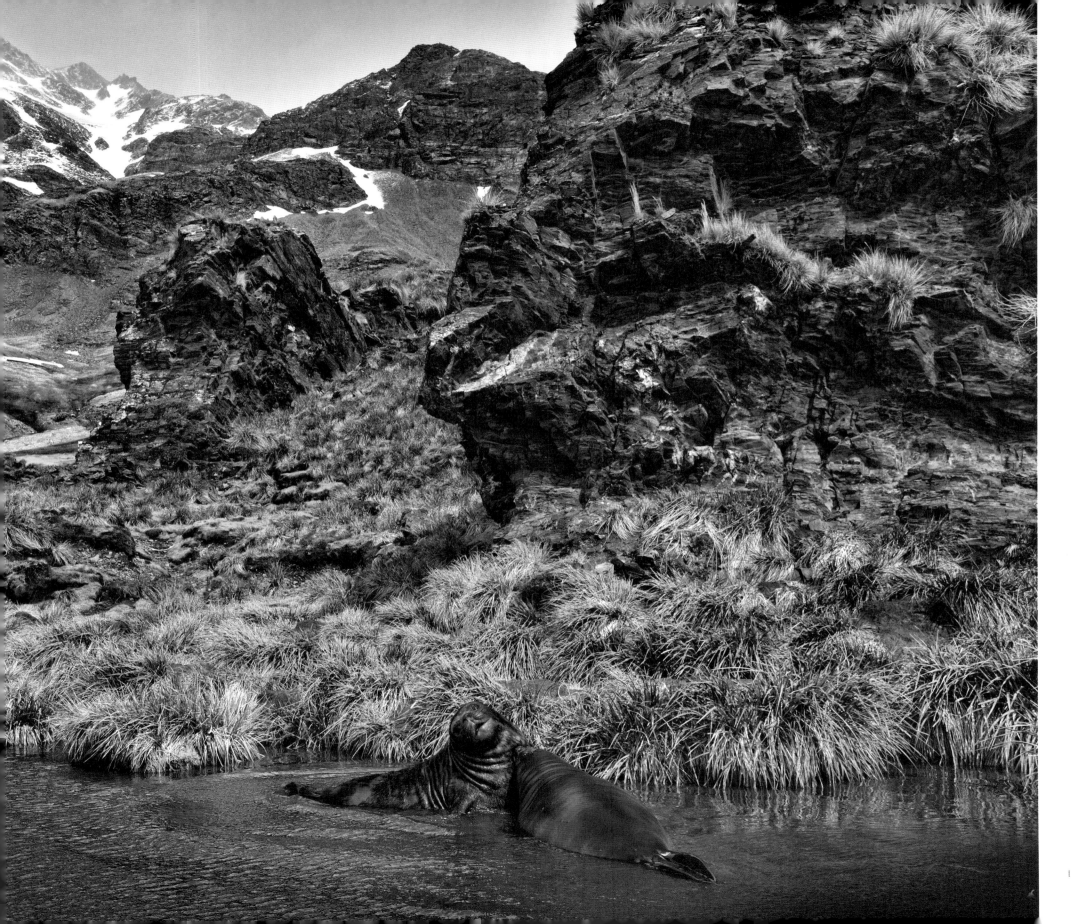

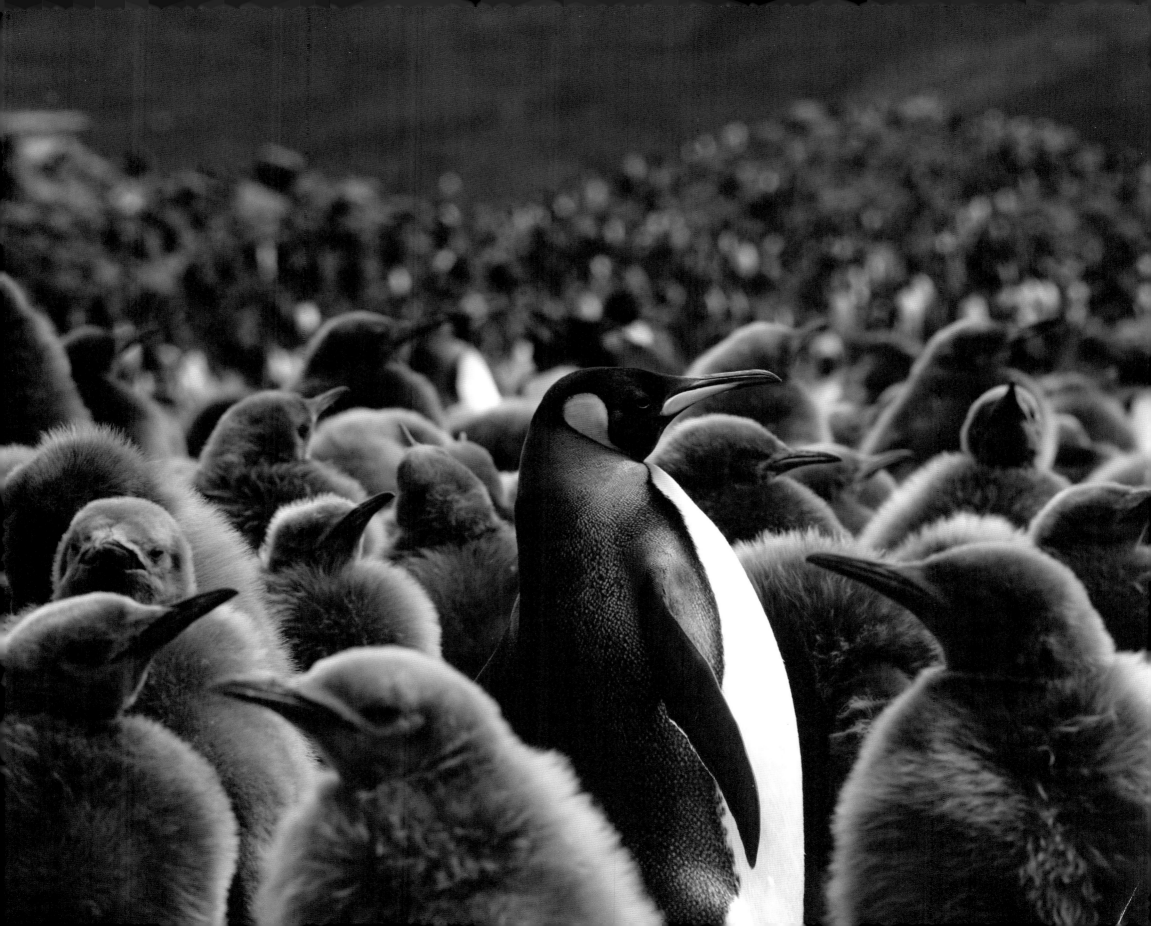

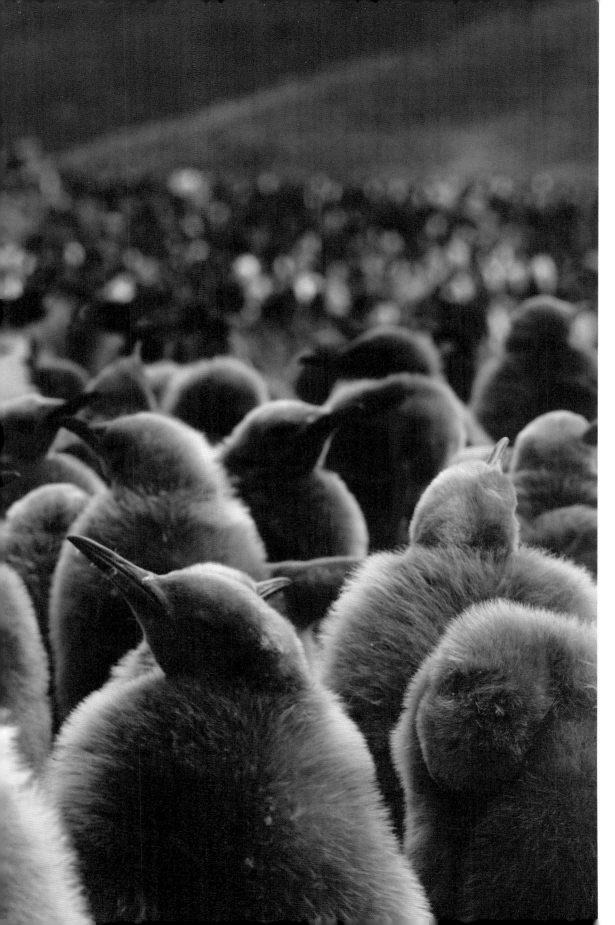

Adult King penguin among juveniles, St. Andrews Bay,
South Georgia.

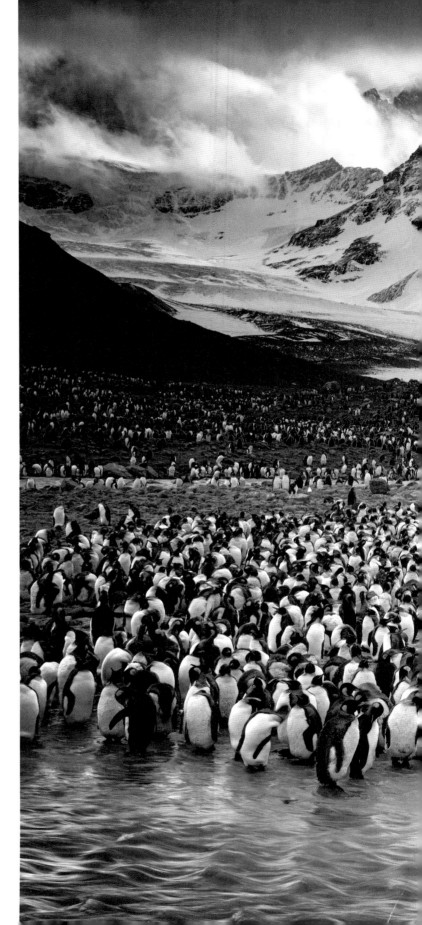

King penguin colony, St. Andrews Bay, South Georgia.

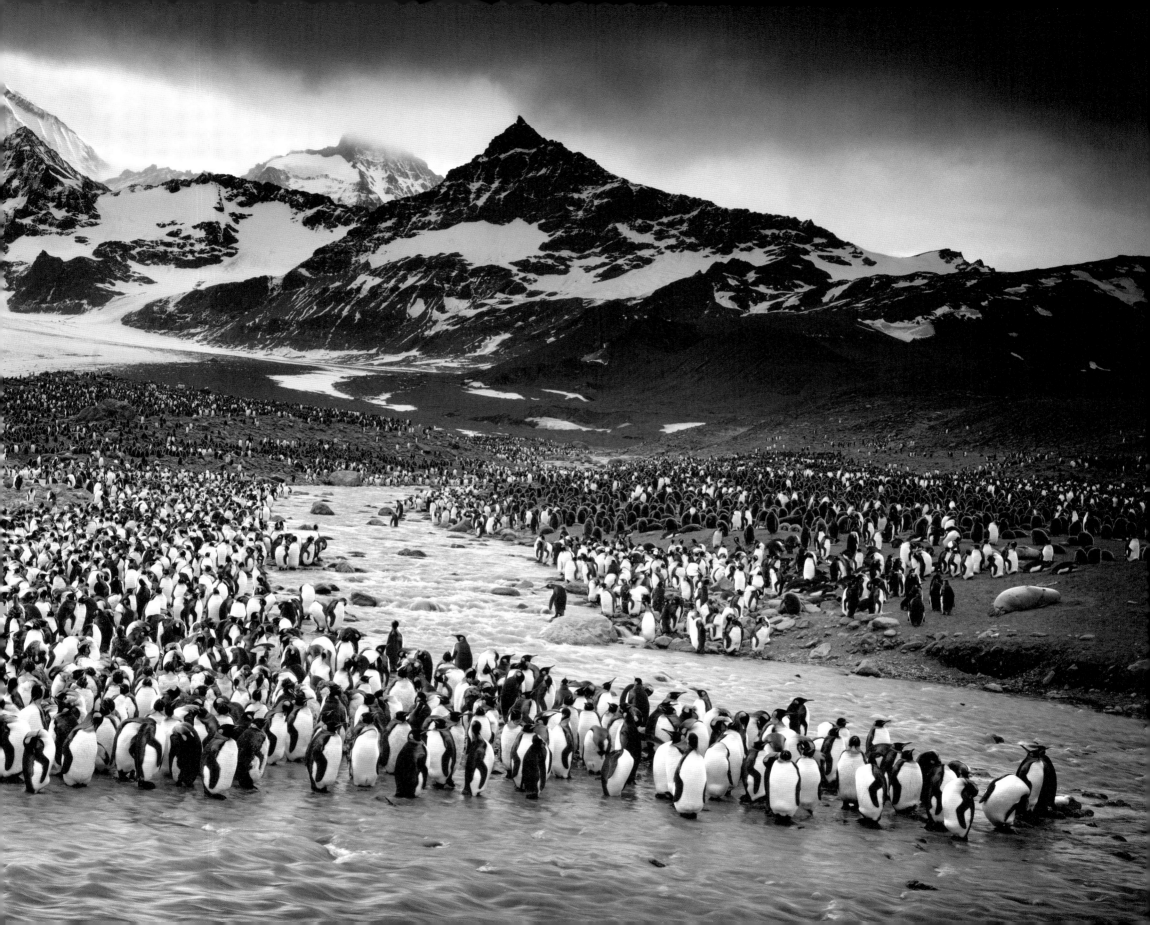

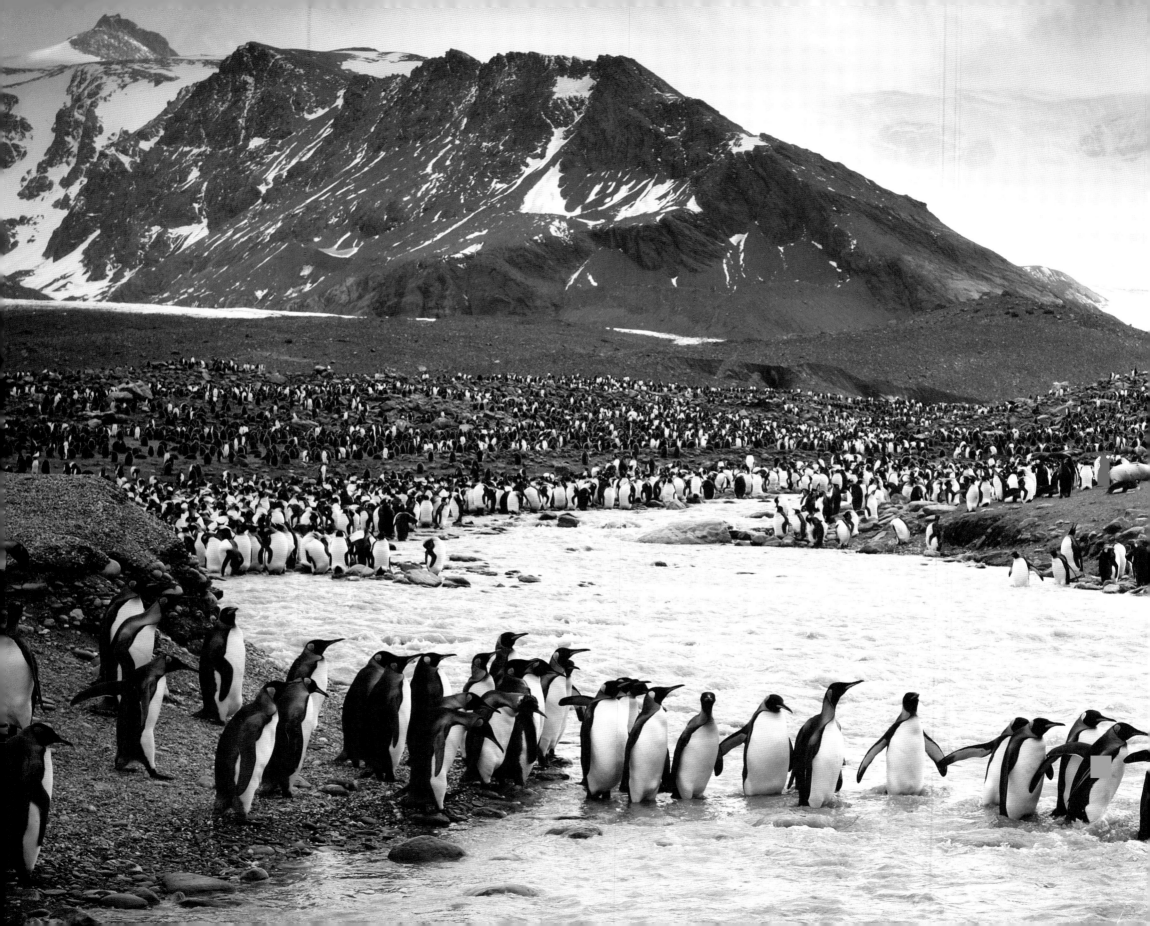

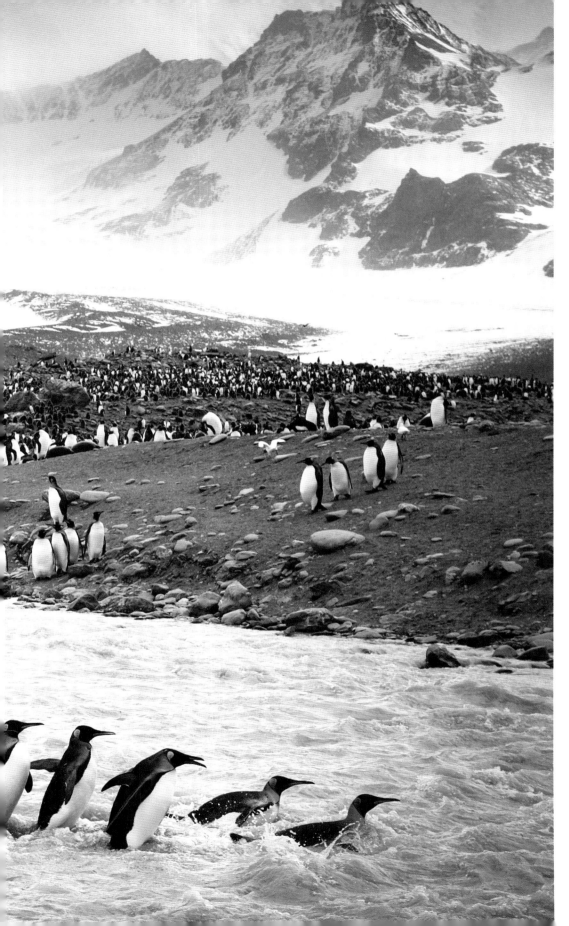

King penguin colony, St. Andrews Bay, South Georgia.

Opposite and overleaf:
King penguin colony, St. Andrews Bay, South Georgia.

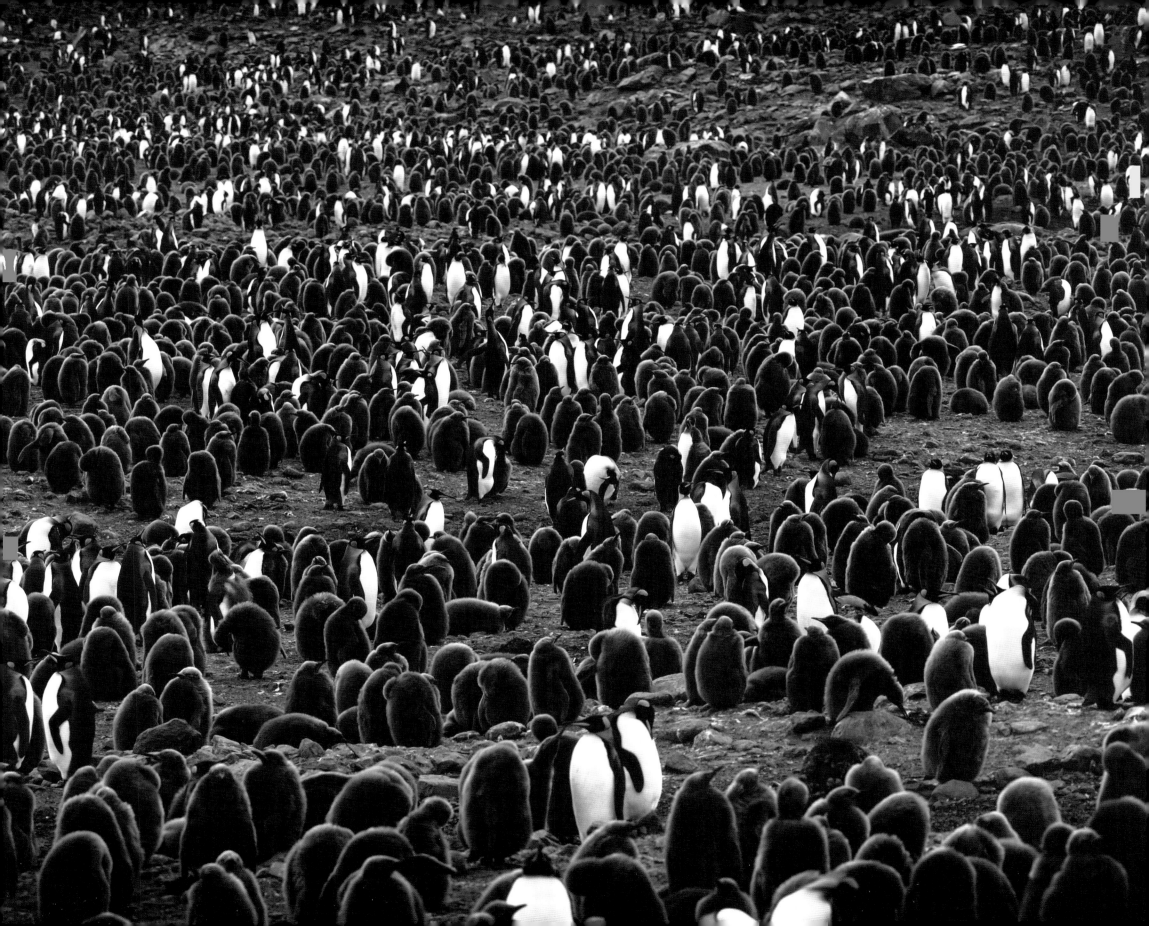

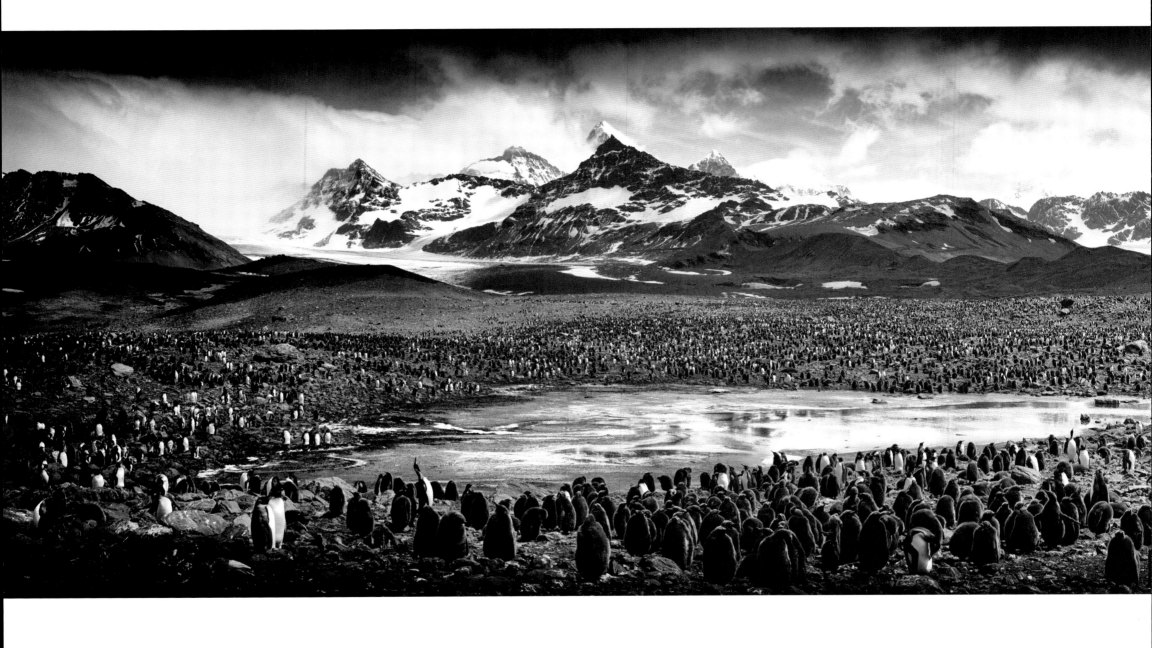

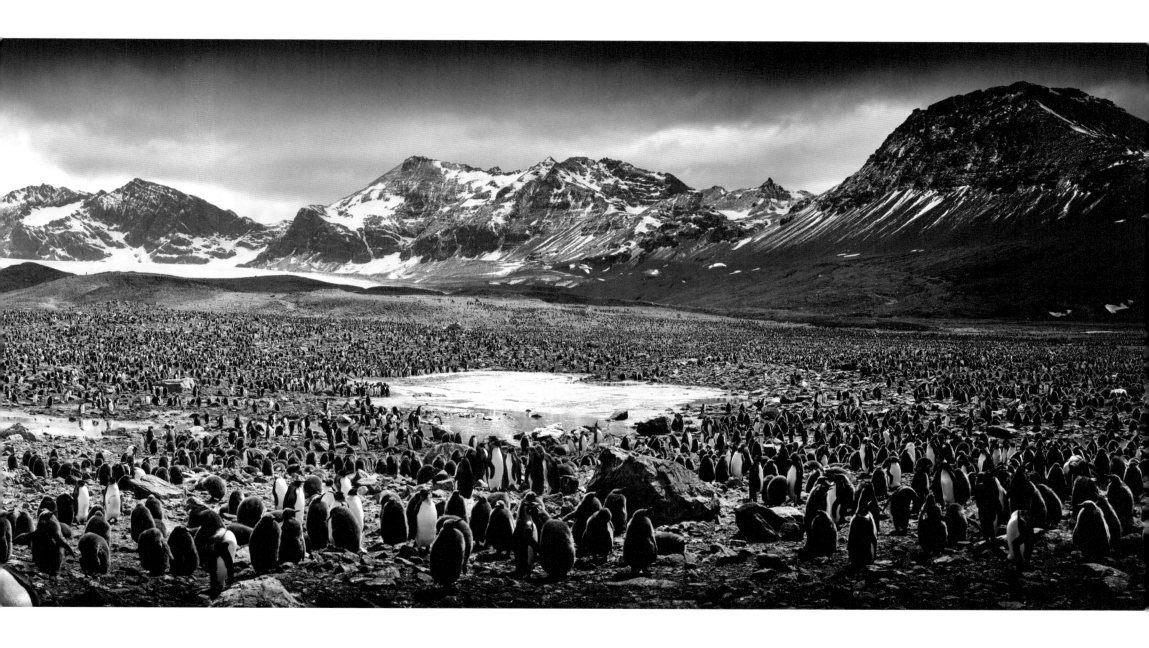

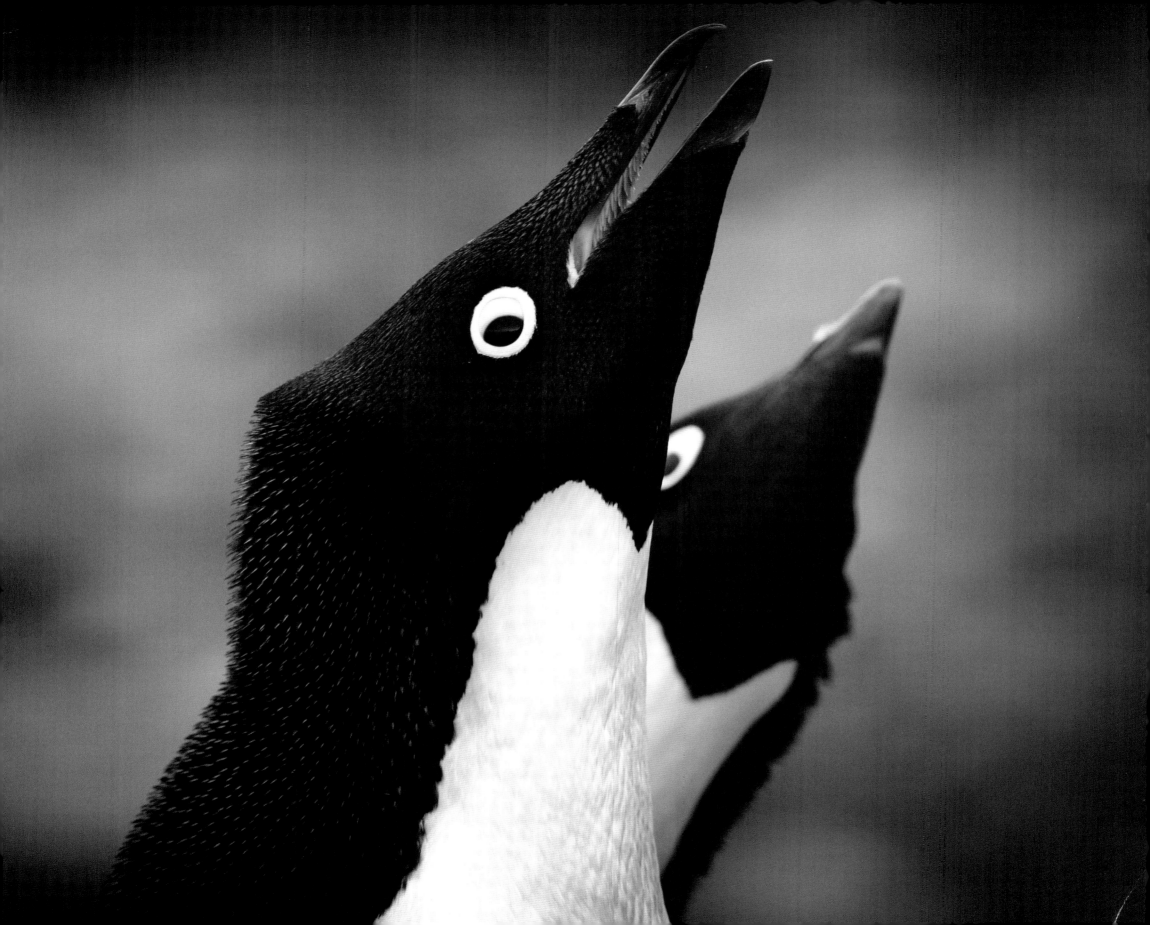

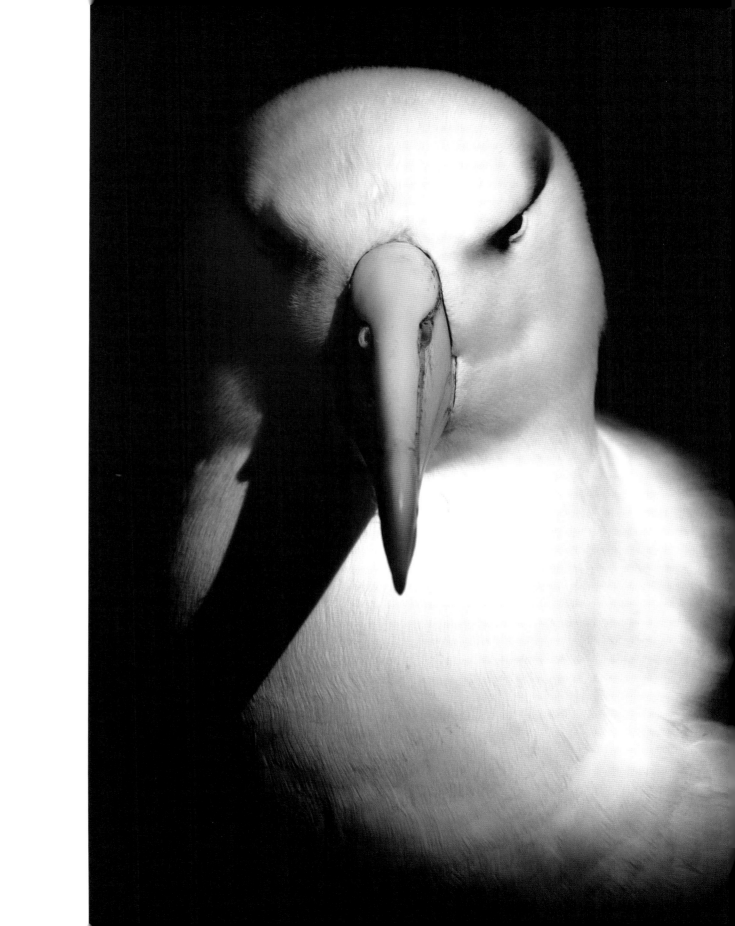

Portrait of a fur seal, King Edward Point, South Georgia.

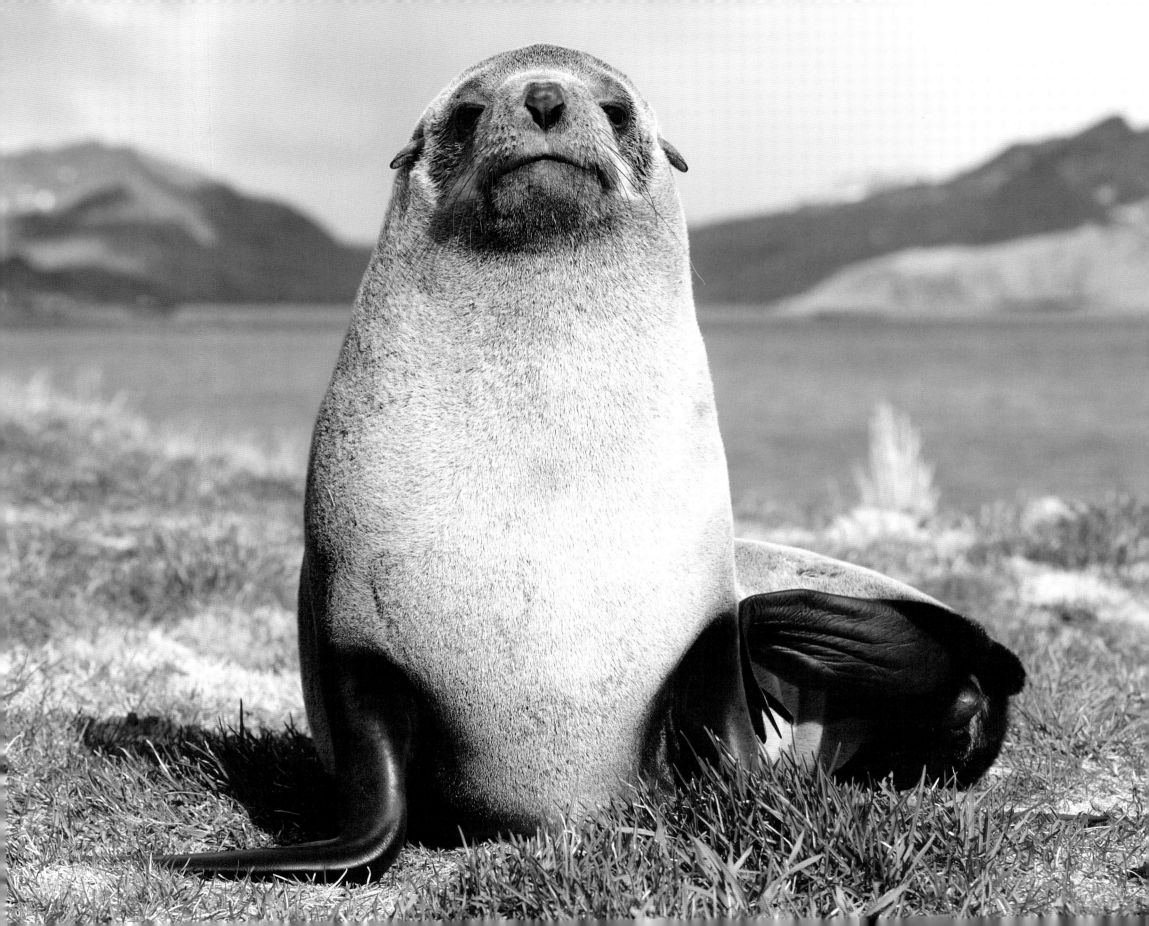

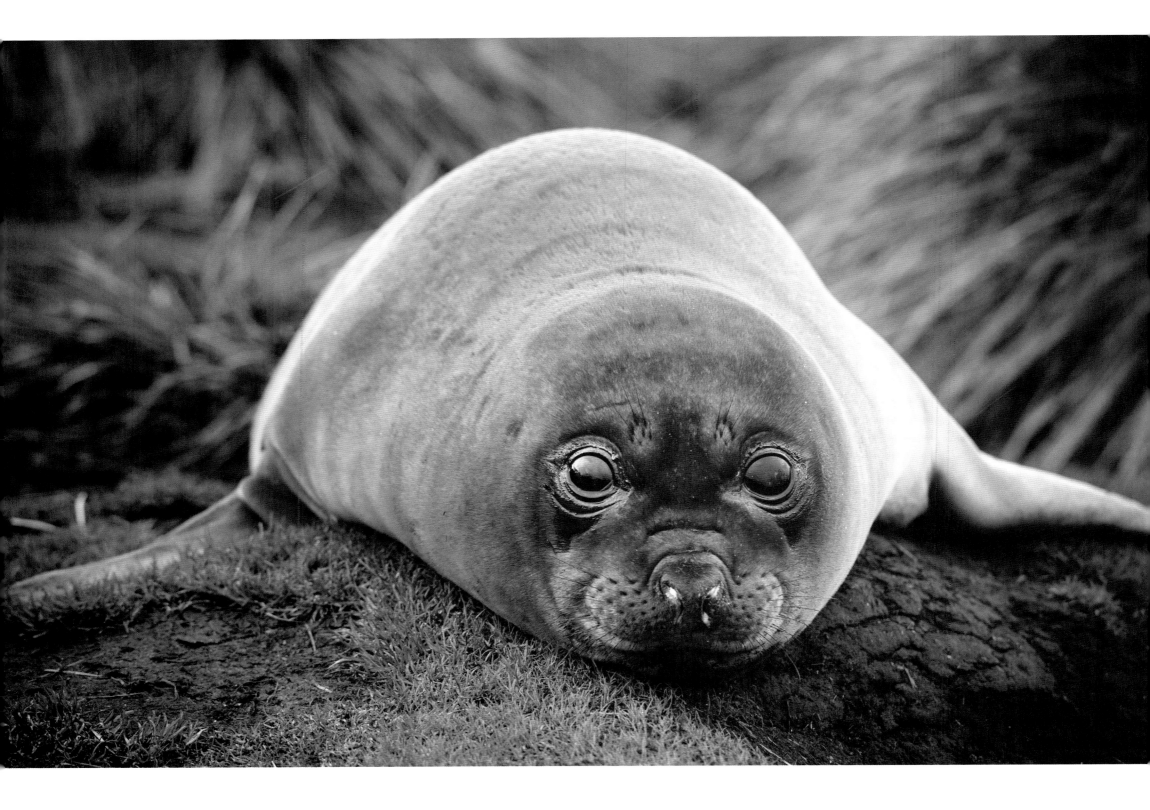

Baby Elephant seal, Prion Island, South Georgia.

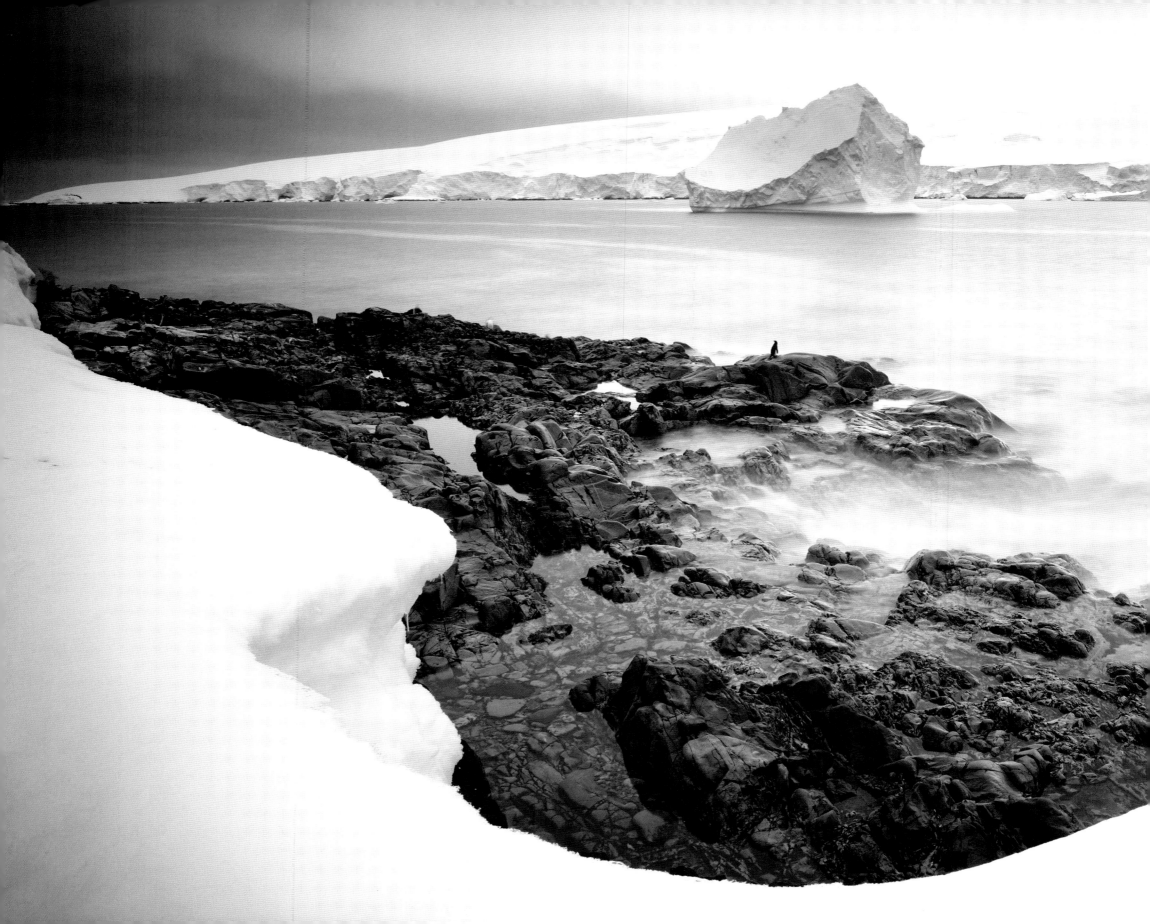

Lonely penguin waiting at a diving spot.

Overleaf:
Chinstrap penguins on an iceberg
near the South Orkney Islands.

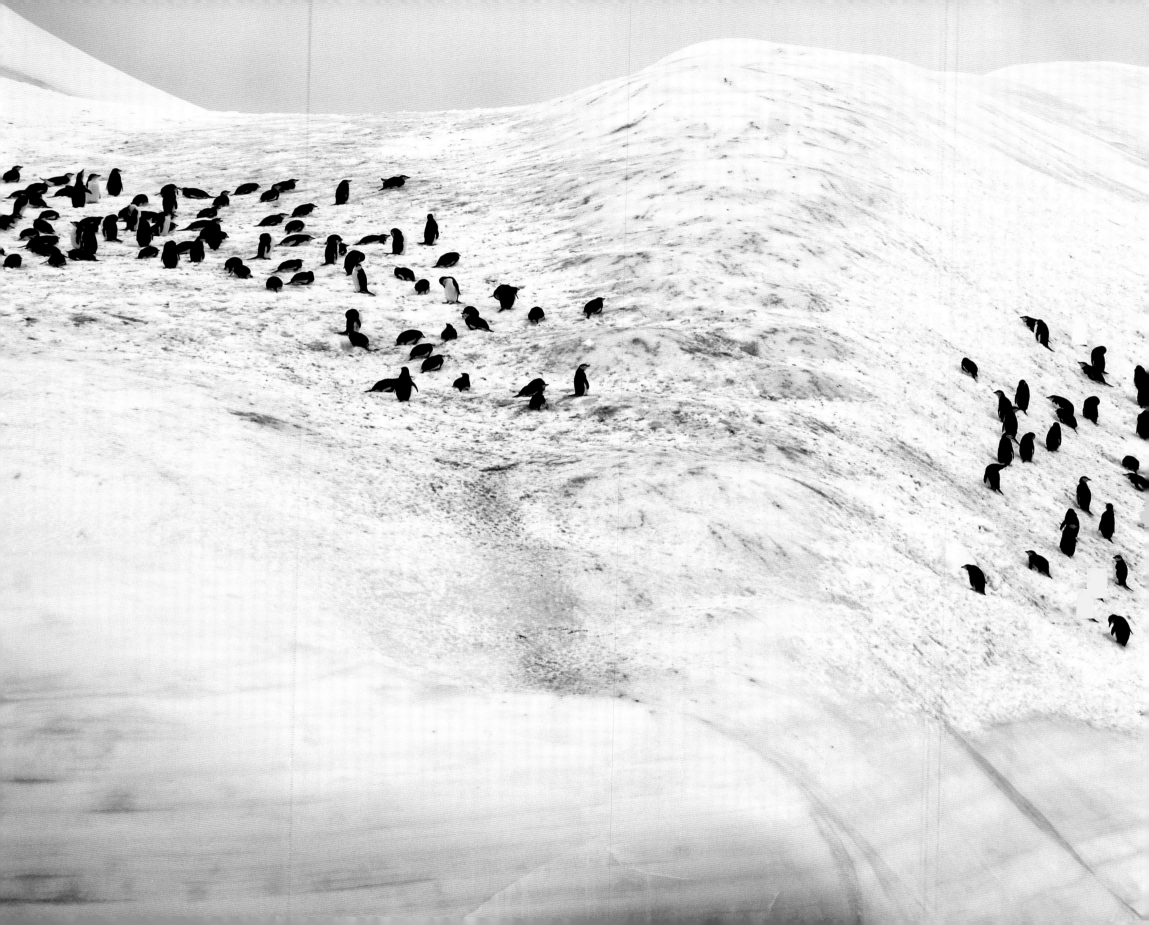

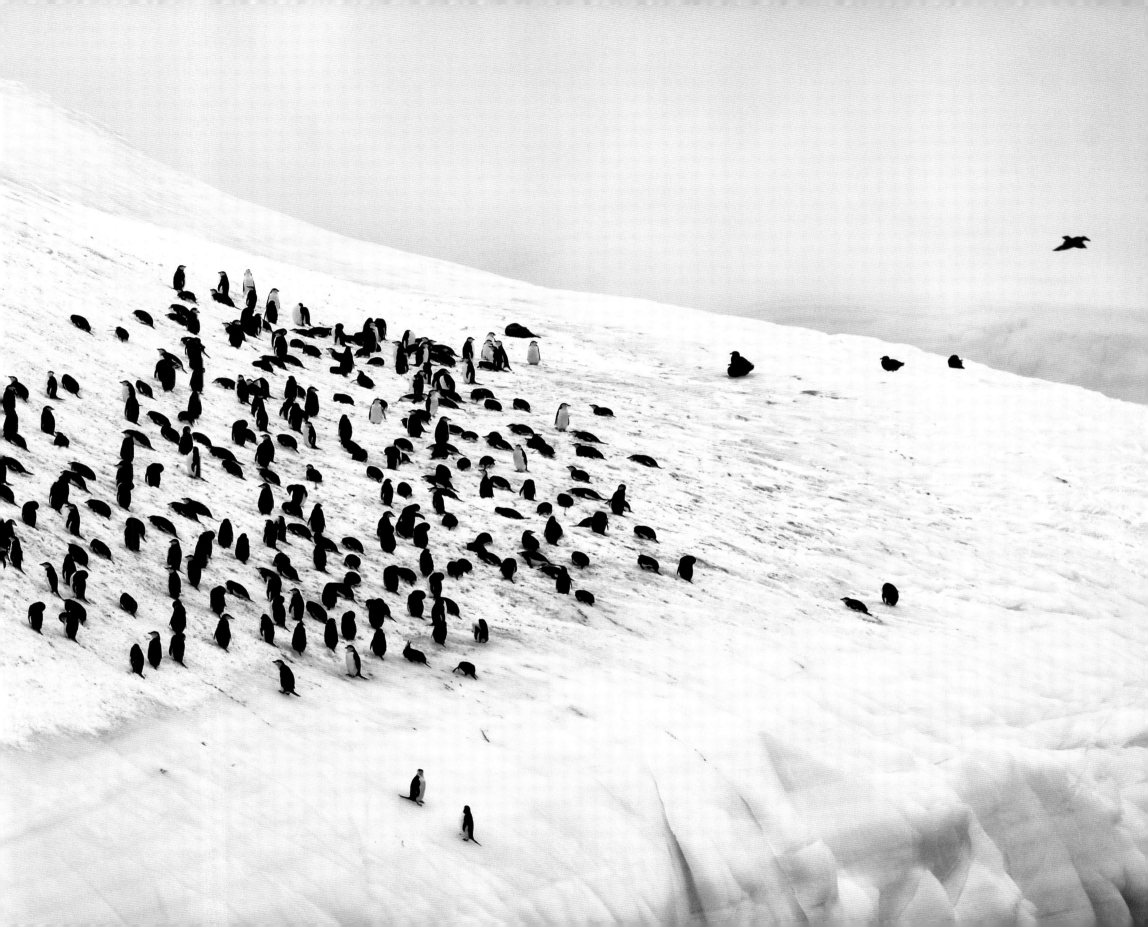

Ice floes in fog in the Croker Passage, a deep water passage
providing an entrance to the northern end of the Gerlache Strait.

Overleaf:
A tabular iceberg in the Southern Ocean.

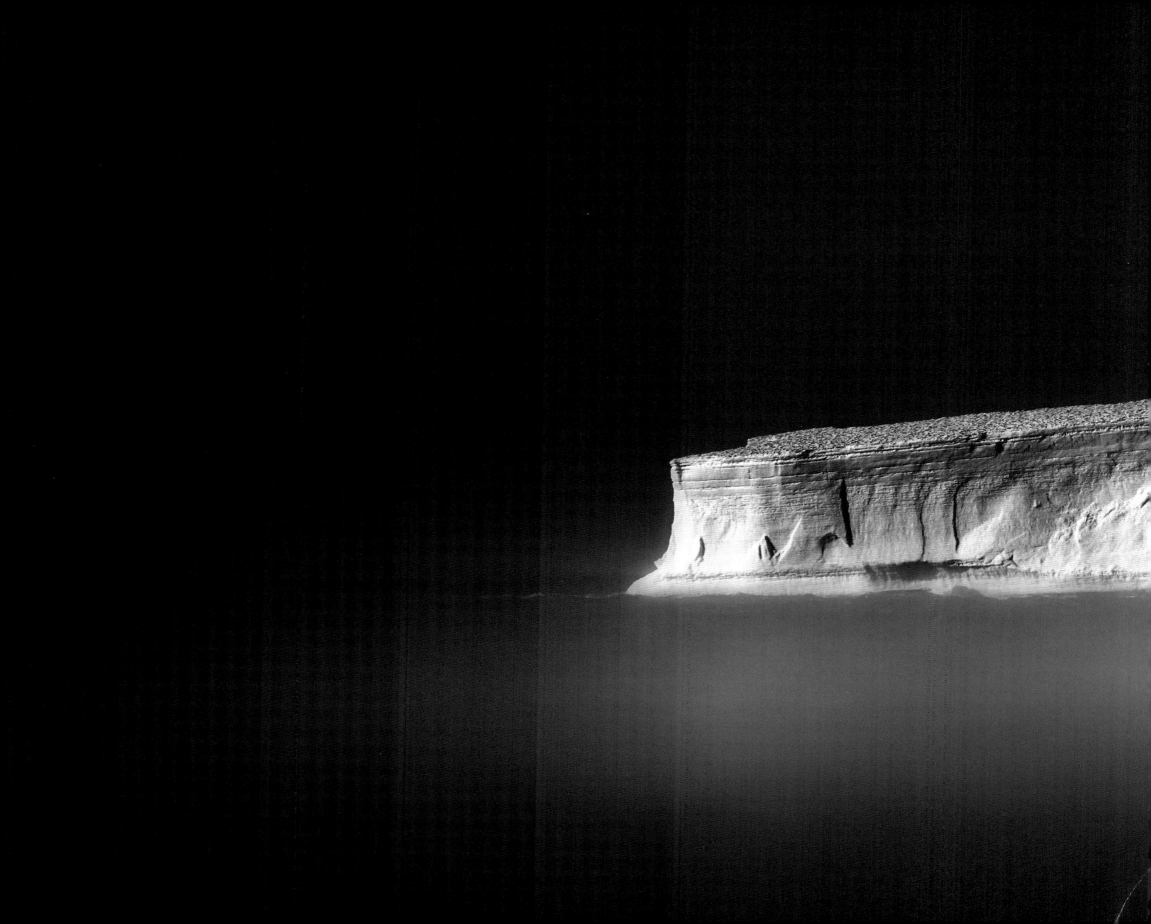

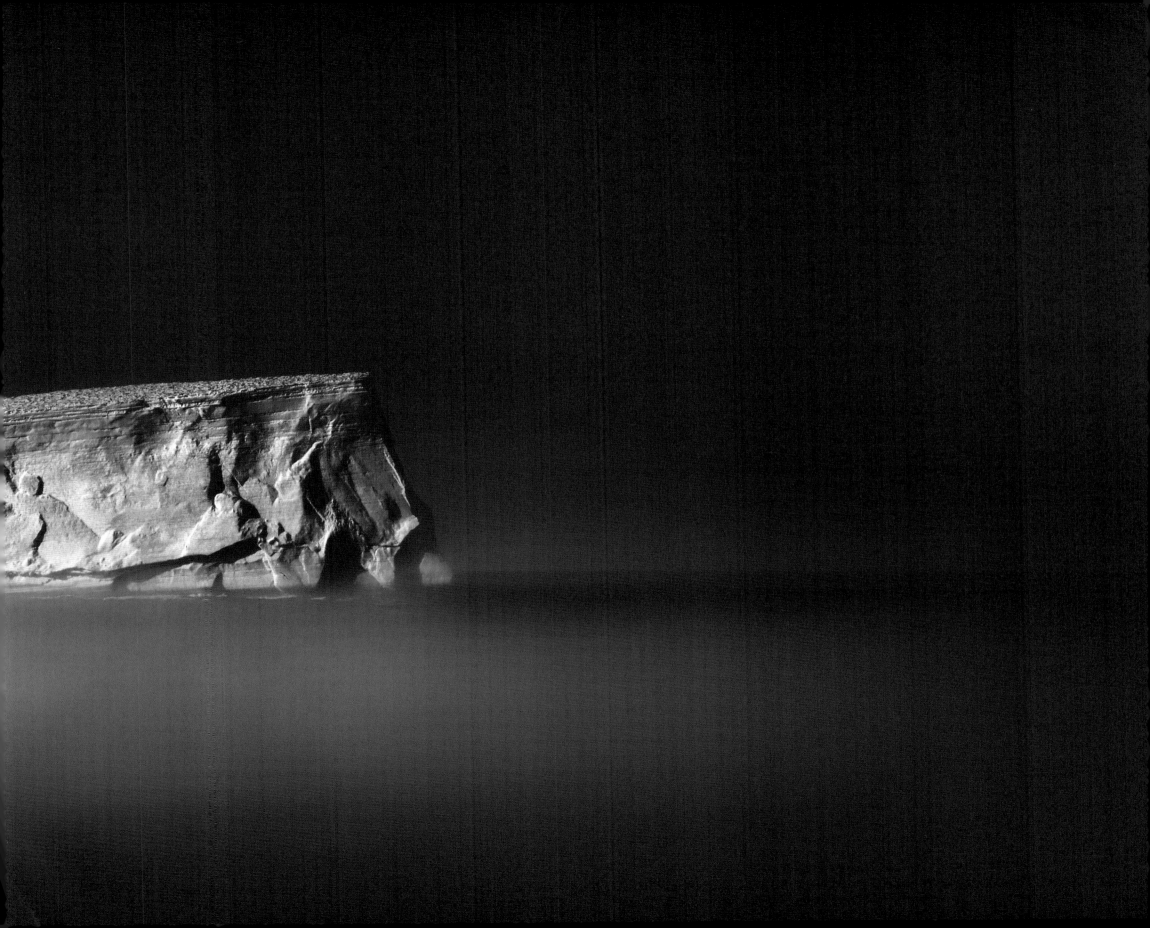

A wonderful arch in an iceberg, Paulet Island.

Overleaf:
Lemaire Channel, Antarctica.

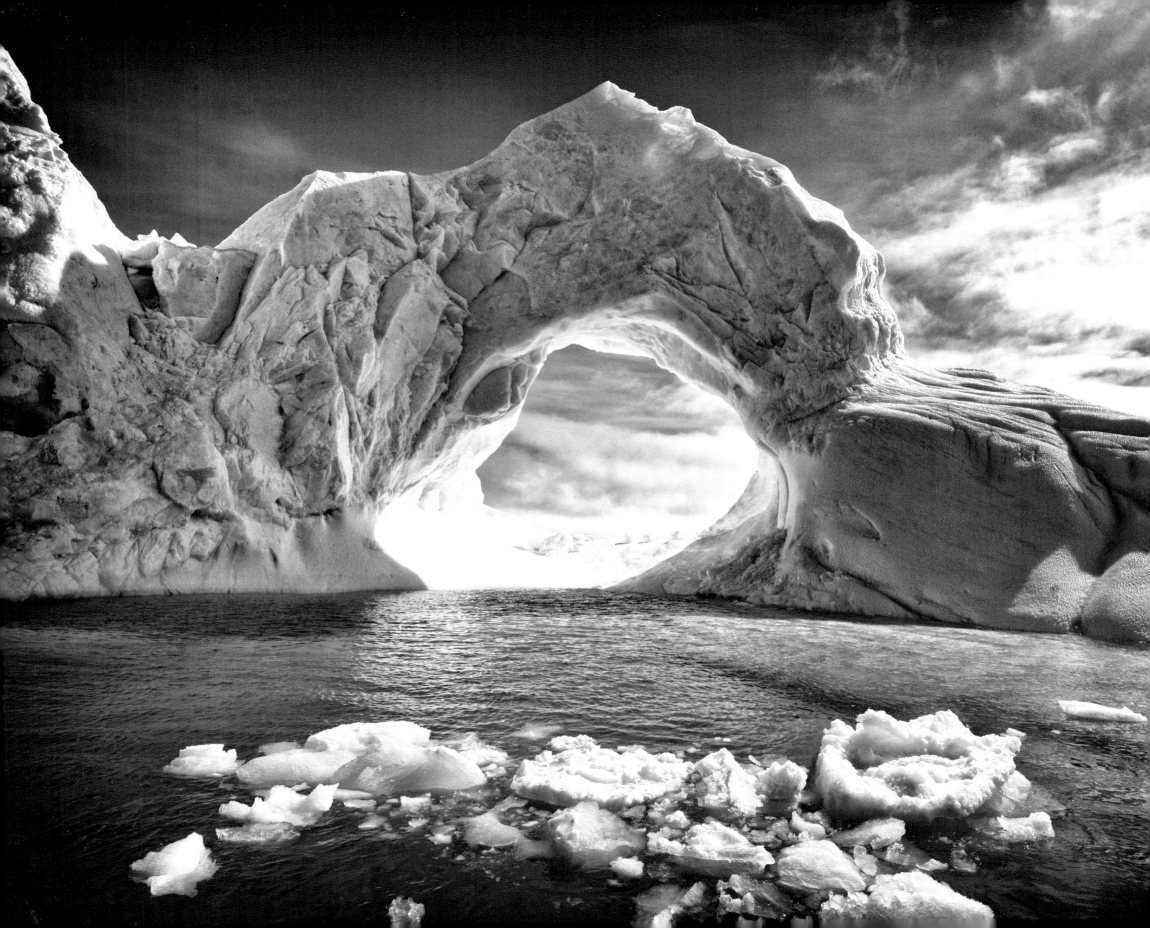

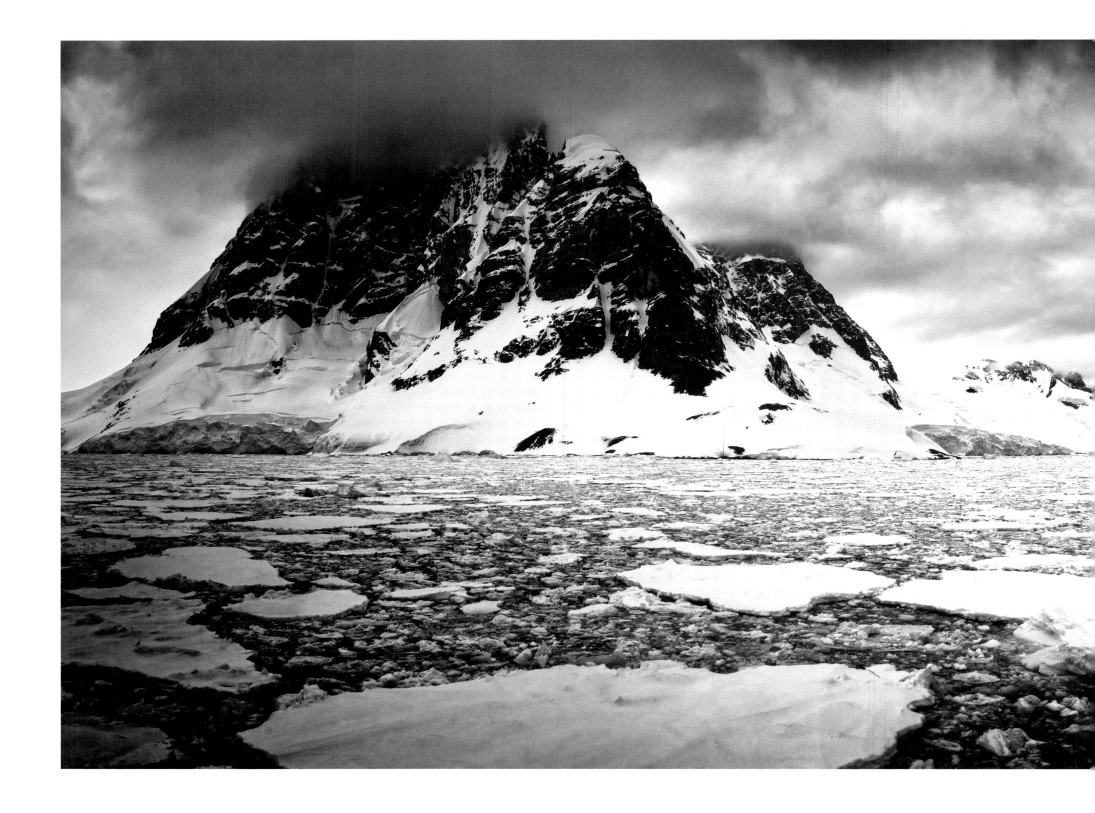

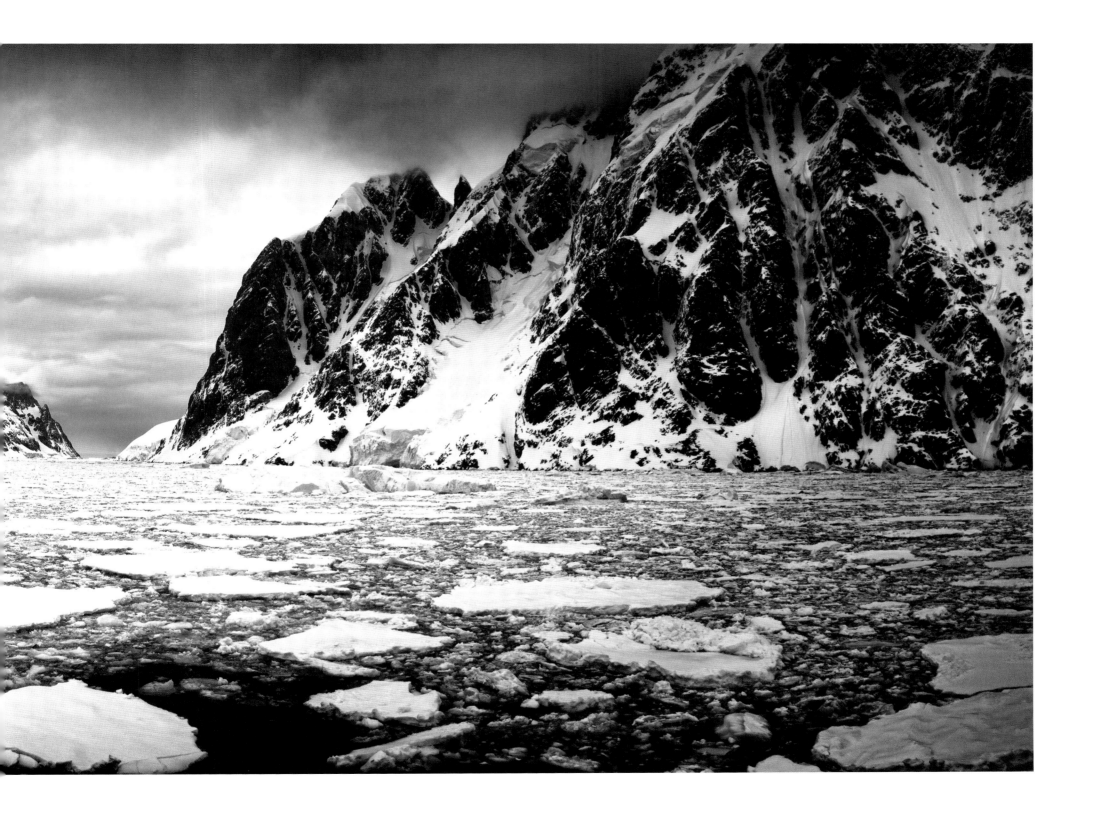

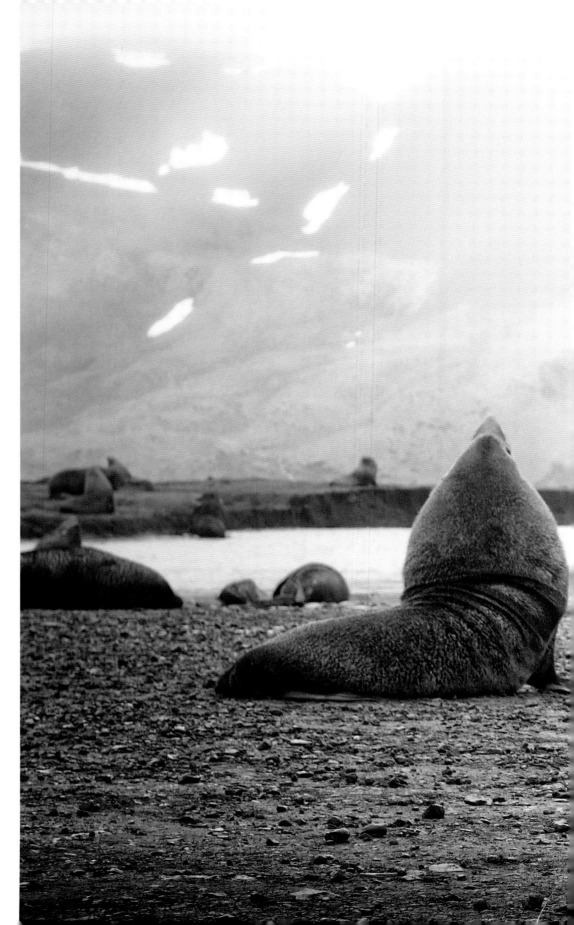

Fur seals in the fog, Right Whale Bay, South Georgia.

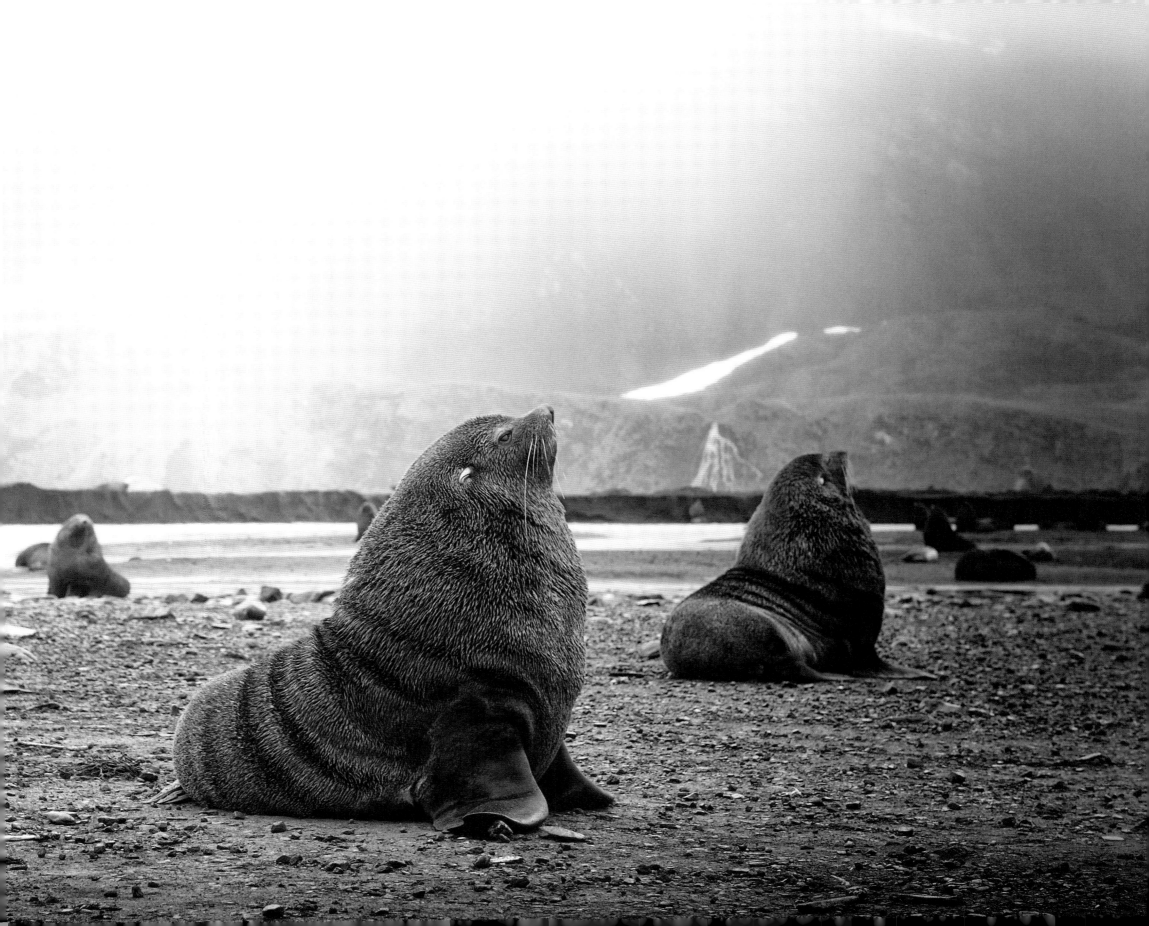

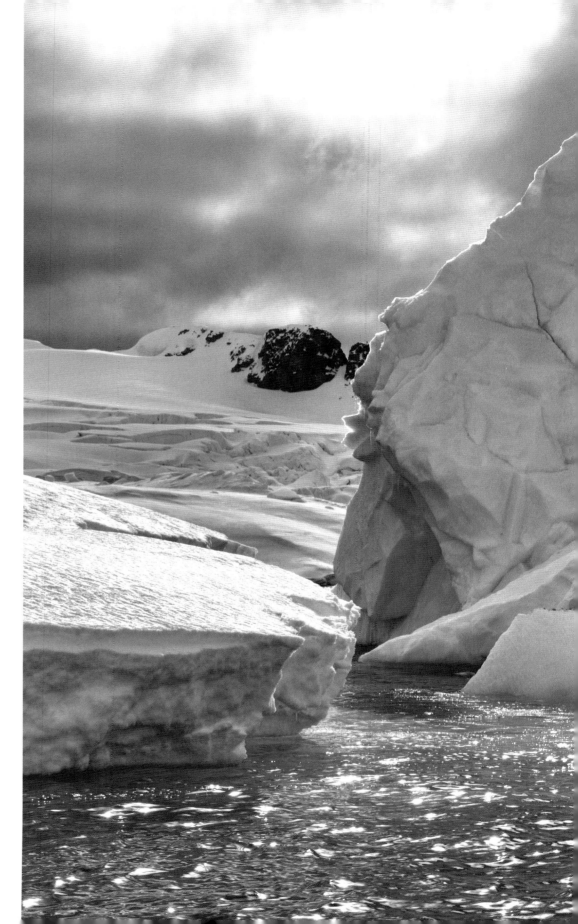

Ice sculptures at Cuverville Island, a rocky island in the
Errera Channel, off the west coast of Graham Land, Antarctica.
Two-thirds of the island is covered by a permanent ice-cap.

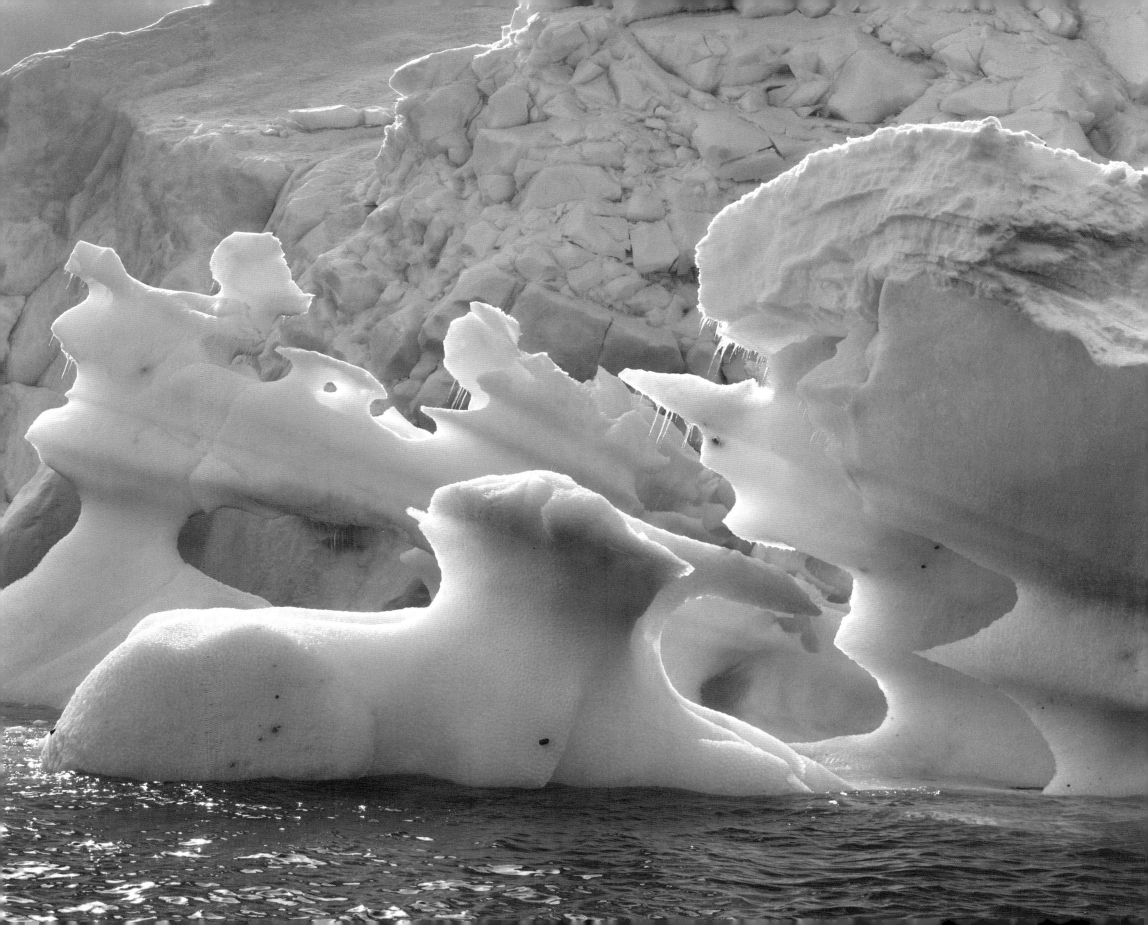

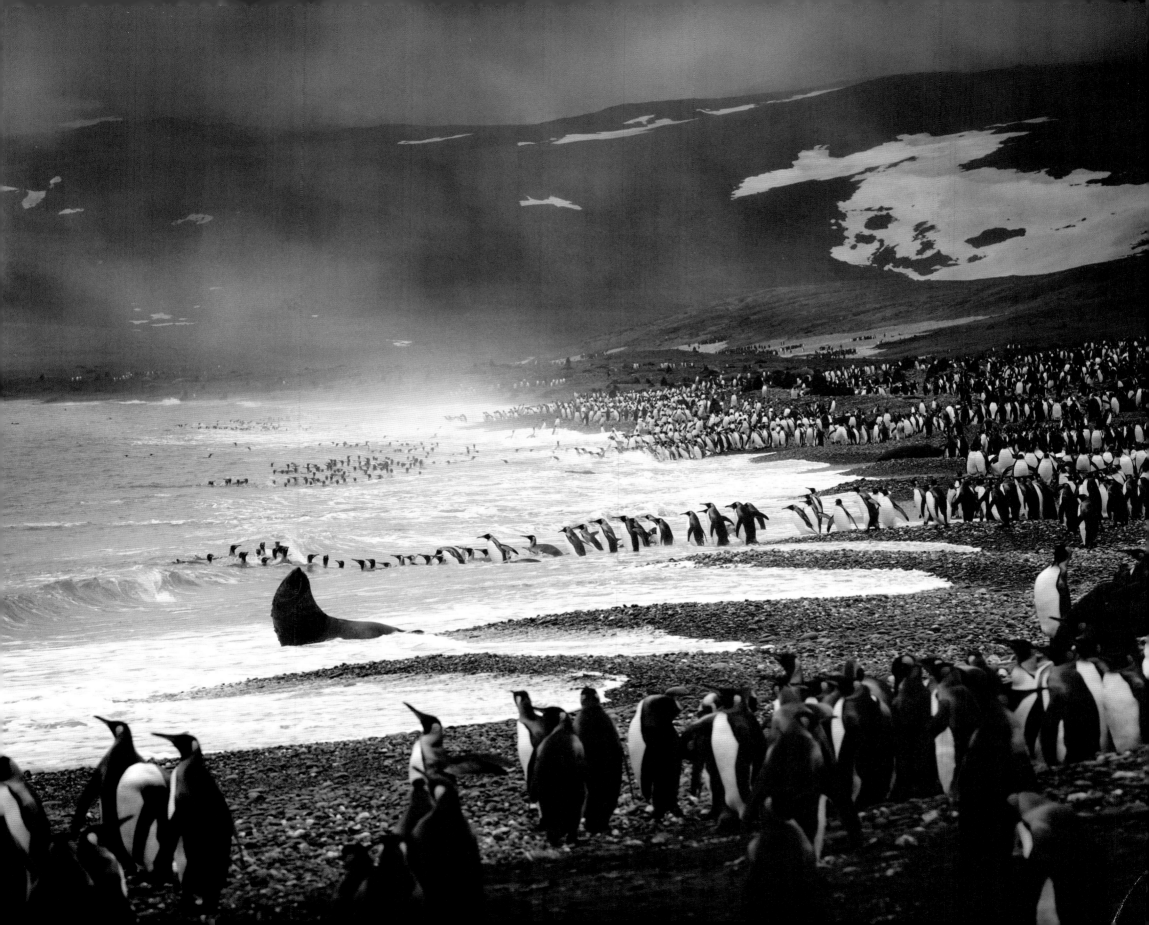

King penguins and fur seals, Salisbury Plain, South Georgia.

Opposite:
Elephant seal, St. Andrews Bay, South Georgia.

Overleaf:
Paradise Harbour, Antarctica.

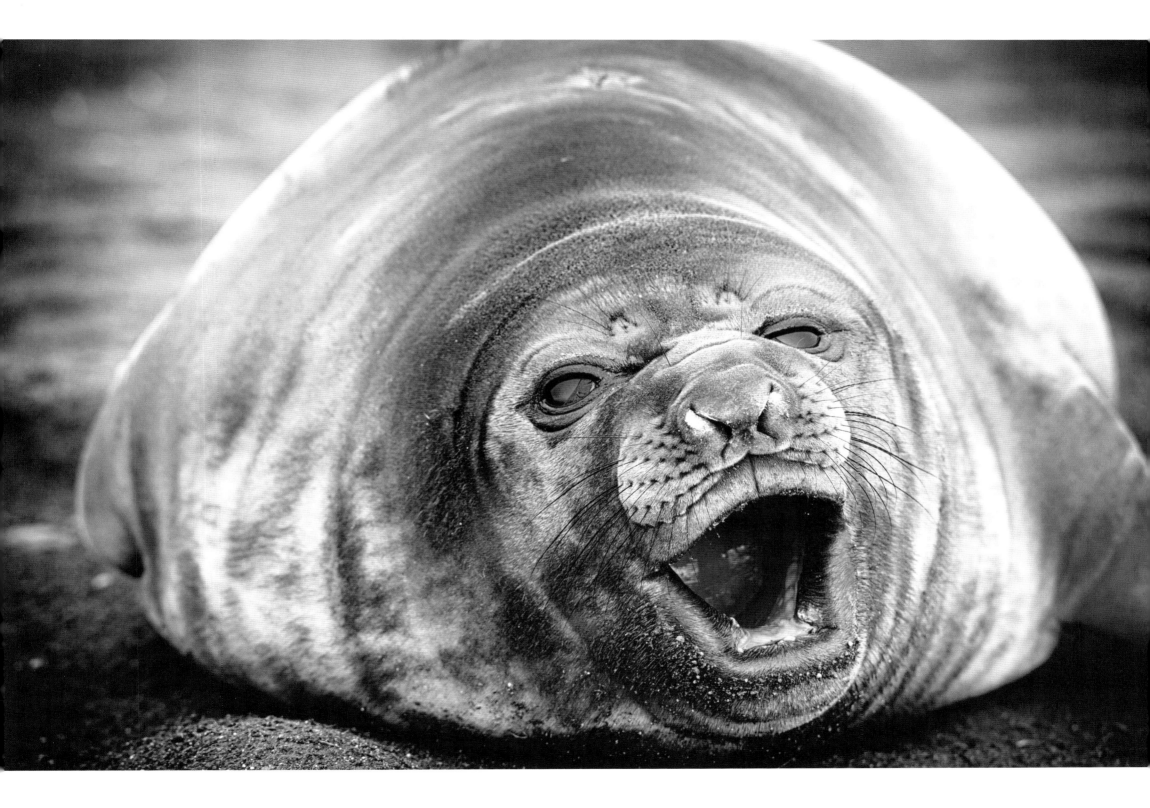

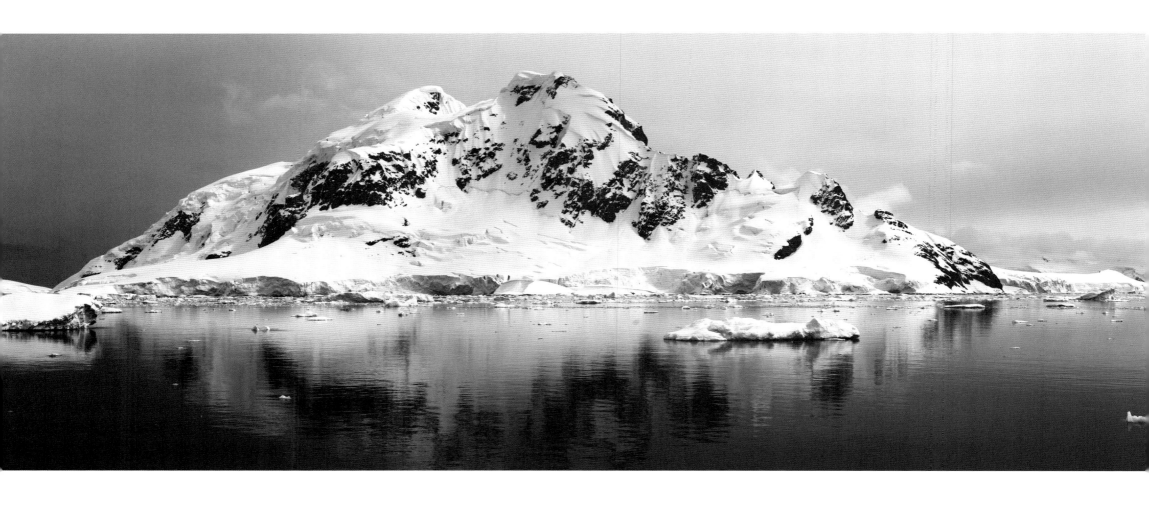

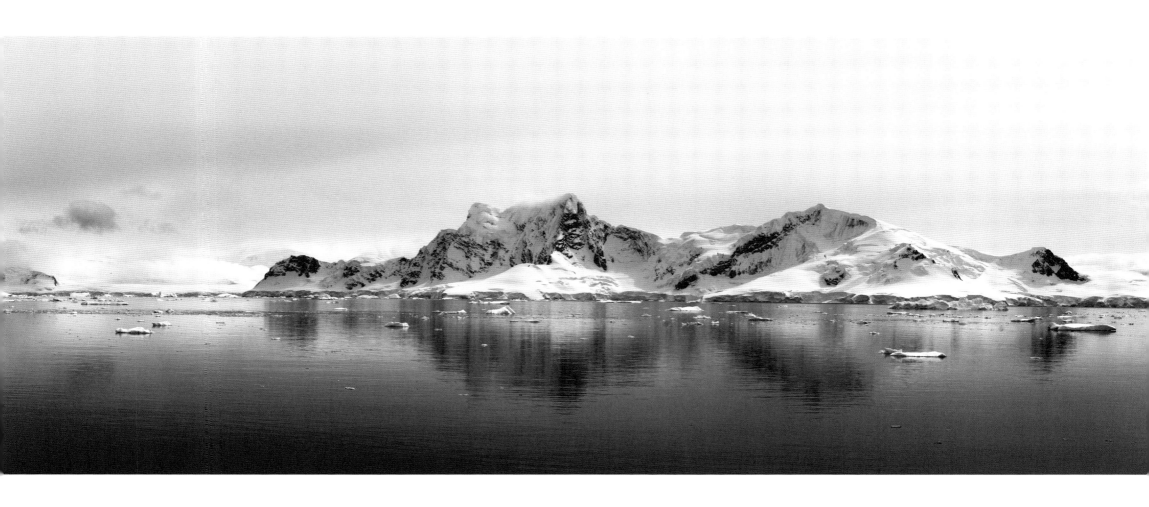

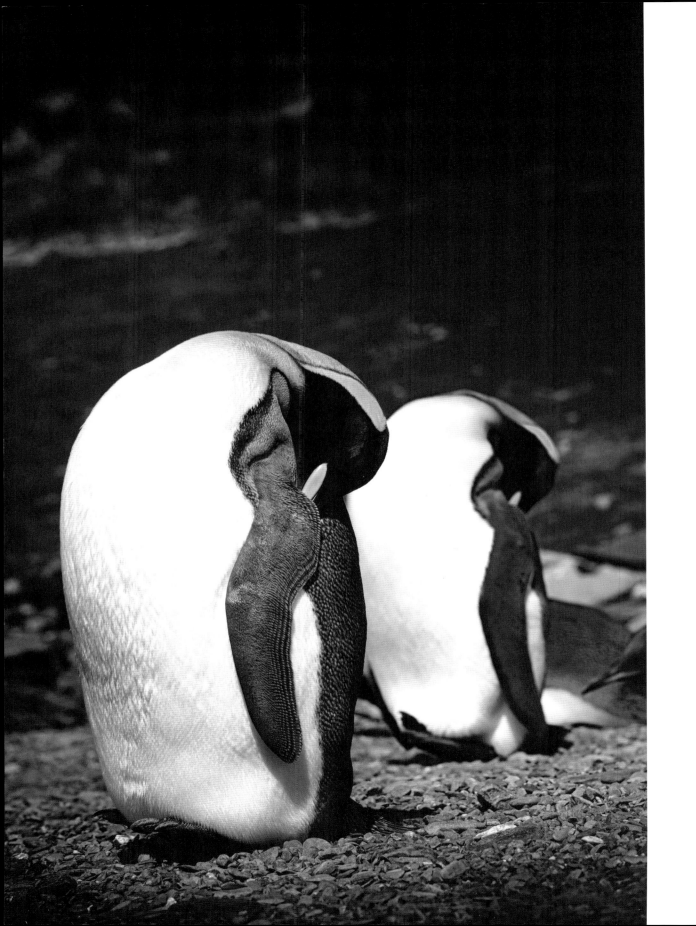

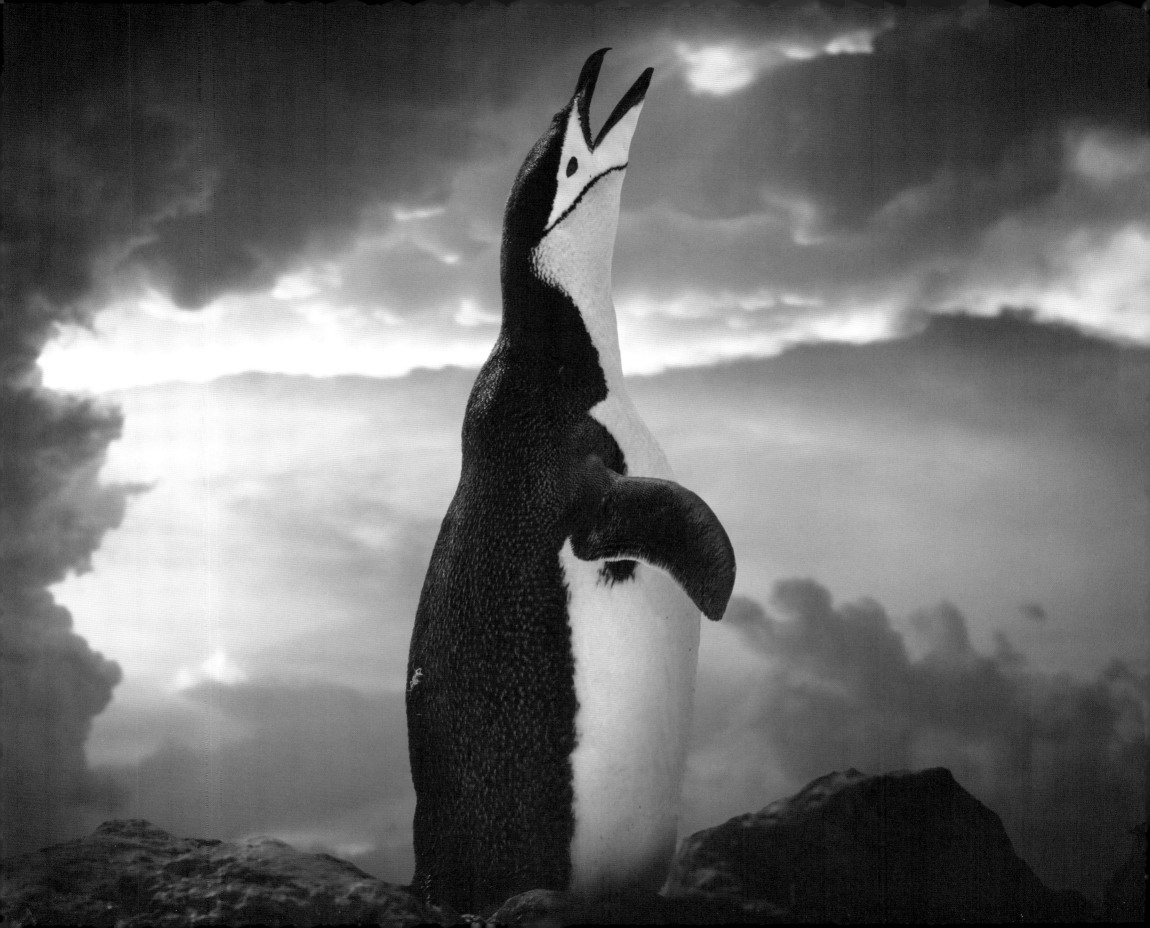

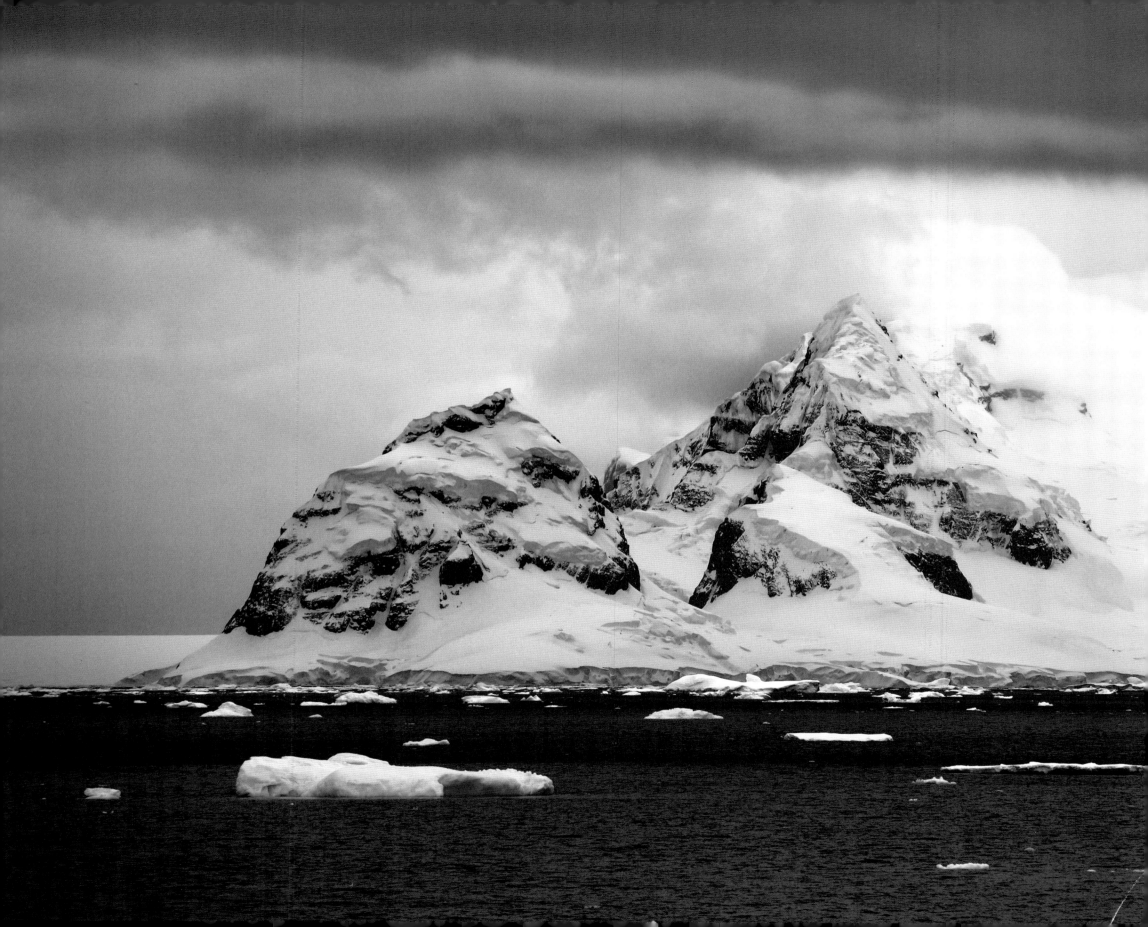

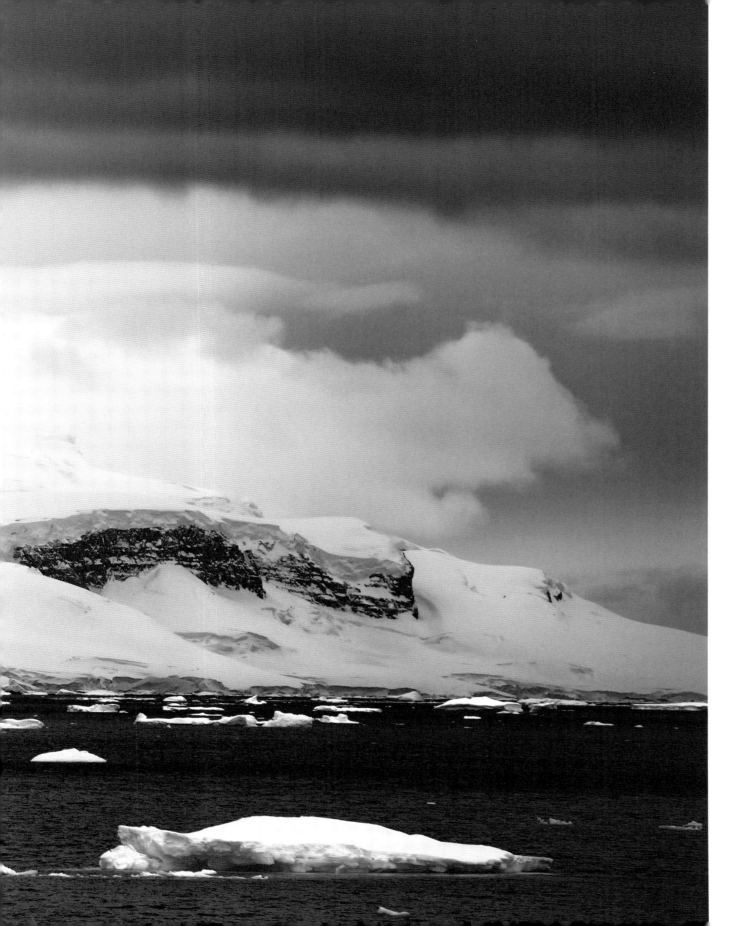

Gerlache Strait, Antarctica.

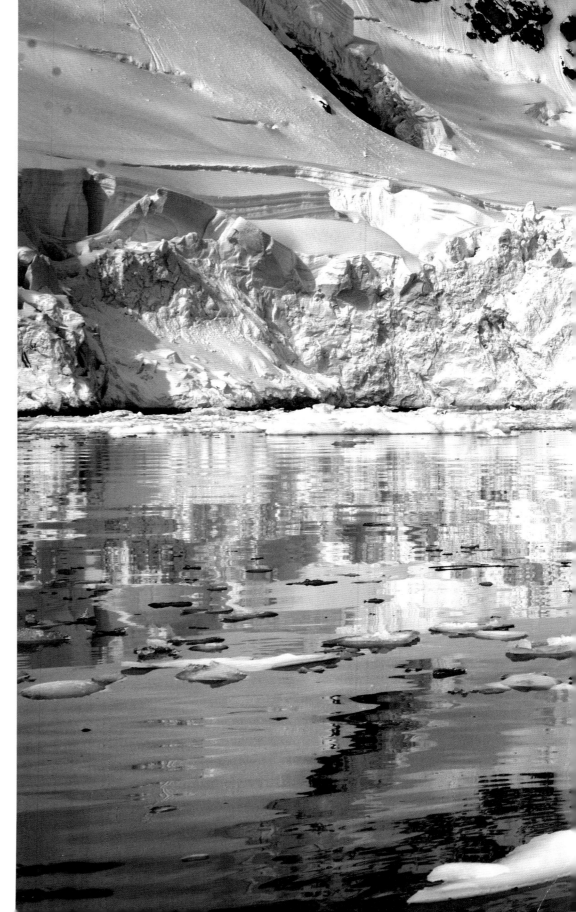

Glacier at Paradise Harbour, Antarctica.

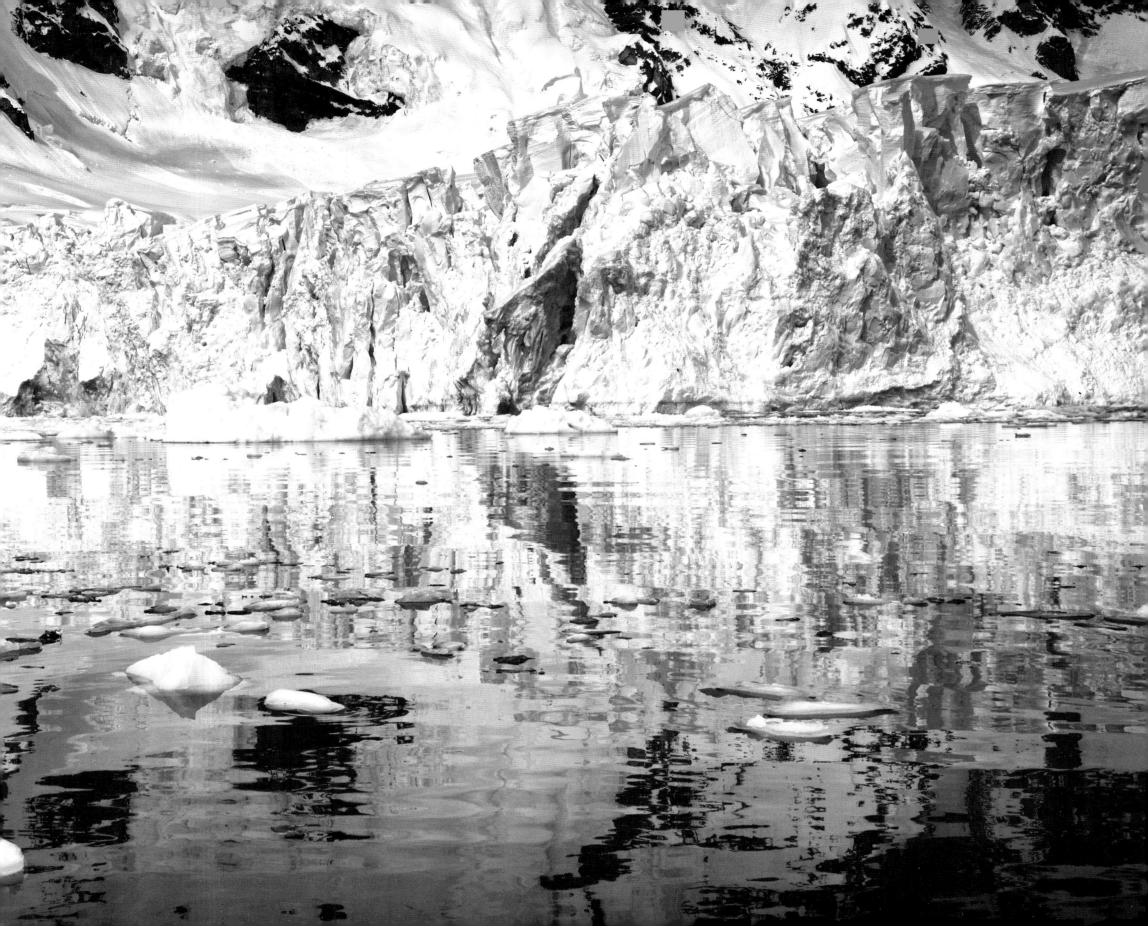

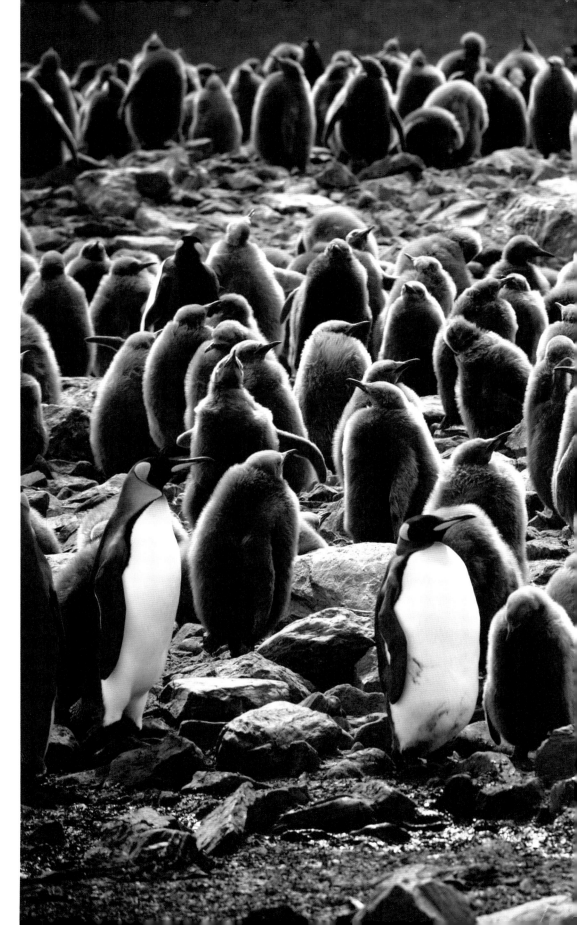

King penguin colony, St. Andrews Bay, South Georgia.

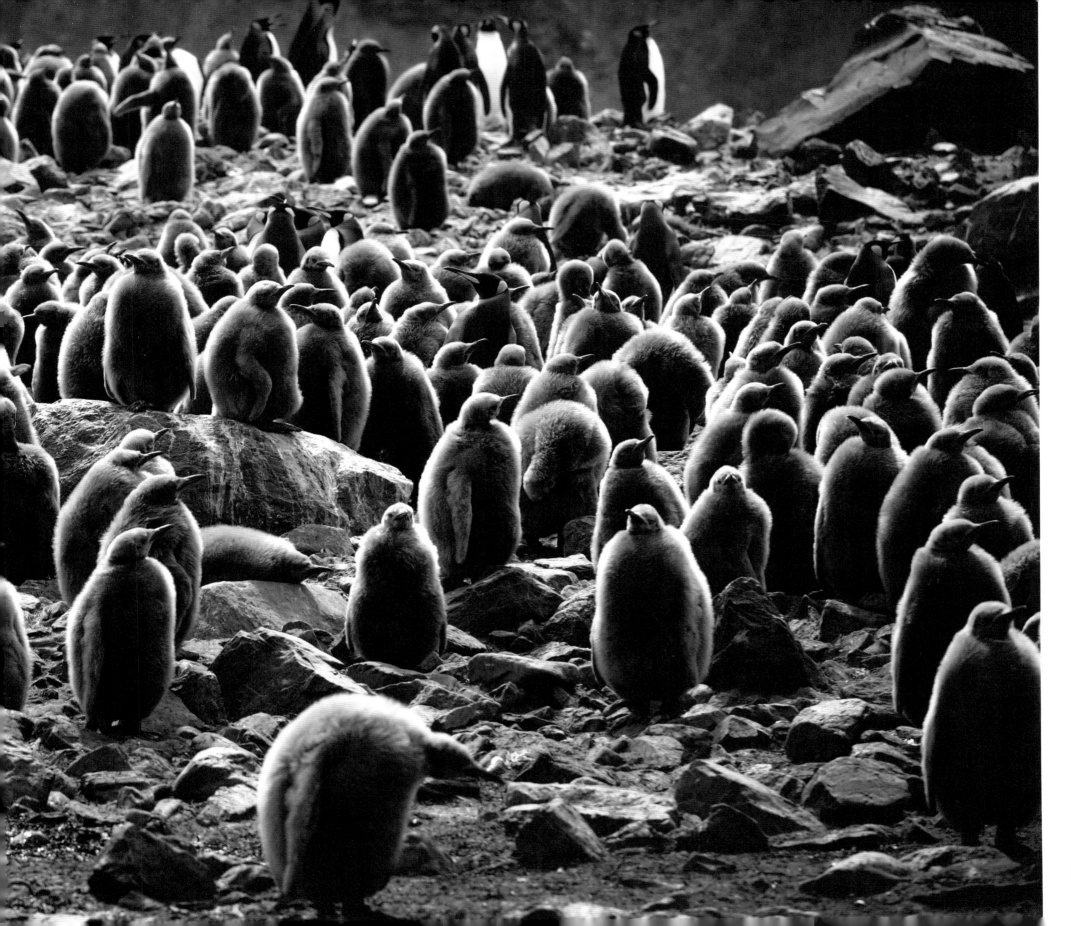

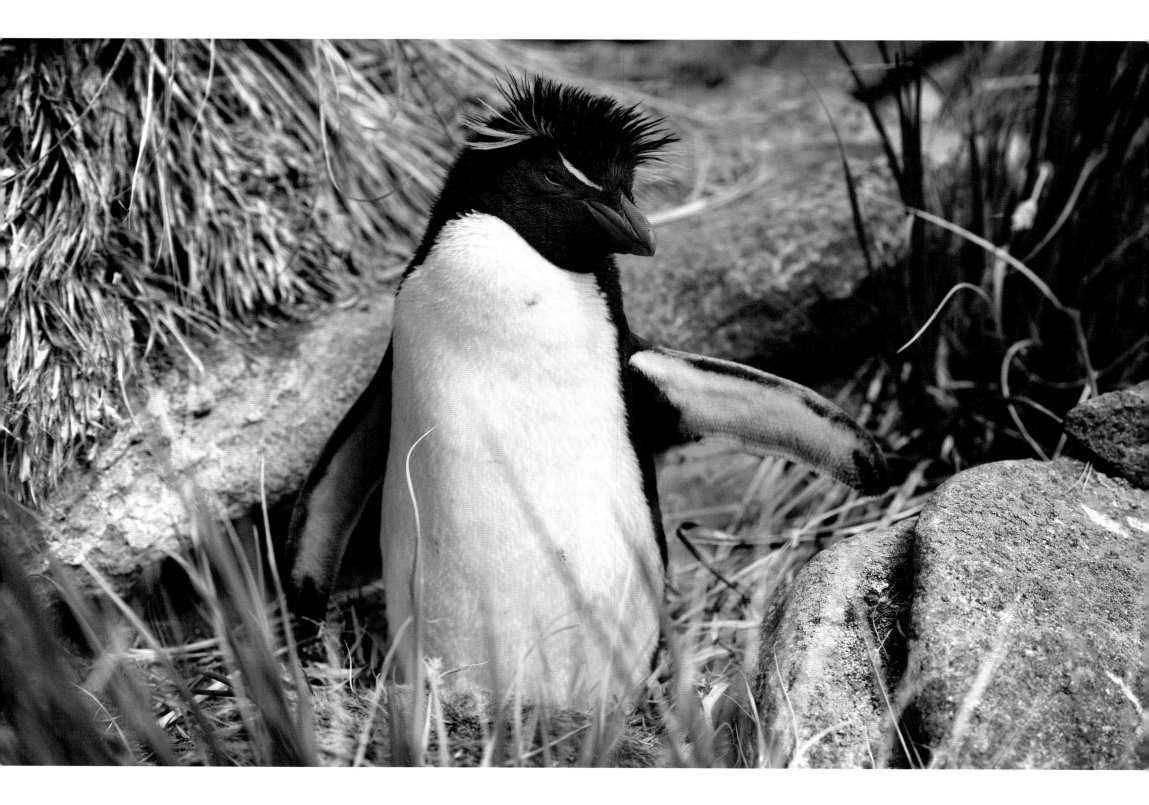

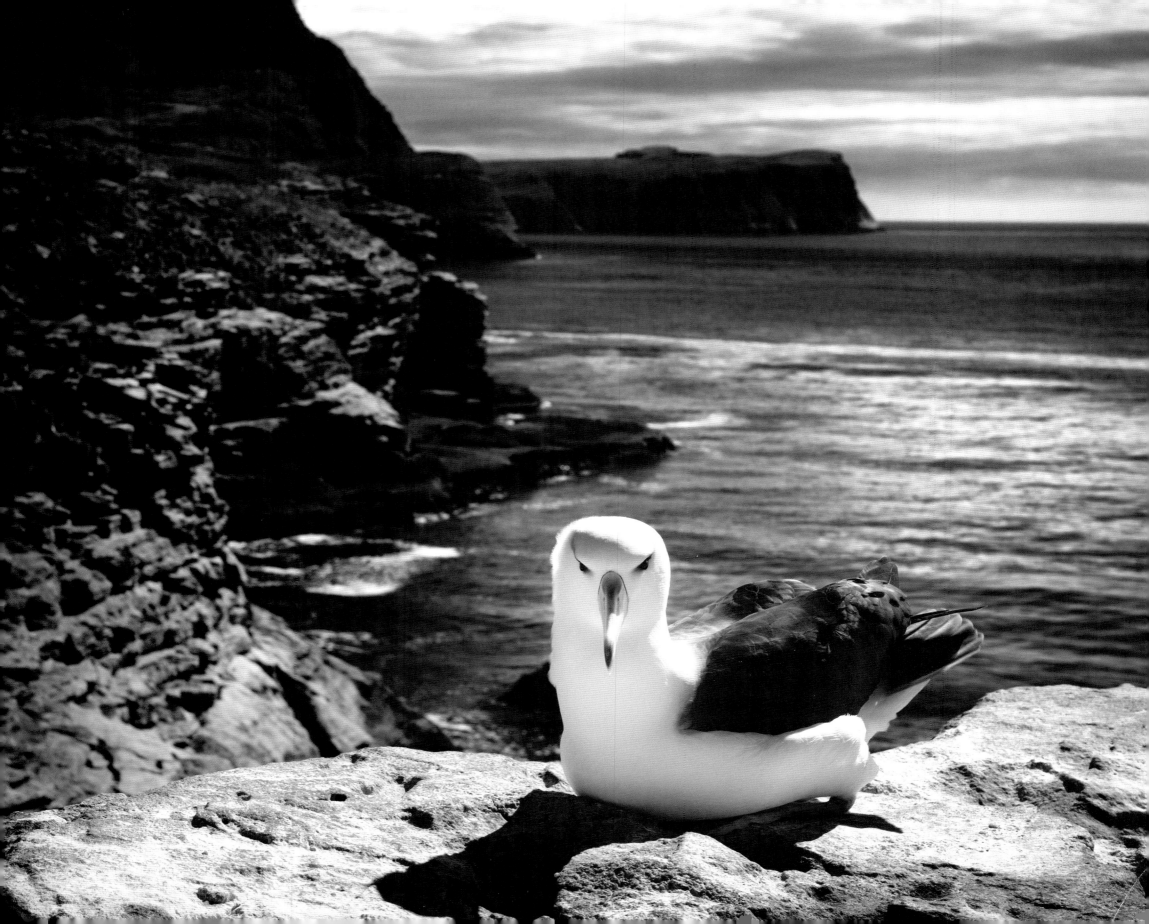

Opposite:
Black-browed albatross on New Island, western Falkland Islands.

Overleaf:
Westpoint Cove, Westpoint Island, north-western Falkland Islands.

Pages 194–195:
Cave iceberg, Brown Bluff.

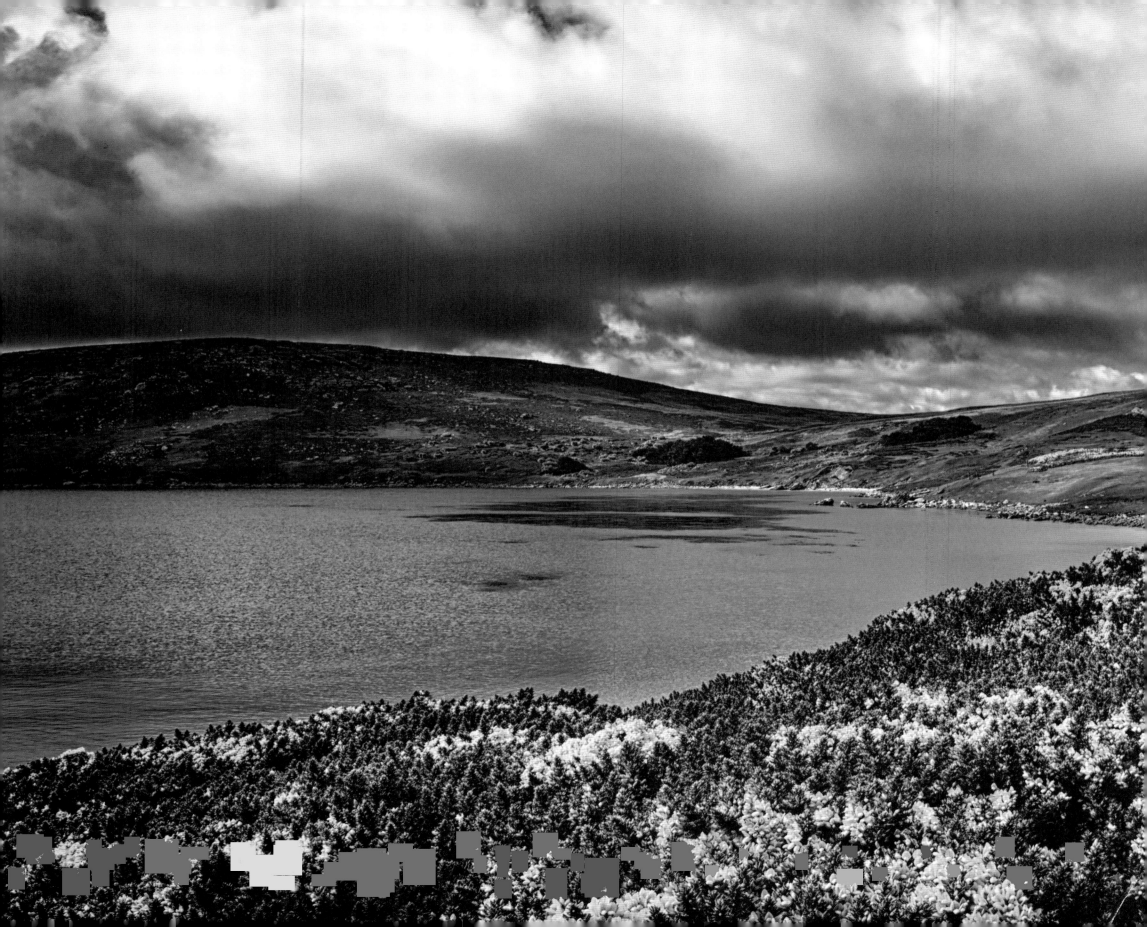

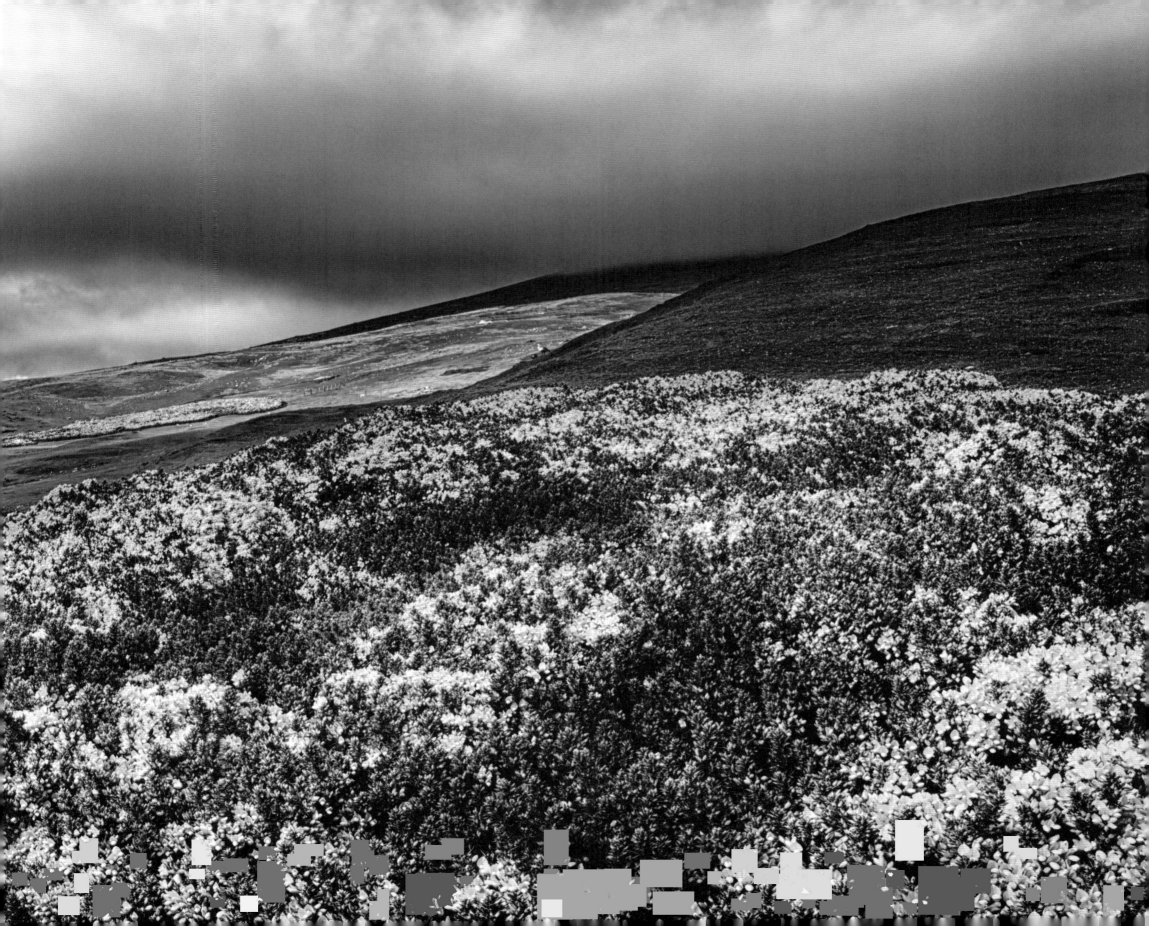

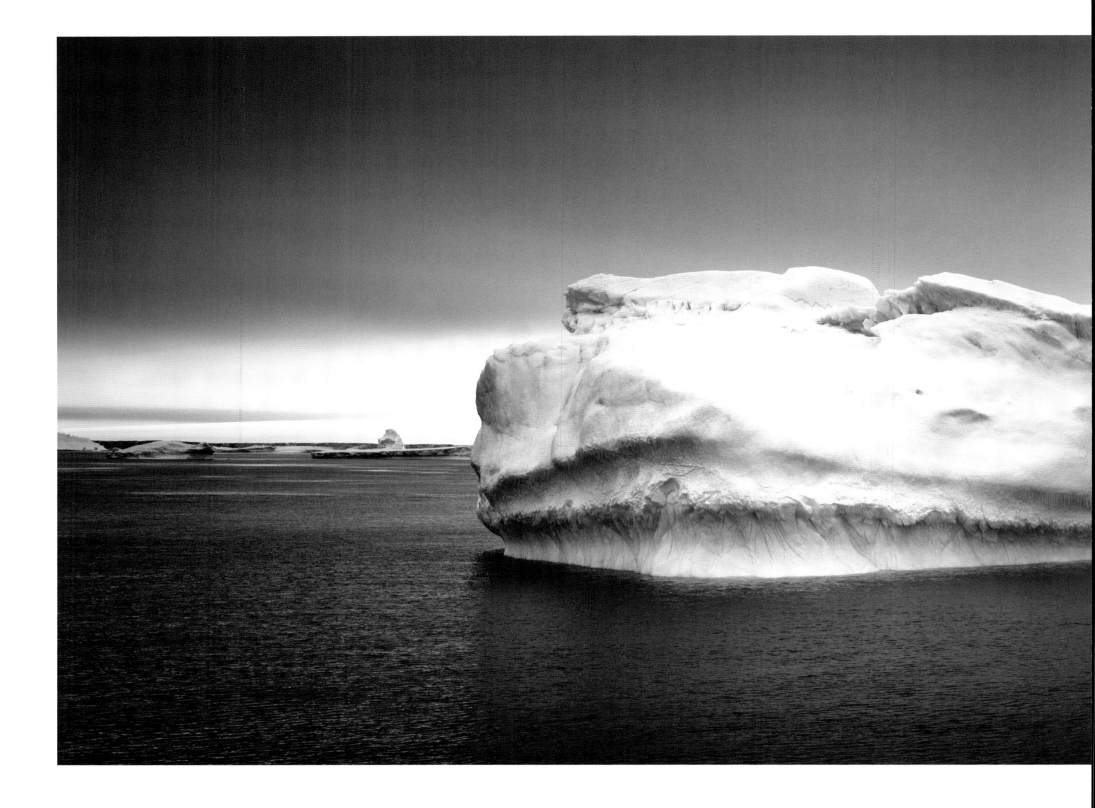

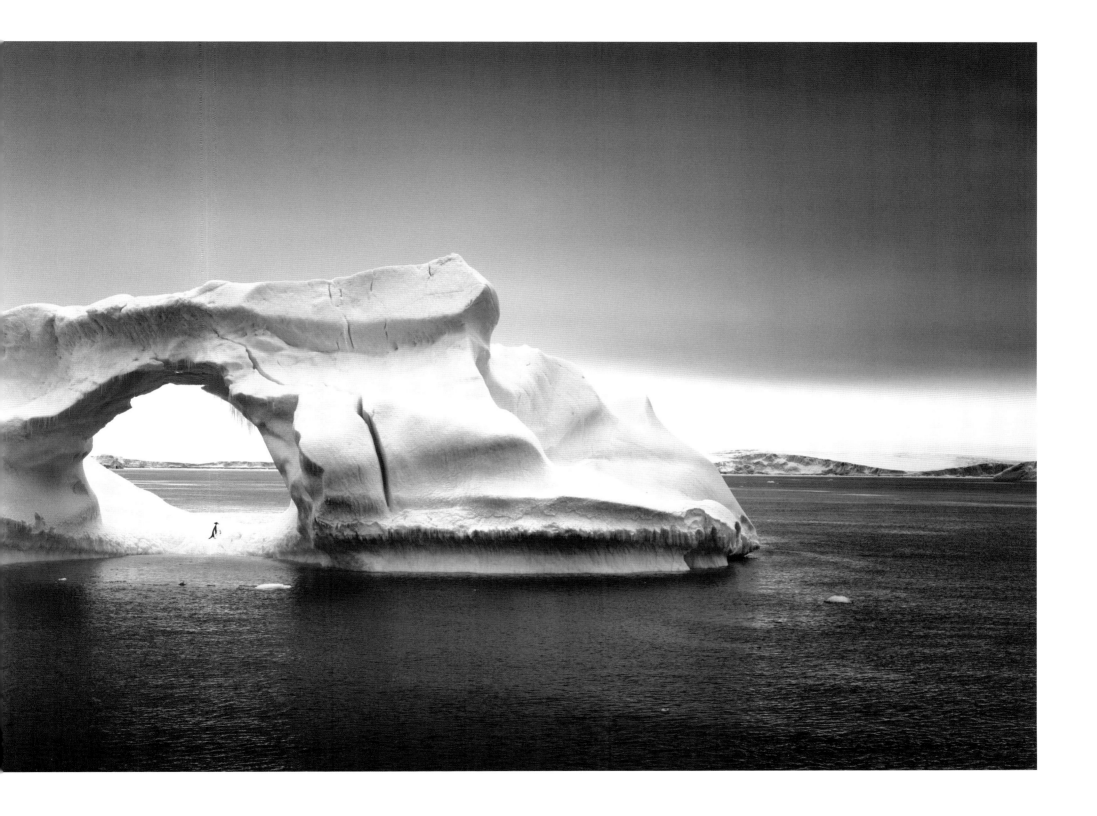

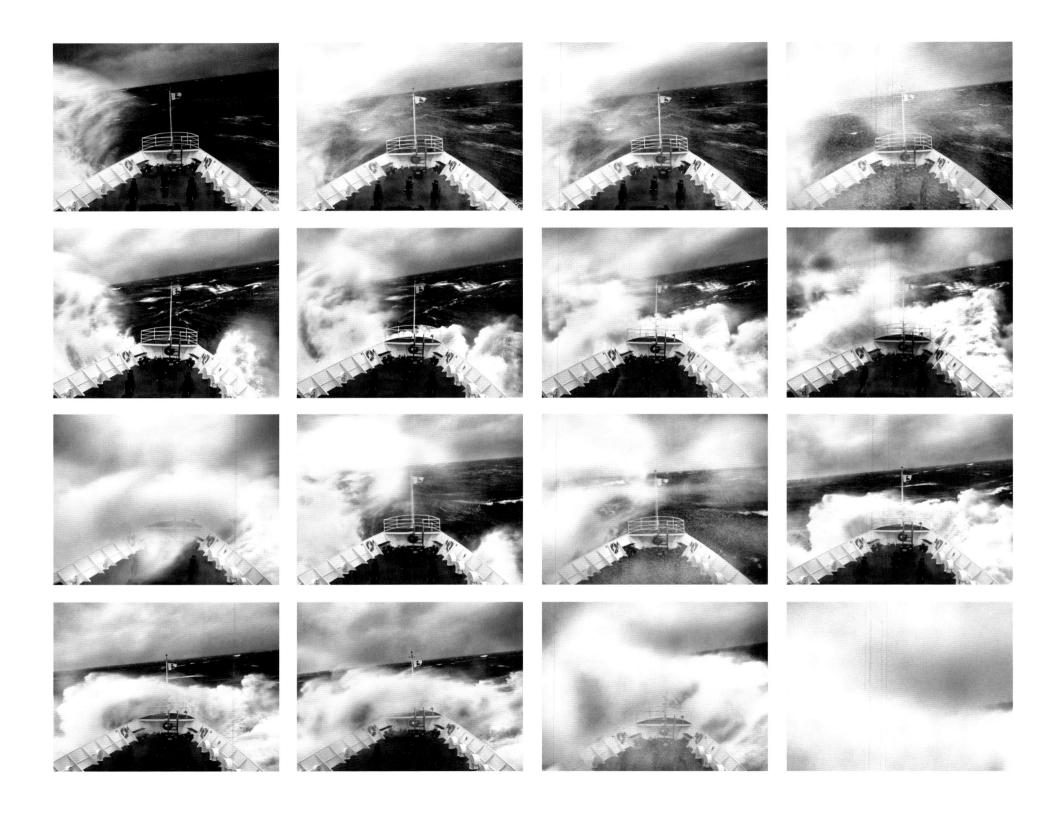

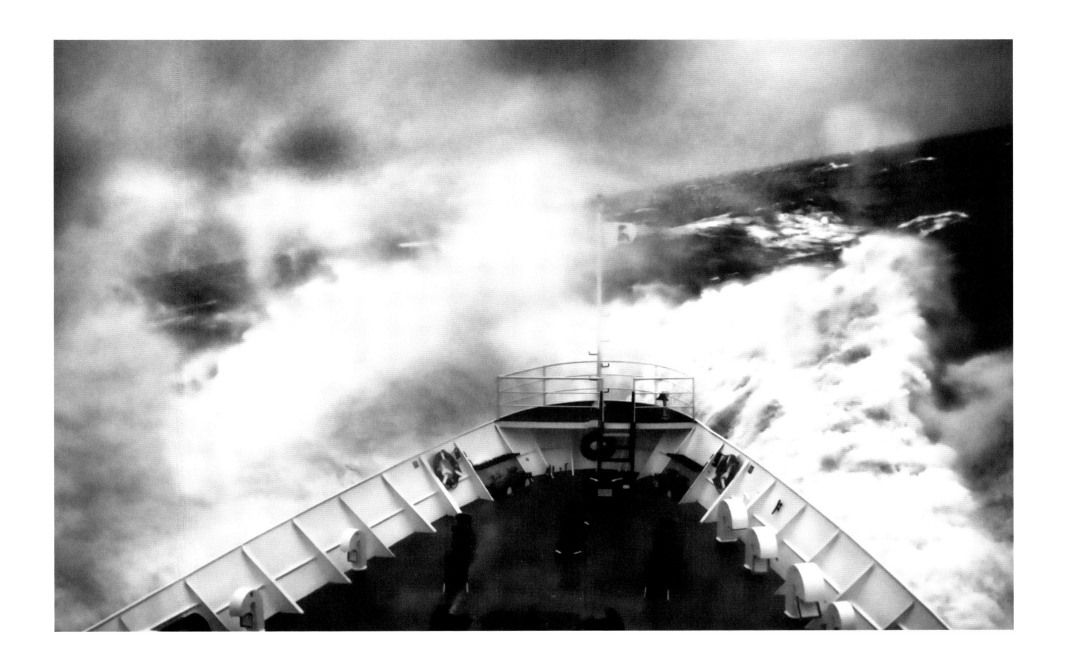

A storm in Drake Passage. Drake Passage, named after Sir Francis Drake although he was not the first to sail through it, connects the Atlantic and Pacific Oceans between Cape Horn and the South Shetland Islands, north of the Antarctic Peninsula.

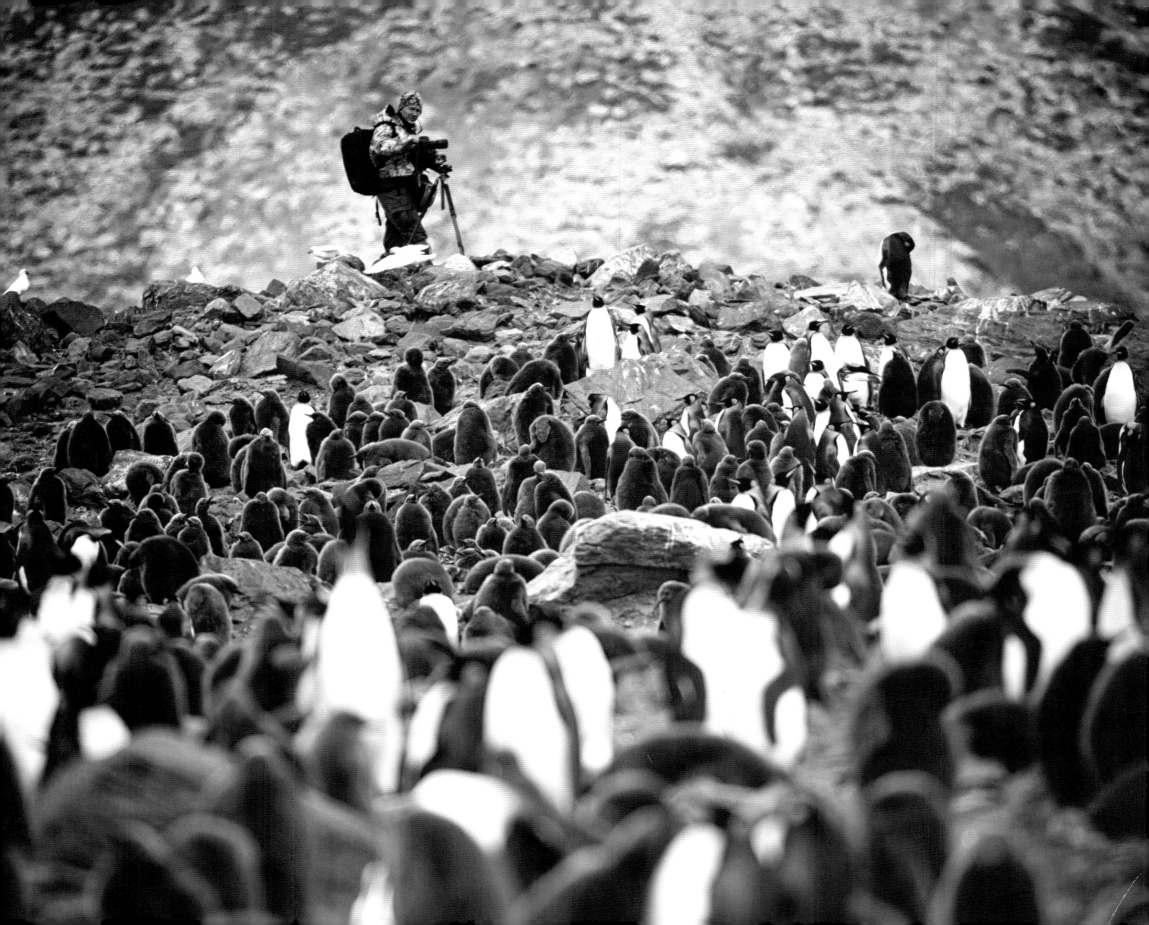

ALEX BERNASCONI

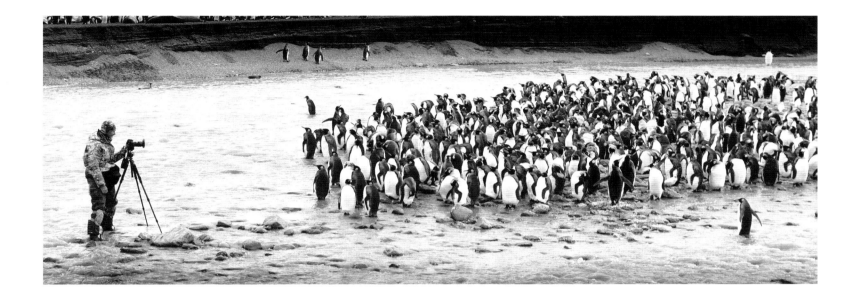

Alex Bernasconi is a world-renowned, multi-award winning nature, wildlife and fine-art photographer. Born in the historic Italian design city of Milan in 1968, he has carved out a life as outdoorsman, sportsman, adventurer and traveller – always with his camera. His need for challenges has taken him around the world, from Asia to Africa, and from glaciers and deserts to the jungle, where his passion for animals has led him to photograph some of the most dangerous predators on the planet.

He has experienced and photographed some of the most inspiring places on Earth. Each image reflects his attention to all aspects of photography as an art and his deep love for wildlife seems to be rewarded by the complicity of the animals themselves.

Bernasconi's iconic images have been featured in magazines worldwide, exhibited in art galleries and are part of important private collections. He has won many prizes at the most prestigious international photography awards including the IPA (International Photography Awards), Trierenberg Super Circuit, PX3, WPO Sony World Photography awards, Graphis, and the Epson International Pano awards. His first book *Wild Africa* received a Gold medal as the best photography book of the year at the Independent Publisher Book Awards (IPPYs) in 2011.

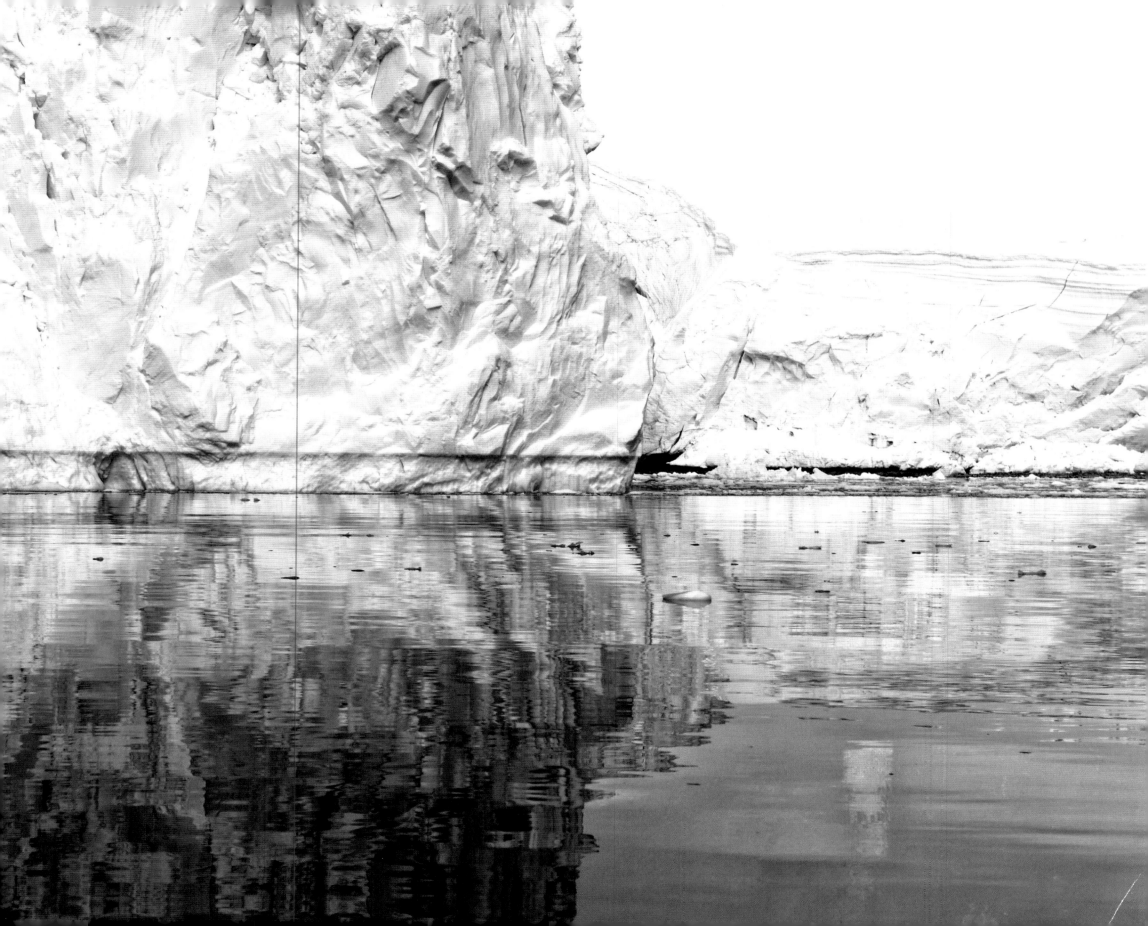

PROFESSOR JULIAN DOWDESWELL

Julian Dowdeswell has been Professor of Physical Geography and Director of the Scott Polar Research Institute at the University of Cambridge since 2002. He is also Brian Buckley Fellow in Polar Science at Jesus College, Cambridge. Julian graduated from the University of Cambridge with first class honours and studied for a Masters Degree in the University of Colorado before returning to Cambridge for his doctorate.

His research interests are in glaciology and glacial geology, working on the form and flow of glaciers and ice caps and their response to climate change, and the links between former ice sheets and the marine-geological record, using a variety of satellite, airborne and shipborne geophysical instruments. He has worked in many parts of the Arctic and Antarctic, and in mountain areas of the world, in a series of field research projects over the past 30 years. He has written over 275 scientific papers and eight books, including several, such as *Islands of the Arctic*, for general audiences.

He has been awarded the Polar Medal by Her Majesty the Queen and has also received the Founder's Gold Medal from the Royal Geographical Society (2008). In 2011 he was awarded the Louis Agassiz Medal by the European Geosciences Union and recently received the 2014 IASC Medal of the International Arctic Science Committee.

DR PETER CLARKSON MBE

Peter Clarkson developed an interest in the polar regions from an early age. As a schoolboy he followed the progress of the Commonwealth Trans-Antarctic Expedition (1955–58), led by Sir Vivian Fuchs, and soon decided that he wanted a polar career. He graduated from Durham University in 1967 and immediately joined the British Antarctic Survey as a geologist. He spent the 1968 and 1969 austral winters at Halley Bay station on the Brunt Ice Shelf, Coats Land, Antarctica, and was Base Commander for the second year. He carried out geological mapping in the Shackleton Range (80° S, 25° W) during the 1968–69 and 1969–70 austral summers before returning to the Department of Geology at Birmingham University to write up the work. He returned to Antarctica to do further summer field work in the Shackleton Range (1970–71), South Shetland Islands (1974–75), Shackleton Range (1977–78), and Antarctic Peninsula (1986–87).

He was awarded the Polar Medal in 1976 and received a PhD from Birmingham in 1977. In 1989 he left the British Antarctic Survey to be Executive Secretary of the Scientific Committee on Antarctic Research (SCAR). SCAR is an international organization that "initiates, promotes and coordinates scientific research in the Antarctic and provides scientific advice to the Antarctic Treaty System". His work took him to meetings all over the world but not to Antarctica! He has now retired and takes occasional Antarctic refresher courses on cruise ships to the Antarctic Peninsula when he lectures on a variety of Antarctic subjects. In the 2010 New Year Honours he was awarded the MBE "for services to Antarctic science". He has written numerous scientific and general articles about the Antarctic, contributed Antarctic articles to travel books and two encyclopædias. He has written a book on volcanoes and, with a colleague, a history of SCAR. He is a total enthusiast for all things Antarctic and will talk endlessly about his passion to anyone prepared to listen!

Iceberg reflections,
Paradise Harbour, Antarctica.

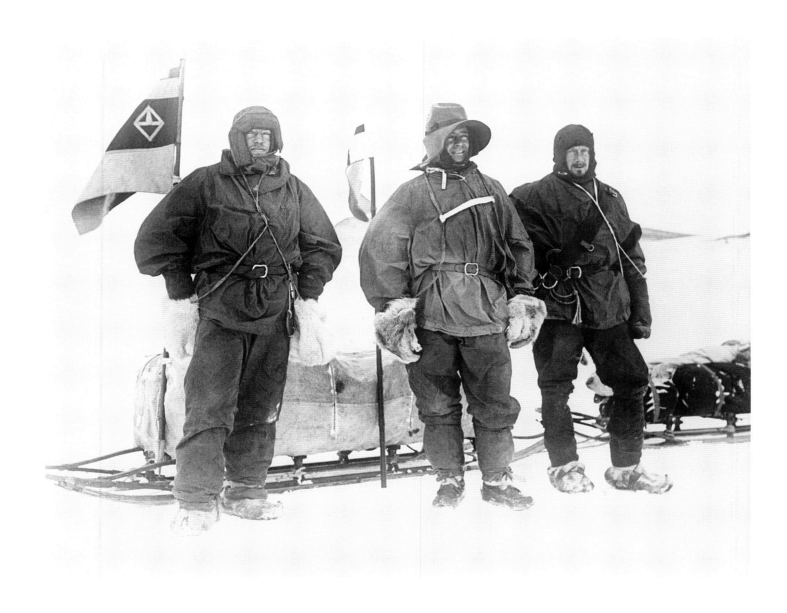

Scott, Shackleton and Wilson prepare to depart for the South Pole,
standing in front of the laden sledges in full sledging outfits.
Photo © Scott Polar Research Institute, University of Cambridge

THE SCOTT POLAR
RESEARCH INSTITUTE

The Scott Polar Research Institute (SPRI) was established as a national memorial to Captain Robert Falcon Scott and his four companions – Henry Bowers, Edgar Evans, Lawrence Oates and Edward Wilson – who died on their return from the South Pole in 1912. Scott's commitment to science is central to the Institute's mission – world-class research in polar science and exploration.

Frank Debenham, geologist on Scott's *Terra Nova* expedition, formed the idea for a centre or institute to collect information about the Arctic and Antarctic, and as a place for scientists and polar explorers to meet. The Institute was founded in 1920 in Cambridge – its initial building was erected in 1934 and has been extended several times to house its sixty or so staff and research students.

The Institute is a centre of excellence for the study of the Arctic and Antarctic, its staff undertaking research in the natural and social sciences – research topics range from the flow-dynamics of glaciers and ice sheets to the culture of the reindeer herders of Siberia and economic and social change in the Canadian Arctic and Greenland. The SPRI also houses the world's premier polar library, and archives and historic photographs on the history of polar exploration, science and culture. In addition, Britain's only dedicated Polar Museum, with displays on the history and contemporary significance of the polar regions, is a part of the Institute.

For almost a century, the SPRI has served as an unrivalled source of polar information and expertise, providing a strong core of intellectual activity focused on the Arctic and Antarctic and their adjacent seas. The importance of the polar regions lies in their contemporary significance in the context of global environmental change, and in the history of their exploration, which includes first encounters and subsequent interactions with the indigenous peoples of the north. The Institute provides authoritative information on a variety of polar topics including issues of climate change and the management of natural resources. Its broad audience ranges from school children, the general public and policy-makers, to students and scholars of the University of Cambridge and researchers from other higher education institutions worldwide.

The SPRI's faculty members are Fellows of Cambridge colleges and all teach on undergraduate courses in Cambridge. About thirty science and social-science doctoral and masters students are based in the Institute, the latter taking our Master of Philosophy course in Polar Studies. Staff and research students are regularly involved in polar fieldwork, including recent projects in, for example, Greenland, Svalbard, Russian Siberia, Arctic Canada and Antarctica. These field research programmes are supported by grants from the UK research councils and other private foundations and trusts.

The Institute's Polar Museum engages and informs its visitors about polar history and science, utilising the resources of the Institute's historic collections and current scientific research. It was recently transformed with support from the Heritage Lottery Fund and many generous private donations, reopening in June 2010 to commemorate the centenary of the departure of Scott's *Terra Nova* from London. The moving last letters, found with the bodies of Scott, Wilson and Bowers at their final camp on the Ross Ice Shelf, are displayed alongside Wilson's Book of Common Prayer and Captain Oates' sleeping bag. The original diaries from Sir Ernest Shackleton's four Antarctic expeditions are also part of our collection. The Museum welcomes about 50,000 visitors each year. The Institute's Archive and Picture Library are internationally renowned as research resources for polar history, and are used intensively by scholars from around the world. The collections of the Institute include manuscripts, printed books and other objects of remarkable historical, cultural and scientific importance; drawings, paintings, artefacts, photographs, film and sound archives and other material charting the advance of geographical and scientific knowledge about the Arctic and Antarctic, from the early days of their exploration to the present. These rich historic and academic collections have provided a basis for decades of scholarship.

Today, the use of the collections in research and public programmes is an important part of the Institute's role as a lasting memorial to the achievements and sacrifice of Captain Scott and the polar party. The Institute's scientific research on, for example, ice and environmental change, is also an important legacy of the early scientific endeavours of the expeditions of Scott, Shackleton and many others, and their investigations of the natural science of Antarctica.

www.spri.cam.ac.uk

ACKNOWLEDGMENTS

Above all I want to thank my family, my daughter Angelica, my wife Francesca and my father Fabrizio
who supported and encouraged me in spite of all the time it took me away from them.

I also thank my mother Edvige, whom I miss so much, for being ever present in my life,
and giving me the motivation and determination to accomplish my targets.

I would like to thank my publisher, Alexandra Papadakis for her continued support and enthusiasm over the years,
a close association which started with the publication of my first book *Wild Africa*. Dr Caroline Kuhtz was instrumental
throughout the production process, as was Sheila de Vallée in her help with the translation and editing of my texts.
I am once again indebted to Aldo Sampieri for creating such a wonderful design and layout.

I only press the camera shutter to record the overwhelming natural beauty around me, and do my best to survive
the natural elements, and so I am honoured to have a Foreword and Introduction by such great scientific personalities as
Professor Julian Dowdeswell and Dr Peter Clarkson, who have devoted their lives to research and conservation in the polar regions.

Finally, I am grateful to all of you who have accompanied me in spirit on my travels. I feel you at my side when I am in the field, and this
gives me the strength to venture to the extremes to capture and then share with you the soul of such extraordinary wild places and wildlife.

PUBLISHER'S NOTE
I would like to extend my grateful thanks to Dr Iain Bratchie, who is also a patron of the Science Museum, London,
and who personally introduced me to Professor Julian Dowdeswell, Director of the Scott Polar Research Institute.
The resulting association has been invaluable in developing *Blue Ice* into a beautiful and authoritative book.